C000102114

HOW
I BLOGGED
MY WAY
TO BOLLYWOOD

MALINI AGARWAL

FOUNDER OF MISSMALINI

#to the Moon

HOW
I BLOGGED
MY WAY
TO BOLLYWOOD

HarperCollins *Publishers* India

First published in India in 2017 by
HarperCollins *Publishers* India
A-75, Sector 57, Noida, Uttar Pradesh 201301, India
www.harpercollins.co.in

2 4 6 8 10 9 7 5 3 1

Copyright © Malini Agarwal 2017

P-ISBN: 978-93-5277-447-0
E-ISBN:978-93-5277-448-7

The views and opinions expressed in this book are the author's
own and the facts are as reported by her, and the publishers are not
in any way liable for the same.

Malini Agarwal asserts the moral right
to be identified as the author of this work.

All rights reserved. No part of this publication may be reproduced,
stored in a retrieval system, or transmitted, in any form or by any means,
electronic, mechanical, photocopying, recording or otherwise,
without the prior permission of the publishers.

Typeset in 11.25/16 Scala at
Manipal Digital Systems, Manipal

Printed and bound at
Thomson Press (India) Ltd

'To read is to voyage through time.'
– Carl Sagan

'To write is always to rave a little.'
– Elizabeth Bowen, *The Death of the Heart*

Mom, this one's for you. Thank you for letting me chase my dreams – and following me around with a handy-cam while I did!

To the CEO of my company and my heart, Nowshad, and my co-founder, Mike – because you believed, even before I did

For love #goals

CONTENTS

MissMalini.who?

I guess you could say my story begins like any good '90s Bollywood movie, with a pigeon and a damsel in distress. When I first moved to Mumbai nearly two decades ago, I had two suitcases, knew one friend and lived in an apartment with six girls and a pigeon. And every single night, this suicidal bird would fly around the living room where I slept (on a mattress on the floor), threatening to impale itself on the ceiling fan, as I cowered under a thin white bedsheet. My rent at the time was around Rs 1, 625 per month, so just imagine the state of that apartment. And Facebook hadn't been invented yet. Let me just say that again – FACEBOOK DIDN'T EXIST! Let alone Twitter, Instagram or Snapchat. All I had technology-wise was an alpha-numeric pager and a head full of dreams.

And yet, I wanted my life to be extraordinary and something told me that Mumbai city – with all its leopard-print taxis and kitschy neon lights that stay on all night – was where it was going to happen.

The next thing I know, seventeen years on, I'm sitting here writing this book about things I never thought would feature as oddly charming (albeit sometimes mildly horrific) anecdotes from my life. Surreal? No, hashtag that! #Surreal.

So, what is this book about? Me, I guess, and Mumbai. Because no matter how you slice it, Bombay is the City of Dreams, where if you want something badly enough and are willing to work your ass off for it, the universe will conspire to make it happen. And just like Oprah said, 'The biggest adventure you can ever take is to live the life of your dreams.'

Also, I hope to make this book somewhat useful, with virtual life hacks and all the wisdom I have picked up from the world and the web – along the way in a speed-reading version, under 140 characters at a time. So, look out for the tweets at the end of each chapter (or in my world – at the end of each blog) if you're the 'SNAP'py kind.

But the most important thing I'll *ever* tell you – just in case you don't make it past the prologue and return to your InstaStory-ing – is this:

People often ask me how to become a rich and famous blogger and I have a simple answer: Don't start by wanting to be a rich-and-famous anything. Step back, close your eyes and imagine the one thing you'd want to do for the rest of your life even if nobody paid you to do it. Find a way to make this your career, and fame and fortune will surely follow. I believe the universe will have no choice but to help you succeed. And hey, you'll enjoy the ride no matter what, right? The passionate pursuit of happiness, THAT's what it's all about.

If they ask you, tell them MissMalini told you so and off #tothemoon you go!

 MissMalini ✓ @MissMalini
@MissMalini: #MMProTip If you must choose between money and passion, always choose passion and the money will follow.

@MissMalini: #MMProTip Money can't buy happiness. Passion IS happiness.

@MissMalini: #MMProTip Sometimes happiness is nothing more than having something to look forward to.

@MissMalini: #MMProTip If there is a pigeon in your room, don't sleep with the fan on.

PS. So how does this movie – I'm looking at you, Karan Johar – end? Who knows! I've only just gotten to the intermission... *picture abhi baaki hai doston*!

Foreword

Digital entrepreneur...I like the sound of that. And a very successful one. Someone who is considered an influencer, someone who has built a great brand story around herself – I like that even more. It goes with what I have always said and believed – create your own legacy. Be true to yourself. This is where I find Malini Agarwal's journey so inspiring. From a radio jockey and print journalist, she made her passion her work, added dollops of self-belief and walked the digital talk. What began in 2008 as a blog was nurtured and grown to MissMalini.com, to Twitter and, every conceivable social media platform.

Today, she has truly emerged as the 'Social Media Jedi'. I connect with Malini because carving your own path is one of my strongest beliefs. As for the power of digital, well, when we both began within months of each other, no one knew how this would grow and we just went with our gut!

Malini, the Jedi, who has written in her book in her familiar blog style, gives her readers some funny, some philosophical and some serious 'MM' tips on life, living and working.

She takes us through her journey of coming to this #MaximumCity Mumbai and achieving success on her terms, making us all believe that dreams can come true. You go girl, your story has only just begun.

PRIYANKA CHOPRA

SECTION 1: MUMBAI, I LOVE YOU

'Living cities don't hold still.'
—John Irving, *The World According to Garp*

'Jeena yahan, marna yahan, iske siva, jaana kahan.'
—Mukesh, *Mera Naam Joker*

SECTION 1. MUMBAI, I LOVE YOU

Blog #10: Hello Bombay!

If you're wondering why this book begins with blog #10, you should know that like any good Bollywood movie, you must leave room for a meaningful flashback. If, however, you like your stories told in perfect chronological order, feel free to jump 'back to the future', after blog #01.

I arrived in Bombay (or Mumbai, if you prefer) in January 2000, armed with two suitcases, an alphanumeric pager, Rs 40,000 in the bank and just one dream – to live a life less ordinary.

I remember it was raining that night and cars and rickshaws whooshing by me on the highway from the airport. The pink and green neon lights from restaurants and shops were reflected in the puddles and potholes along the way. I rolled down the window of my signature black and yellow Mumbai Fiat taxi and, as I felt the rain and cool breeze on my face, I knew I was home. Also, by now I had seen countless movies where the heroine of the film rides alone in a taxi to her new life, often

leaving behind all kinds of ache and sorrow. To boldly go where every happy ending has ever gone before. All I was missing was the soundtrack.

Now admittedly, I had no idea what I was going to do here, but so far, I'd had the incredibly good fortune of falling easily into jobs that I truly enjoyed. The catch-22 of this situation was that I had never faced any major rejection. But as they say, without the bitter, the sweet isn't as sweet! So, enter MTV.

Up until now, my life's ambition had always been to become an MTV or a Channel [v] VJ (video jockey). This was a job I had seen first-hand through my dancing days and, at that time, was what you could call the pre-millennial dream job. I was twenty-three and recall marching into the MTV India office with five of my favourite (albeit unprofessionally shot) Kodak prints and meeting a talent coordinator who spent a kind 5 minutes with me before sending me on my way. Back then the MTV office had a basketball court in the middle, and on my way out, I dodged a ball to the nose, while avoiding eye contact with the many faces that I'm sure had seen countless hopeful VJ-wannabes make this exact same trek.

You've probably heard my pigeon and the ceiling-fan story ad nauseam, so I'll spare you any more details. At any rate, the result of the pigeon episode was that I knew for sure I had to find something to do, and do it fast. Bombay is not a cheap city to live in and my reserves were dwindling rapidly.

My best friend from college, Nikki, who had moved to Bombay a few years earlier (and, God bless her beautiful heart, was intent on helping me make it here) was working with the ad-man Prahlad Kakkar at the time and took me to meet him for some career advice.

I walked into his office in Tardeo where he was frying some eggs in the open kitchen, wearing his *Raiders of the Lost Ark* hat and glasses, and invited me to sit down once Nikki introduced us. He said, 'What do you want to do, child?' and I replied, 'I want to be a VJ!' He paused and asked, 'Why do you want to be a VJ? Forget it! What else do you want to do?'

So, I stuttered, 'Well...I like to write?' and handed him some poetry I had written over the years. In hindsight, this is a cringe-worthy way to show someone your skills. To be honest, if someone came to me for a job interview with a bunch of emo poems in their hand, it's going to be a very short interview. But he glanced at them and then looked at me and said, 'This is what you should do then! You should write.' He promptly picked up the phone, dialled a number and said to someone, 'I'm sending over this girl, try her out as a copywriter. *Haan theek hai,* bye.' And that was it. Off I went to become a copywriter.

I don't remember how long that trial lasted, or if I even got a job at that agency, but I do remember being struck by the matter-of-fact way with which he squashed all my dreams. But something about the way he had done it made me believe he was right and I perhaps didn't feel gutted as he had provided an alternative at the same time. In fact, I felt a new kind of excitement brewing inside me.

Now if you've ever encountered 'PK', as he's popularly known, you'll agree that he's quite an unforgettable personality. Aside from some of the campy 'non-veg' jokes he likes to crack and his penchant for saying 'naughty' things, he's brilliant and the reason behind many success stories in Bollywood. Most famously that of having given Aishwarya Rai Bachchan her very first break.

THE STORY

Well, actually, I didn't spot her, but my office girls were casting people. They saw her coming for a test to film-maker Kailash Surendranath's office, Genesis, which is downstairs from ours. They asked her to come up. At that time, we were looking for models for Pepsi. We were at a bit of a loss because we needed somebody stunning. And in walks this girl, an architectural student in torn jeans, and I said, 'What do we test her for?' 'No, no she's very good, look at her,' said my team. I thought she was nice but lacked that 'Pepsi quality'. But my team insisted. So, we put her in an interim film for Prudent Mouthwash. We were shooting somewhere in Madh Island and she went off to do her makeup and hair. She was wearing a pink salwar-kameez. When she walked down the stairs, everybody just stopped in their tracks. They said, 'Who the hell is that?' A collective gasp echoed around the room. We decided to use her for Pepsi, and so sure were we of our choice that we did not try out anybody else. She was young, must have been eighteen or nineteen years old. In the clip, she was supposed to walk into the frame and look sexy. Her line was, 'Hi, I'm Sanju,' to be delivered in a husky voice, 'Got another Pepsi?' She's supposed to knock everybody out, but she was awkward because my brief to her was, 'Imagine you walk into a room full of men and you have to make them desire you, physically.' She was sceptical and scoffed at the idea. She wanted to walk out. I said, 'No, think about it,' but she was adamant and said, 'I've thought about it and I don't know how to do it. I don't have any experience in this kind of rubbish. I go to school, I come home. I'm a good girl.' I then had

to teach her how to stand, how to pose and look provocative. By this time, she was at her wits' end and was ready to call it quits. The nineteenth take is when she finally got it right. But she said, 'I don't think it's going to work.' We all knew she was going to be a big star one day.

After Pepsi, I remember she came to see me. I told her at the time, 'You're going to be very big. I'm going to sign you on now for my feature film.' She laughed, 'I don't want to do feature films.' I gave her a silver one-rupee and said, 'You keep this. This is your signing amount.' I hope she still has it.

Who'd a thunk!

Now in the spirit of finding your mentors and letting them guide you, as you navigate your way through this fantastic adventure called life (or in my case also my 'Second Life' on the internet!), you will find throughout this book future life lessons from some of *my* mentors. See, I went back and asked each of them to give me a piece of advice for the years ahead. That way I can tell you what they already taught me and they can teach you (and me) something new at the same time. Two birds. (No pigeon.)

. .

PRAHLAD KAKKAR
Ad film-maker

Hey, Malini, would love to contribute to your book, but what can I say as you have surpassed our wildest expectations, and the world is today holding its breath waiting for you to reinvent yourself and be the star you have always been for me.

. .

Can I get a collective 'Aww' here? How sweet is that? Also, he makes the most amazing biryani. Try it at Sulafest the next time you go.

MissMalini ✓ @MissMalini
@MissMalini: #MMProTip Giving up on one dream doesn't make you a quitter. Quitting dreaming does.

@MissMalini: #MMProTip The universe sometimes sends you the most unusual messengers. Look past the hats they wear.

@MissMalini: #MMProTip Find your mentors and soak up everything they tell you. Then find them in 10 years and soak up some more!

@MissMalini: #MMProTip Even Aishwarya Rai started in torn jeans.

Blog #11: Copy That!

Being a nerd growing up has its benefits and I adjusted easily to the copywriter life with a dot.com company called Activ8 Technologies (yes, they all had clever names like that back then) run by two brothers, who suggested I join them while I continued to search for my true calling.

My salary was Rs 5,000 and the rent of my new 'apartment' – one tiny 250-sqs. ft. room with a bed, a table lamp, a Godrej cupboard, a microwave (no fridge) plus a joint bathroom with a struggling actress who lived next door – was Rs 3,500, which made the daily commute past the Dominos 'Hungry Kya?' billboard more painfully ironic.

I wish I could remember that girl's name, or if she ever made it big in B-Town. She looked a bit like a young Parveen Babi and I remember she always had expensive-looking lingerie drying

in the bathroom and a rubber ducky toothbrush holder. That odd combination of possessions intrigued me and made me fond of her at the same time. The only downside was that she spent HOURS in there doing her makeup or drying her very long hair and often made me late for work. Imagine telling your boss you're late to work not because of the monsoon or traffic but because your sort-of roommate actress needed soft curls for an audition. Yup, good times!

Anyway, while I was there I started working on a concept note for a website for the second-biggest tabloid in the city, *Mid-Day*, a site which was eventually named ChaloMumbai.com. Each day I would come up with more sections and subsections for the site that were meant to cover everything from movie reviews to property listings. And every evening I would take my ever-growing stack of printouts to the boss and he'd say, 'Great, now flesh this out some more.' After about three weeks, I had written what we came to refer to as the content 'bible'. It sat, printed and bound, completely unaware of the mammoth task it would be to build and populate it.

One day I got a call back from one of the various job hunts I had ongoing and was offered a position at a website called IdeasForYou.com, where they offered me a salary of Rs 15,000, plus benefits. I promptly accepted. My job there was hilarious. I was sent to Vijay Sales each day to check out various home appliances, like washing machines and dishwashers, to get specifications and information from the sales reps and come back and write consumer reviews on the site. Yes, me, the dishwasher expert.

Just about a month later I got a call from Activ8 saying they needed me back to work on the 'bible' since *Mid-Day* had

accepted the proposal. I was thrilled, but bargained that they match my salary and even give me a slight raise to return. Pre #bosslady negotiations.

For the next six months, I worked relentlessly on the website. As the project coordinator, I received flak from both ends. The content team was always confused and struggling with how to use the clunky CMS (Content Management System) and the technical team was working extra hours to keep up. Eventually, I was just stationed full-time at the *Mid-Day* office in Parel and loved the hustle-bustle of a live newsroom, especially the *Sunday Mid-Day* and entertainment desk that always had the latest Bollywood gossip.

There was of course some emotional drama too (isn't there always?) when my then boyfriend's parents, who lived in Dubai, called my mother one day to say, 'Your daughter entertains our son at 4 in the morning!' To which my mother replied, 'Well, we're not there, whatever they're doing at 4 in the morning, they could be doing at 12 in the afternoon.' Boom. Go mom! Of course, she landed into me after that in full parental panic mode, but eventually we worked it out, although the relationship didn't. I also thought the whole 'entertains our son at 4 in the morning' was hilarious because it made me sound like a one-woman impromptu performance act.

Once I finished my stint at *Mid-Day* and the website was running smoothly, I decided I'd had enough of Bombay and roughing it out and would move to the US and live with my big brother and study journalism or dance or something. But I had a few interviews still lined up, so I decided I'd go to one last one.

MissMalini ✔ @MissMalini
@MissMalini: #MMProTip The more you write, the more you will find to write about.

@MissMalini: #MMProTip Never share a bathroom with a struggling actress.

@MissMalini: #MMProTip There's just THAT many things you can say about a dishwasher.

@MissMalini: #MMProTip Don't try to build your own CMS. Find the best product available and use that instead aka I love you WordPress.

@MissMalini: #MMProTip Know your worth and charge accordingly.

@MissMalini: #MMProTip Moms will always have your back.

Blog #12: *Romance & Sexuality*

The company I was interviewing with was called Asia Content and I thought it would be just another copywriting position, but when I got there the guy who was interviewing me, one of my favourite bosses, Anil Nair, said, 'Look, I'll be straight with you. We're looking for someone to run the romance section on MTV India online but you have big shoes to fill.' I sat there thinking: wait, you're going to pay me to write about love and romance all day? Thank you, universe.

My business card said 'Channel Head – Romance & Sexuality'. My mother must have had another heart attack I'm sure, but she's a believer. My job was to fill up the section with interesting articles and I was perfectly happy doing this job and so into it that in my spare time I taught myself Dreamweaver and Photoshop and started playing around with the pages on the site to make them look more interesting on my own. I had by now also moved three times (with varying success) from Andheri to Juhu to Vile Parle. In the monsoon, it used to rain

inside my one-room 'apartment' in Juhu since the ceiling was just a metal sheet with holes in it. We resolved that by tying a giant piece of blue tarp down on it and voila, jugaad.

But that little VJ voice inside my head hadn't fully died yet, so when I heard Channel [v] was auditioning for new faces, I thought I'd give it another whirl. This time I went prepared for the audition in an – at best – questionable outfit, that involved a too-snug beige strappy top, floral print chiffon skirt and knee-high brown leather boots. Yes, in the Bombay summer. (Hold on, I think my stylist just fainted, I'm sorry, Nelly. We *all* have a past.)

My friend Nikki had arranged professional hair and makeup for me on location at someone's shoot, where the makeup artist boosted my confidence BIG time, as he shaped my eyebrows saying, 'You have a nice face, you should do print modelling.' So, I got to the audition and apparently killed it! I read the teleprompter to perfection with a kind of 'VJ' enthusiasm that requires an almost unrealistic excitement about everything you're saying, but they all seemed duly impressed. In fact, they said, 'You're short-listed, we'll tell you when to come back.'

I was thrilled and thought – wait till I tell PK! I went back to the next audition (but did my own makeup, maybe not the best move) and arrived at the poolside of the Sun-n-Sand Hotel in Juhu. The audition this time was apparently going to be conducted IN the pool and they had asked us to carry bikini tops and shorts.

I remember the model Carol Gracias was there too. It was the first time I had ever met her and while the Channel [v] stylist was going through my very average selection of swim wear, Carol sweetly volunteered that I could borrow any of hers if I

wanted to. In fact, I think I did. I was struck by how kind that was of her, especially since we were auditioning for the same job. We got to this pool and we were each supposed to ad-lib something while sexily walking out of the water. I did this about four times, rambling happily without a hitch, but apparently just not sexily enough. At the end of the audition they said, 'Well, you definitely have the gift of gab,' but stopped short of saying 'just not the on-screen sizzle we're looking for'. And that's when I decided I didn't want to be a VJ anymore.

 MissMalini ✔ @MissMalini
@MissMalini: #MMProTip The world is round and so is your path.

@MissMalini: #MMProTip Teach yourself new skills, even if nobody asks you to learn them.

@MissMalini: #MMProTip Be kind, even to your competition.

@MissMalini: #MMProTip People won't see what they're not looking for.

Blog #13: Love in the Time of Bollywood

If you know me, you probably already know by now that my one true obsession in life is LOVE. Especially the kind you see you in the movies. Yes, I blame Bollywood and you, Meg Ryan.

I even have a tattoo of a quote from the movie *Moulin Rouge* on my ribs that says, 'The greatest thing you'll ever learn is just to love and be loved in return.'

And now my job was to write about it too. I remember that one of my best friends in high-school, a wonderful guy called Sushant Mukherjee, once shared with me an article he had written on love.

He wrote about his experience at a local radio station in Senegal, West Africa, where he was struck by how far and

wide the net of Bollywood had been cast. Where people would
listen to hours of Bollywood film music on the radio and talked
fondly of Dilip Kumar and Nargis, saying they had found hope
in the kind of love stories we told in India. The larger-than-life,
all-consuming, impossible love stories that made you want to
fall in love. The overwhelming kind that the movies promised
surely existed, but no one could ever say for certain, because it
was so hard to come by in the real world. I asked him if I could
share the article he wrote and he was kind enough to say yes.

THE LONG REACH OF BOLLYWOOD: TALES OF AN INDIAN VOLUNTEER IN WEST AFRICA
By Sushant Mukherjee

A few years ago, when my family was living in Egypt, I
remember being told a story by the young son of an Indian
Foreign Service officer. He had been taunted and threatened
by classmates in his school in the Suez Canal town of Port
Said for daring to claim that Amitabh Bachchan was, in fact,
not a Muslim. 'Didn't you see him recite from the Quran in
Coolie?' they angrily demanded. Surrounded by a crowd of
belligerent schoolboys, the frightened young boy could only
manage a bewildered, 'Why do you even care?'

Like my young friend, I too have long been struck by the
intensity of passions aroused by Bollywood films and actors
in lands far from India, and particularly in countries with no
local Indian population. Yet nothing in Egypt prepared me for
what I was to experience on my recent three-month sojourn
in a very different corner of Africa.

Six weeks ago, I found myself sitting in a recording booth of
a radio station in the coastal town of Saint Louis, in northern

Senegal. I cleared my throat, fidgeted nervously, tried to scribble a few notes, and wondered how I had gotten myself into this situation. In a few minutes, I was to be co-hosting a national call-in show on Hindi film music. My qualification for this role? Merely the fact that I was, to the best of people's knowledge, the only Indian currently living in Saint Louis, and one of very few who had ever spent more than a passing weekend in this part of the country.

It had been my friend Malal, a young local radio journalist, who had first drawn my attention to the fact that every Wednesday evening between 9 to 11 p.m., Senegal's biggest private radio station aired a popular show on Hindi film music. He urged me to go to the radio station the following Wednesday, and promised to speak to the DJ who ran the show. 'Indian music is everywhere here, it's in our blood,' he said, matter-of-factly. 'But a real Indian, in the flesh, now *that's* a novelty.'

By this point in my stay in the country, I was not all that surprised to hear that there was a weekly Hindi music show. I had arrived in Saint Louis two months earlier to work as a volunteer teacher, and was amazed from the outset at how familiar Indian culture seemed to be to the Senegalese people. One evening, as I sat eating dinner in front of the TV with my local host family, I almost choked on my fish when I heard a character in the Wolof (Senegal's national language) soap opera we were watching, slap her forehead, and exclaim melodramatically, '*Nahin, baba.*' My host family snickered at my surprise, and the father explained that Hindi films were so popular in the region that common expressions to be heard in the films had made their way into everyday parlance in Senegal, particularly among the older generations. For example, he remarked, one of the common ways of saying 'crazy' in Wolof is '*paagal*'. Another friend later told me about

a certain gentleman in Dakar who was renowned throughout Senegal for his impersonations of Indian actors and renditions of Bollywood song-and-dance numbers – fittingly enough, the man went by the name of Amadou Bachchan.

Even so, when Malal introduced me to his DJ friend Yacoub, and the latter greeted me effusively with 'Namaste, bhai sahib...Aap se mil kar badi khushi hui,' I was a little taken aback. Yacoub, it turned out, spoke fairly good Hindi, learned almost entirely through years of watching countless Hindi films. He insisted that I co-host that evening's show with him on air, despite my feeble protestations that I was the furthest thing from an expert on Bollywood films and music. It didn't matter – I was Indian, and that, apparently, was more than enough.

The next two hours passed in a blur. After a brief introduction, in which Yacoub asked me what I was doing in Saint Louis, and who my favourite actors and actresses were (I think I stammered something about Kajol), he opened the phone lines, and events took a decided turn for the berserk. The calls poured in, and I was welcomed over and over again – in a combination of broken Hindi, French and Wolof – and asked questions ranging from whether life in India really was like what one saw in the movies, to why Hindus cremate their dead. My French, which is passable at best, was sorely tested by some of these explanations, as was my very superficial knowledge of Hindi film music – when one gentleman asked me what my favourite Manna De song was, I had to skilfully change the subject. Another old man called in and serenaded me with Kishore Kumar's 'Zindagi Ek Safar'. During a commercial break, Yacoub brought me a tattered edition of an Amar Chitra Katha comic and asked me to help him with his diction.

By this point, I had begun to get overwhelmed by how surreal it all was, and was relieved when the show finally

came to an end. Yacoub thanked me for my participation, and asked me if I could become a regular feature on his show, as he had never received these many calls. I explained to him that, sadly, I was leaving the following week to travel a little in the region before returning to India.

I returned from West Africa less than a month ago. As I had expected, my time there was a magical experience and an incredible cultural education. The unexpected bonus, however, was that after seeing how respected and valued Indian films are in the region, I returned with a newfound appreciation of this aspect of my own culture. At a time when the urban, middle-class youth of India are increasingly fascinated by all the trappings of Western culture, I think it is important to acknowledge that there are still parts of the world for which India – and not the West – represents the possibility of a better world.

I am reminded of a conversation I had with an elderly proprietor of a hostel in the dusty little town of Kidira, on the border between Senegal and Mali, who held my arm and said to me: 'Indians need to understand what their culture has meant to us. It allowed us to dream of a world full of romance and passion and hope. The youth of today prefer American films, but when we were young, Dilip Kumar and Nargis were the king and queen of the world. They need to know that.' I promised him solemnly that I would do my best to relay the message.

I thought that was just about the best thing I had ever heard. Sometime later I came across a novel about a guy who hitchhiked his way across Russia because taxi drivers would

give him free rides if he told them about Raj Kapoor movies
and sing '*Jimmy Jimmy Jimmy Aaja Aaja Aaja*' in return!

> *Jaane kahan gaye wo din*
> *Kehte the teri raah me*
> *nazron ko hum bichayenge*
> *Chahe kahi bhi tum raho*
> *Chahenge tumko umra bhar*
> *Tumko na bhool payenga*
> *– Mera Naam Joker*

That.

In fact, once I was in London with a friend, walking down
Tottenham Court Road, and a random guy stopped us and
pointed at my salt-and-pepper-haired friend, saying, 'Amitabh
Bachchan?!' I wish he had said yes and made that guy's day.

MissMalini ✔ @MissMalini
@MissMalini: #MMProTip We don't need to go very far looking
for inspiration; sometimes we *are* the inspiration.

@MissMalini: #MMProTip Every country needs an Amitabh
Bachchan.

@MissMalini: #MMProTip Jeena yahaan marna yahaan iske
sivaa jaana kahan?

Blog #14: Bombay, 143*

**143 – I Love You. (Get it?)*

There's another movie concept I am somewhat obsessed with.
Two films called *Paris, Je T'aime* and *New York, I Love You*. The
latter came out in 2008, the same year I started my blog. Both
are anthologies, each short film by a different director, where

each film relates, in some way, to the subject of love against the backdrop and flavour of that city. How brilliant is that?

I have always maintained that Bombay is a curious beast. Every single day its population of millions swells by a find million as countless dreamers pour into the city for their daily bread and butter or with dreams of becoming the next Shah Rukh Khan.

Did you know, by the way, that well before he became famous (back in 1991 I'm told), Shah Rukh himself stood on Marine Drive with the setting sun behind him and proclaimed, 'I will rule this city one day.' How crazy is that?

'Agar kisi cheez ko dil se chaaho toh puri kayanat usey tumse milane ki koshish mein lag jaati hai.' – Om Shanti Om

Move over Miami, how do you not love a city that can make THAT happen?

The other thing about Bombay is that you either love it or *hate it*. If you land here channelling Russel Peters anticipating 'the smell' to hit you and the bodies to bump you, that's exactly what you'll get. If you come here with an open mind, ready for an adventure, the city will go Shantaram on your ass and take you on a trip of a lifetime! What's your poison – red pill, blue pill?

I'll tell you this though, when it comes to living in Bombay, location is EVERYTHING. And I don't mean having a fancy 'SoBo' (South Bombay) address. If you ask me, the joy of your experience of living in this city is directly proportional to the distance between your office and your home. The closer you live, the happier, less stressed out you'll be; especially come monsoon.

For many years, I lived at the Rewa Bungalow in Mahalaxmi. Most importantly, it was walking distance from a bar called the Ghetto. The bungalow is owned by the Princess of Rewa, Madhu Singh. Rewa is famous for its white tigers and the bungalow even had a few white tiger skins as part of the décor. I lived in one of the rooms at the back with a view of Haji Ali on the water. I spent eight years of my life there and threw some legendary Holi parties in the garden too. To this day, when my friends and I talk about this house, we say these unforgettable words from *Mr India*, '*Bangla, bangle ke aage balcony, balcony ke aage garden, garden ke aage samundar!*' ('A bungalow, a balcony in front of the bungalow, a garden in front of the balcony, the ocean in front of the garden!')

Yes, I know it's crowded.

Yes, I know there are places that reek of poor civic sense.

Yes, I know there's an ugly underbelly of corruption and greed.

Yes, I know.

So, to all the expats and ex-Indians and foreigners that come here and complain about how crowded it is and how much it smells, I say you're just making it more crowded and smelly then, aren't you? But you're in luck. There's a red eye with your name on it back to wherever you came from around 2 a.m. Auf Wiedersehen!

PS. You'll miss your maid and driver a hell of a lot more than you think.

But for those who choose to stay, there's also magic in the air sometimes. You get a whiff of it when you see your dreams unfolding in front of you. You catch a glimpse of it when you hear people tell their stories of going from 'zero to hero' with

a twinkle in their eyes. I know, because I can say without a shadow of a doubt that Bombay let me be the best that I could be. And I don't think too many cities with cookie-cutter living can claim to give you that.

Which is why we need our own compilation of short stories. Because Mumbai, I love you. (Geez, now I'm tempted to write one.)

In fact, I even tweeted to Anurag Kashyap* that he should make a movie on Mumbai and this was his reply:

MissMalini ✔ @MissMalini
@ankash1009: @MissMalini oh we made one.. 4 years ago.. called Mumbai Cutting.. my best little film.. Sahara has been sitting on it.

Can we request that one out of the archives please? I'd love to see it.

On that note, another anthology I'm looking forward to is *Bombay Talkies Part 2* (not a sequel I'm told). You know, I got a lot of flak for giving *Bombay Talkies* five stars on my blog, but I guess it spoke to me. Ashi Dua, a producer, knew that in 2013 Indian cinema would celebrate its hundredth year, and to commemorate that she asked four directors – Anurag Kashyap, Karan Johar, Dibakar Banerjee and Zoya Akhtar – to put together a short film each as their ode to Indian cinema. Each film pretty

* FYI, *Mumbai Cutting* is a 2010 anthology Indian film with eleven short stories based in Mumbai by directors like Anurag Kashyap, Sudhir Mishra, Rahul Dholakia, Kundan Shah, Revathy, Jahnu Barua, Rituparno Ghosh, Shashanka Ghosh, Ruchi Narain, Ayush Raina and Manish Jha. It played at a few international film festivals but was never commercially released.

much takes you on a GIANT roller-coaster ride through all the Bollywood emotions I love best: hope, drama, dreams, desire, joy, pain, want, love, longing, ache and sorrow.

Rashmi, my senior-most Bollywood blogger, has always had this to say about love and longing; 'If there's a feeling stronger than love, it's longing. You can love someone a lot, but you can't love someone as much as you can want them, or miss them.'

Sigh. Be still, my tortured heart.

But, of course, one of those brilliant films was by Anurag Kashyap. Aside from the expected ache in his short story, he also threw in one of my favourite dialogues of all time, '*Allahabad ka paanwalla bhi intellectual hota hai!*' Damn straight. And fist bump Mr Bachchan from a fellow Allahabadi.

But looking back now I think I was just so fascinated by the concept of a short story that touched a chord, teased an emotion or captured a moment that I hoped one day I'd get a chance to do something like that. And if you think about it, what else is a blog but one little story at a time? Okay granted, not all blogs are meant to make you cry (or at least I hope not all mine do), but to me they each feel like little tales because the blogger is a storyteller after all. You know there's a real person on the other side of those words, who was feeling something and was then compelled to share it. Whether it was a passion for motorcycles or movies, for travel or trends.

The world can be a lonely place until you stumble upon someone you can relate with and whose words speak to your heart and mind in a way that you've always wanted them to. And that's why the World Wide Web is my favourite playground in the world. Remember 'Friendster'? Like that. With an infinite number of matches.

MissMalini ✔ @MissMalini
@MissMalini: #MMProTip If there's a heart-wrenching story to be told, Anurag Kashyap has probably already told it.

@MissMalini: #MMProTip Bollywood has an emotion for everything and everyone.

@MissMalini: #MMProTip 'You can't love someone as much as you can want them, or miss them.' – credit @tehrashminator

@MissMalini: #MMProTip 'Words are, of course, the most powerful drug used by mankind.' – Rudyard Kipling

@MissMalini: #MMProTip 'Will you walk into my parlour?' said the spider to the fly. – Mary Howitt

@MissMalini: #MMProTip 'Allahabad ka paanwalla bhi intellectual hota hai.' – *Bombay Talkies*

Blog #15: Dot Gone

Soooo, I appear to have gotten a bit derailed here by the topic of love but in my defence, it was also my job for three years, until one day, they pulled the plug. Basically, the whole 'dot. com' bubble burst and they down-sized us (a word you would hear often back then) from a team of fourteen to four. My boss Anil, two eccentrically awesome colleagues, Ashok Cherian (whom I called Cat for some reason) and Clyde D'Souza, and me. I remember they would both call me 'Ramani', you know like after my namesake fashion designer whom I hadn't met yet – Malini Ramani? They did this for years. Funny how the universe leaves you little nuggets of foreshadowing everywhere, isn't it?

On the upside, when the internet bubble burst (or in my opinion had a temporary deflation), they marched the surviving troops into the main MTV India office from our previously separate digs on the other side of the building. As I walked

across the oh-so-familiar basketball court to my new desk, I thought – well, isn't this funny.

Four other major things happened to me during this time.

1. I made my first legitimate Bombay best friend – Diya Kurien. She was interning at MTV before returning to Boston University. We spent many weeks smiling politely at each other with little to say (I now know it was pure shyness not judgement of my utter geekiness), till one day someone brought up the movie *Memento* and we got involved in dissecting the film. The person who had brought it up hadn't seen it, so we were banished outside to continue our conversation. Funny are the things that start a friendship, aren't they? In 2017, Facebook alerted me to the fact that we've been friends for a whole decade. Happy frieniversary, DK! #MoveItShakeItRockIt (I feel like we had a hashtag before anyone else had a hashtag. We also had friendship half a decade before Facebook was invented, so technically happy fifteenth frieniversary!) #JustSaying

. .

DIYA KAPOOR
Self-employed (Yoga Master)

Our story begins with being left-handed. And slightly off-centre, together.

From bonding over movies like *Memento* and *The Hitchhiker's Guide to the Galaxy* (I did say off-centre, didn't I?), to breaking it down with some seriously bad dance instructors, to bringing down the house on some wild Friday nights, my journey with Malz has been one long winding road.

Distance (and marriage and some incredible kids) has had its toll on us, taking us in opposite directions sometimes but somewhere, somehow we've managed to find that one point of absolute synchronous ground. Malz, you have now arrived on the moon.

Time to reach further, girlfriend.

I've got your back!

. .

2. I met Alex Kuruvilla and Cyrus Oshidar – two people who became my media mentors. Alex taught me that you need to constantly evolve in your thinking and not be afraid to hire people who could someday take your place. Cyrus in fact came up to me one day and said, 'Hey, what do you do here exactly?' to which I said, 'I work on the website.' He said, 'Cool, do you want to write promos?' And from there on I started writing MTV show promos and scripts (for which I wasn't expecting to get paid extra but I did, so bonus!), including some scripts for Nikhil Chinapa. In fact, Nikhil came looking for me one day to ask who had written his last script because he liked it so much. Maybe I WAS a writer after all.

. .

NIKHIL CHINAPA

You've come a long way from writing my scripts at MTV, to re-writing the books on how to build a media house, MissMalini! You're witty, hardworking and tenacious and the team you've built around you reflects your personality. It's plain to see they love a good story just as much as you do and together, you've re-imagined the way entertainment is presented and consumed in India.

. .

ALEX KURUVILLA
Managing Director at Conde Nast India

It was internet 1.0 and MTV India was an early player. Looking back, some of our moves seemed positively Neanderthal, even embarrassing. But a few moves were absolute genius, ahead of their time. For instance, the hiring of a cool, young lady who was very 'with-it' as the lead of the Sex and Relationships online channel. Her name? Malini. The moniker Miss came later when the lady became a brand.

Every time I come across the name MissMalini (which is once every few minutes these days!), it is with tremendous pride. She has built a brand and a business that is original, unique and very millennial (a great compliment in these times!).

So, MissMalini, you've barely got started. Just continue doing what you are doing, being who you are – spontaneous, glamorous, exuberant. But every once in a while, pause from your regular beat, and unleash the power of your reach to make a difference. About any issue that you feel strongly about. Domestic violence against women? Corruption? Girl child? Whatever. This country needs it. Bad.

CYRUS OSHIDAR
Managing Editor & Chief Creative Officer, 101India.com

Simplify. Cut out the extra and focus on what matters. And who matters. The rest is frills, bullshit and noise.

3. With my new-found confidence (about my writing prowess), I wrote an article for *Mid-Day* about the dot.

com bubble bursting and it was my first full-page article in a newspaper ever, yay.

4. And probably the most crucial of them all: one of my colleagues at MTV India Online, the head graphics guy, Rajeev Chudasama (who went on to co-found the advertising agency Marching Ants), told me that his friend was holding auditions for a brand-new commercial radio station and maybe I should give it a shot. The next afternoon at lunch, that's exactly what I did, not knowing just how much the next 45 minutes would change my life!

MissMalini ✔ @MissMalini

@MissMalini: #MMProTip The universe has pre-planted your best friends around the planet, they'll show up when you need them, just keep your eyes and hearts open.

@MissMalini: #MMProTip Basketballs and laptops don't play well together.

@MissMalini: #MMProTip Never say no to extra work that will teach you something new for free.

@MissMalini: #MMProTip You'll be amazed what can happen over a wisely spent lunch break.

SECTION 2: MY RADIO DAYS

'It's not true I had nothing on. I had the radio on.'
—Marylin Monroe

'In radio, you have two tools. Sound and silence.'
—Ira Glass

Blog #16: Theatre of the Mind

They say that video killed the radio star, but in my case, it was the opposite. Radio killed the wannabe video star in me and I spent nine incredible years on the radio. I fell in love with this medium almost immediately. My audition involved writing six content pieces, which served as 'links' between songs. These links consisted of music trivia or entertainment news (sound familiar?) and I remember being offered the job almost immediately (yay!). As it turned out, my first on-air shift would be from 9 p.m. till midnight. For a while, I even did the graveyard shift from midnight till 4 a.m. for practice. So, I would spend my days at MTV and my nights at WIN 94.6 – one of the two brand-new commercial English radio stations back in the day.

I lived nearby. My little world existed in the confines of Tardeo–Mahalaxmi–Worli. This was also because I loved a little dive bar called the Ghetto, nestled next to Mahalaxmi Temple. It has a pool table and graffiti on the walls, which you're welcome

to add to, and is the kind of bar where everybody knows your name. I made my first few friends there playing pool. I remember when I told my now business partner Mike that I wanted to take him to Ghetto, he jokingly replied, 'Should I bring my gun?' And I said, 'It's not that kind of Ghetto, Mike.'

And for the next decade, my world remained within Tardeo, Maxalaxmi and Worli. But, once I was on air, I could be literally anywhere.

I have always attributed my love of radio to the fact that it is, without a doubt, 'the theatre of the mind'. You know, just like when you read a book and imagine the characters and the setting; they take shape in your mind just the way you want them to. What your imagination conjures will always be the Oscar-worthy screen adaptation of the book. Why do you think only a handful of movies have ever done justice to the books they are based on? Because the vivid imagery created by your very own theatre of the mind is so much more satisfying than anything anyone else can create for you.

And this is also the reason why, when you listen to a radio host, you imagine them to be the most beautiful version of themselves. I've always loved this aspect about the radio – it frees you in so many ways. For example, people can be heard joking, 'Oh, he has a great face for radio,' hinting at the lack of conventional attractiveness of the host in question, but the radio lets you be your perfect self – or at the very least, your truest self – without any outwardly trappings to distract people from your sparkling personality. Years later, I found this to be true of the internet as well. Here, again, your words and your identity were set free from your physical appearance. You should probably watch the documentary film *Catfish* to truly

understand how impactful that is along with both its rewards and perils.

Here, your imagination is an enabler too; it helps you believe what you want to believe. I remember this legendary story about the radio host Howard Stern, the original 'shock jock', who would often get porn stars on the air, taking his title to the next level. In one radio bit, he tried to give a listener an orgasm over the radio by getting her to sit on her speaker while he hummed into the microphone! If you haven't seen it, please watch the movie based on his life called *Private Parts*. It is epic.

So, yes, 'the theatre of the mind'.

Oh, man, I just remembered this crazy thing that happened to me once. One evening when I was done for the day at MTV, Nikki said she'd pick me up on the way home (we finally lived together now, just like we always wanted). As I was standing on the street, expecting her to pull up in a cab, this car I didn't recognize came to a halt in front of me. I took a few puzzled steps back (half-expecting some douche bag) until I saw Nikki and another colleague of hers sitting inside. They waved to me to jump in, but were behaving a little oddly and I couldn't figure out why. I did once I sat inside and noticed that in the front seat, next to the driver, was seated a movie star. I can't say his name for legal reasons, but let's just say *Raju Ban Gaya Gentleman*. Yup, *that* guy. And if you're thinking SRK, I'm going to say 'na' twice. Also, if your Bollywood knowledge extends this far, I'm going to sing you '*Loveria Hua*' the next time we meet! #JustSaying

I was already speechless with surprise, and then in a deep husky voice he said, 'Could you pass me what's in the back pocket [of the seat]?' As I put my hand in to grab whatever it was

wrapped in cloth, which slipped off as I pulled it out, I realized in utter shock that it was a gun. Not the garden-variety toy gun you get at Party Hunterz. Oh, no, it was the real deal, you-could-kill-somebody-with-that heavy-ass-gun. I passed it over to him and proceeded to sit very still as all of us in the back seat had a collective 'this is how it ends' moment. The good news is we didn't end and he very kindly dropped us off to our Lala Lajpat Rai College lane, because we decided not to specify which building we lived in, just in case! Phew. How crazy is that? I have held in my hands a legit handgun *and* lived to blog about it. #Ghoda. No idea why, but in all Bollywood gangster movies a gun is usually referred to as a ghoda, which literally means a horse.

Now tell me, when you read that story did you picture it? What did the gun look like? What did HE sound like? How scared was I? Your imagination has already told you all these things and put into technicolour the images from my 'you had to be there' experience and you definitely weren't there. All I did was put boring black ink on a page. How's that for theatre of the mind? Let's give it up for the human imagination, folks. *crowd goes wild*

Speaking of theatre, that's also where I met my friend Nadir Khan, one of the few men I have met who are passionate about actual theatre. Till this day we host a radio show together, which you can hear across all the Shoppers Stops in the country. We talk about everything from U2 (his favourite) to the latest beauty techniques (my favourite) that might be all the rage on the scene today. Yup, and I think we've probably been doing this for almost a decade.

You may not know this about me, but when I began out my career, I was one of those uber-practical people who believed it

was more important to have a steady income than throw caution to the wind just because you think you've found your passion. Passion doesn't pay the bills, right? So, even though I was offered a more popular afternoon slot on the radio, I resisted at first, saying, 'But how can I quit my day job for a part-time gig? That's so irresponsible.' It was the PD (programming director) at WIN 94.6, Aditya Patwardhan, who looked me straight in the eye and incredulously told me that I was making a HUGE mistake turning down the offer. He said I was clearly made for the radio and that if I didn't take this chance now, I would regret it for the rest of my life.

To this day I remember that moment as one of the most crucial turning points in my career and my way of thinking. Suddenly I was going off the charted path, switching off Google maps, if you will, and navigating alone. Side note: The gravity of this analogy will only make sense to those directionally challenged like myself. I swear, it's a thing. It's just hard for some people!

Captain Pattu, you were right and IOU this one.

• •

ADITYA PATWARDHAN
Former Programming Director at WIN 94.6

I remember interviewing Malini for a gig in radio over a decade ago on a rickety desk that served as a sit-out for the thinkers. She walked in thinking content, and walked out being delivery. My first impression of her? 'This one's gonna go places.' And we now have a book. You asked me for advice going ahead, here it is: You don't need any, just look to the moon. Up, up and away!

• •

At this point, I would be remiss if I didn't mention an incredible personality I had the fortune of getting to know while on the radio – Roshan Abbas. He needs no introduction considering he's dabbled in everything from radio to event management, writing and directing. Among his varied talents, my favourite thing about Roshan has always been his incredible storytelling ability. In fact, he leads a session called 'The Storytellers', which is an attempt to take you back to the basics and capture the essence of sharing a true-life experience, in an intimate captivating way, almost campfire-style. The premise: tell a five-minute story, it must be a true story, something you've never told before and that moved you. Cool, right? (Can you think of one? I can hook you up for his next session.) The reason I bring this up is because I feel blogs have the same capacity for intimacy. Your readers are gripped by your very personal voice and feel as if they are being spoken to directly. Like a letter to a friend.

I will also never forget how, when I had just about decided to quit my day job, Roshan warned me that they were planning to drop my show without telling me and that I shouldn't give up my gig at MTV yet. He needn't have done that; we had just met and he knew the station head much better than he knew me. But he did what was right, *because* it was right. Luckily it all worked out and I managed to keep both jobs, and that's where I learnt that as long as you're having fun, two jobs are better than one.

ROSHAN ABBAS
Managing Director, Encompass

Everyone likes to be featured on MissMalini.com, and Malini has made that urge to know and to be known a trademark. Going forward MM needs to preserve her unique identity. She is no longer a singular voice but a channel of many voices. Keeping the freshest ones, making them relevant as part of the brand and planning brand extensions are critical. On a separate note, she should invest in cloning herself. I wonder where she gets the stamina to attend three events per night and keep the smile on! I would have written a business plan for her but then thought I need to make this short and snappy. Stay as you are, just be careful of the ones trying to be you. This copycat market filled with big media houses always looks to bring down fresh talent.

MissMalini ✔ @MissMalini

@MissMalini: #MMProTip You can't grab onto the next trapeze bar if you don't let go of the one you're holding.

@MissMalini: #MMProTip Where there's a Patwardhan, there's a way.

@MissMalini: #MMProTip 'I loved being on the radio. Being paid to talk? It's like being paid to eat.' – Rachel Maddow

@MissMalini: #MMProTip If you get in the back seat of a stranger's car, always check the back pocket of the front seat for a handgun, better safe than sorry!

@MissMalini: #MMProTip The big boys might try to knock you down, but just...*get right back up again cos nobody's gonna keep me down!* #chumbawamba

Blog #17: 3 Creepy Things

Unfortunately, no her life goes without dealing with at least three creepy things happening to them, which she won't ever forget. My hope is that the lessons you learn from them, or the opportunity they offer you to raise a voice and stand up for all women, especially those who may be in a situation where they can't, allays some portion of the creepiness of it all. Whatever doesn't kill you makes you stronger, right? Here are mine thus far.

1. When I was seventeen years old, I went to watch a movie with my mom at a cinema in Delhi. I was wearing a mustard-coloured, giant floral print, loose-fitting salwar-kameez, with tied up greasy hair and had my nerdiest glasses on. (Because as most desi girls know, that's how you went to the movies with your mom.) As we made our way through the crowd, this guy suddenly reached out and squeezed one of my breasts with his entire palm. He even lingered and I was stunned speechless having just recently relocated to the motherland. By the time I could call out to my mom, who was just a few steps in front of me, he disappeared into the crowd and I was embarrassed telling her what had happened. I hate that *I* was embarrassed.

 Anyway, we pushed past it and chose not to create a 'scene', as the offending party had already flown the coop. But looking back I wish I had said something. And if you're reading this and if it ever happens to you, say something; say it for me too.

2. When Nikki and I lived in Worli (probably our fourth move), we had these grand hopes of finding our dream apartment with mood lighting and floor cushions. Instead, we ended up in a slightly creepy one-bedroom apartment (1bhk – 1 bedroom-hall-kitchen – as they call it here) with old, always dirty-looking, speckled floors and too much of the landlord's useless paraphernalia everywhere, including way too many pictures of his dead wife.

 But then things took an even creepier turn. One day, we found out that the landlord had been sneaking into the apartment while we were at work to shower and just 'hang out'. Apparently, the maid would just let him in! We had to get two guys we knew to pretend to be 'bhai'-type thugs and scare him off because he refused to stop coming over and wanted to sleep in the hall, saying he had nowhere to go when he was visiting the city. He also refused to let us remove his dead wife's pictures from inside all the cabinets. So, I covered the glass with pictures of my own to block the view. Now, when I tell you this next thing you're going to sleep with the lights on tonight. He looked EXACTLY like the psycho old guy from *Human Centipede*. Yup. Never going to forget THAT image, are you?

3. The third and most bizarrely creepy thing happened to me while I was on the radio, and probably because of it too. I developed a stalker. This was pre-Facebook, so I'm not talking Instagram-comment kind of stalker. This was the real deal. The kind of stalker who shows up at your window, at work, at midnight at the end of your shift.

Here's what happened. I would often put out random
Yahoo! interview-esque questions on my show. Like, 'If
I gave you an elephant, where would you hide it?' and
people would call in with silly replies. One day I got an
email on our fan-mail account which said, 'Why did you
call me an elephant?' I found this odd but also hysterical.
I don't remember whether I replied or not, but the next
day there was another slightly longer and more emotional
email from the same address. This listener was slowly
but surely unravelling via the internet and developing
a relationship with me that didn't exist. He would send
long love notes followed by angry rants about how I was
treating him so poorly.

The way he wrote made it seem like he was replying to
someone. I even asked my colleagues if they had mailed
him back. No one had. I stopped reading the emails after
a while and forgot about it till one day at midnight there
was a knock on the station door. Our studio doors were
all glass and you could see through...I spotted someone
pacing up and down the hallway. Since I did the last shift,
it was just me and a studio engineer at work. Since I was
in the booth, the engineer got up to answer the door
and then closed it, thankfully leaving the visitor waiting
outside. He came to and said, 'There's a guy outside who
says he's here to see you,' and then he said his name.
Alarm bells went off in my head. It was the same name
the emails were coming from. Let's just call this man
Y. Total panic ensued and two very sweet colleagues of
mine, Neetu and Rohit, rushed over to my rescue. By
this time said stalker had already disappeared. Over the

next six years, this guy would turn up at events I was at, e-mailed relentlessly and followed me to the next radio station I worked with. He would often leave cards, teddy bears and handwritten notes that I was too grossed out to even touch. The thing was, it was clear his imagination had taken him somewhere else. He wasn't just being a sweet fan. He was hovering dangerously around total psycho-from-the-movies territory.

Finally, at my next place of work, Go92.5 FM (now known as 94.3 Radio One), we set a trap. We pretended to have a contest and rigged it so he won the 'prize' and asked him to come to the station to collect it. He came, oblivious and totally unprepared for the plain-clothes police officer who was waiting for him. The policeman dragged Y by the ears – yes, just like they do in Bollywood movies – to Tardeo Police Station for interrogation. Y's response to the questions was that I had encouraged him by answering his phone calls. I vehemently protested, 'He's lying! He doesn't have my phone number!' To which he replied, 'No, you always pick up the phone when I call the radio station.'

Um. Please take a moment to let your brain compute that sentence. It took me several. Also, that was my job, bro. Where were you, TrueCaller, when I needed you?

Y was around thirty-five years old and, of course still lived at home. All his 'lunch' money was being donated to Archies for my regular supply of teddy bears and musical love cards.

Anyway, long story not-so-short, his 'mother', a sweet Parsi aunty in glasses and a flowery kaftan, was

summoned to the police station. She looked upset, but also had an air of resignation about her, like *mujhe toh pata tha, nalayak kuch aise hi gul khila raha hoga.* Translation: I knew you must've been up to something like this, you good for nothing son of a... Without so much as a pause, she gave Mr Y a resounding slap across the face with a forehand that would put Roger Federer to shame. Total *thappad ki goonj* moment, just like when Dilip Kumar slaps Dr Dang across the face in his jail cell, in the 1986 movie *Karma* – and it echoes dramatically throughout the land.

And there you have it. Stalker goes bye-bye. Yet more proof that an aunty with a strong forehand is all you need to change the world.

 MissMalini ✔ @MissMalini

@MissMalini: #MMProTip These are my boobs not your boobs, go play with your own boobs. You f*cking boob.

@MissMalini: #MMProTip If your landlord doesn't have his own shower, he's probably not a good landlord.

@MissMalini: #MMProTip Most stalkers are in a relationship with themselves, you're just a profile.

@MissMalini: #MMProTip There is no consequence as effective as an Indian aunty's slap.

@MissMalini: #MMProTip If I gave you an elephant, where would *you* hide it?

(Me? I wouldn't hide it, apparently, I'd go to school on it. Refer to blog #5 #goals)

Blog #18: How Bollywood Taught Me Everything

As you can surely see, Bollywood is *everywhere*. Especially in my universe. In fact, this blog is about the ten practical life hacks Bollywood has taught us all along the way. Some of this has

been written by the wonderful Rashmi Daryanani, one the most 'filmy' and hilarious writers on Team MissMalini.

1. *'Main apni favourite hoon.'* Film: *Jab We Met*
 Translation: I am my favourite.

 You must learn to love yourself (because you are *awesomesauce*) before you can love anyone else. If you love yourself, you'll know what you deserve and won't settle for anything less. You'll also be less emotionally dependant on one person for all your happiness, which helps take a lot of pressure off any relationship.

2. *'Bade bade deshon mein, aisi chhoti chhoti baatein hoti rahti hain.'* Film: *Dilwale Dulhania Le Jayenge*
 Translation: Small incidents such as these keep happening in big cities.

 Don't sweat the small stuff. Stand your ground for the important things, but let the tiny issues go. Pick your battles.

3. *'Mere bete ayenge.'* Film: *Karan Arjun*
 Translation: My sons will come.

 Resilience and patience are the currency of karma. Believe in something long enough and the universe will make it so. Perhaps just shy of bringing your murdered sons back in another life to avenge their death. Just shy...

4. *'S-O-R-R-Y, sorry. Hum bure toh hain par itne bhi nahin. Thode achhe bhi hain.'* Film: *Roja*
 Translation: S-O-R-R-Y, sorry. I'm bad, but not that bad. I'm a little good too.

But to answer your question, Justin Bieber, it's *never* too late to say you're sorry. No matter what you've done, no matter how long it takes to get a chance to own up to your mistakes and however long it is before the person you have wronged will give you the opportunity. You may not be forgiven, never assume that, but always say you're sorry. It's never too late to try.

(PS. JB, I'm sorry too, I've recently moved on to Ed Sheeran and '*Shape of You*'. But you'll always be my song of the year 2016.)

5. '*Teja main hoon, mark idhar hain.*' Film: *Andaaz Apna Apna* (My favourite movie of ALL TIME)
Translation: I'm Teja, the mark is here!

Always leave a mark. My goal in life is to become *unforgettable*. What's yours?

6. '*Aaj Sunday ka din hai, din mein daaru pine ka din.*' Film: *Chalbaaz*
Translation: It's Sunday, a day for drinking during the day.

Seriously, I cannot stress the pivotal role Sunday brunches have played in my life. From de-compressing to networking, daytime drinking is the best!

7. '*Goals paane ki khushi tabhi mehsoos hoti hai...jab usey kisi ke saath share kar sako.*' Film: *Wake Up Sid*
Translation: You'll only be happy about achieving your goals when you have someone to share it with.

You've heard the saying, 'It's lonely at the top,' right? What if you didn't climb that ladder alone? What if it was

a penthouse party where everyone who ever helped you on your way was invited?

8. *'Oye hoye chhod chhaad ke apne Saleem ki gali, Anarkali disco chali.'* Film: *Housefull 2*
Translation: Leaving behind the lane of her beloved Saleem, Anarkali went to the disco.

Every once in a while, break out of your comfort zone.

9. *'Ek baar jo maine commitment kardi, uske baad toh mein khud ki bhi nahi sunta.'* Film: *Wanted*
Translation: Once I make a commitment, I don't even listen to myself.

Simple. *Always* keep your promises.

10. *'Success ke peeche mat bhaago. excellence, excellence ka peecha karo, success jhak maar ke tumhare peeche ayegi.'* Film: *Three Idiots*
Translation: Don't chase success, chase excellence, and success will then run after you.

Don't start out wanting to be rich and famous. Find a passion, find your calling, work your ass off...and bam! You'll be a legend. And in the 900+ blogs we post a month, I somehow missed this gem, 'Calling someone an "idiot" means confessing to them, "I Do Ishq Only Tumse".' Best.

MissMalini ✔ @MissMalini
@MissMalini: #MMProTip Everything I needed to know in life, I learnt from Bollywood.

@MissMalini: #MMProTip When in doubt, quote Bollywood.

@MissMalini: #MMProTip Let's be honest, Bollywood is the *Queen* of content.

Blog #19: You Are Now Live on Air

In case you didn't know, commercial radio in Bombay started out with six radio stations, all owned by major newspapers or media houses. This happened because the government, in all its wisdom, decided to turn the acquisition of a radio licence into a private auction. Each party put in a bid (as high as they could muster) to get a licence. As a result, the bids shot up by crores, in double digits. Now with a population of millions you'd think there'd be a market for all *kinds* of different radio programming, right? Not so much. The English stations were doing about 250,000 listeners a month while the big fat Bollywood stations close to a whopping 9 million. Quite rapidly, all the stations switched over to banging out the best (and worst) of commercial Bollywood music. And as you might agree, they all started to sound the same.

The one last bastion of half-Hindi, half English radio hope was Go92.5 FM, which is where I wanted to be. I started out doing afternoons, but was soon promoted to evening drive with the most fabulous co-host of all time – Jaggu! He eventually moved on to the breakfast show *Good Morning Mumbai* and formed the legendary duo 'Jaggu & Tarana' and the evening drive became my three-hour solo act called *Horn Ok Please*.

. .

JAGGU & TARANA
Radio hosts

We saw it happen from the time of the Big Bang of the MissMalini universe. We witnessed the beginning of the column, the blog and website all the way to you becoming the maverick social media Jedi who turned entertainment on its head.

The ability to know what people will want and using the first-mover advantage koi aap se seekhe! The beauty of your process is the way you have handled creative expansion by adding to quality, not reducing it. Going forward, never, ever give that up. We'd love for you to go more international and see you do more production and intellectual property creation rather than just content.

There is no way for us to tell you what we think your next opportunity is because you will see it before us. Knowing that you will be on it before most, stay true to your quality, do your thinking the way you have from the time of your personal Big Bang.

With so much happening in your universe, what we'd like most is for you to continue being you, because you're so damn good at it.

· ·

Horn Ok Please changed my life. I spent 6 to 9 p.m., Monday to Saturday, in a cosy little studio on the ninth floor of a building in Tardeo and invented my own magical ride. I'd take requests, talk about music and dispense random trivia about weird things from a website called straightdope.com, which by the way is still an amazing read. I covered everything from 'Can you get addicted to chapstick?' to 'Did Mahatma Gandhi sleep between twelve-year-old virgins?' Not kidding, the answers are on the website, go look.

I'd also comment on things that caught my attention in pop culture, play tons of little radio games, take callers (enter stalker as per blog #18) and – my personal favourite – on Fridays I did something called 'Flirty & 7:30'. This involved picking a 'bachelorette' who would introduce herself on air and three guys who would be short-listed to try to impress her in 30 seconds

each. Then she'd pick one (or none) and we'd send them on an all-expense-paid date. Want to hear the kicker? One couple who met on my show even got married. *cue karmic mic drop*

I also did another Sunday afternoon slot. It had a more chilled-out vibe with a rather lonely studio, as I would be the only one at work. I started something called 'Going Solo'. This is where I would invite listeners to join my *very* rudimentary 'club' on the G092.5 website and then I'd make fortnightly plans to meet with all of them. We'd go bowling or watch a movie, sometimes even a salsa class! It was heaps of fun and I met some fantastic people. The club was open to anyone who wanted to join and yet we managed to keep the creepies away. And I have a theory about this, like the kind in *A Beautiful Mind*: Everyone has the ability, intrinsically, to behave in a kind and acceptable fashion, but often their social conditioning or environment flips a switch in their minds that makes them behave in some terribly odd and disturbing ways. If, however, you create an environment of happy normalcy, a socially challenged person may also find it easy to mimic his/her surroundings and behave in an acceptable manner while interacting with a group.

My point though (social experiment aside) is this; all of this was happening pre-Tinder and Facebook. When we did things the 'old' way, in person, sans swiping right, but with shades of what has turned into 'social media' today. But guess what? Technically, these forms of interactions were social media too. It's just like how we used to listen to music on cassette tapes and then came iTunes; same purpose, different tools. Although I didn't know it back then, I was already training for the job I have today! How cool is that?

PS. I must give props to model Pia Trivedi, who somewhere between 2006 and 2007 told me about Facebook. She said, 'Have you tried this thing, Facebook? It's fun. You should try it. You'll like it.' And boy-oh-boy, did I LIKE it.

MissMalini ✔ @MissMalini
@MissMalini: #MMProTip People aren't just BORN creepy.
@MissMalini: #MMProTip Social media has existed for longer than you think.
@MissMalini: #MMProTip Sometimes the karma is you.

Blog #20: A Few Good Men-tors

During my radio years, I had the incredibly good fortune of having not one, not two, but FOUR amazing mentors and they taught me some incredible things.

Tariq Ansari, then managing director of *Mid-Day* and the visionary behind the commercial radio boom in Bombay, taught me that radio is an intimate and personal experience. While your show might be broadcast to millions of people in the city, even the four people listening to the radio in the same car will experience the programme in their own unique ways. Which is why, the best way to host a radio show is to imagine that you are speaking to just one person. In fact, imagine your best friend, be your most enthusiastic self and take it away. This was a lesson that eventually formed the core of MissMalini's identity and is the simple secret to how I created a voice on the internet. It's the same logic: There might be billions of people out there scouring the web, but when they're coming to your blog, they're coming for a one-on-one with you. THIS is the lesson that gave the blog the identity for which it is known. Thank you, TMan! I am forever in your debt.

TARIQ ANSARI
Former MD, *Mid-Day*

Not a great one for advice but if I were to volunteer something
it would go like this:
Deep waters make you a better swimmer
Strong winds make you a better sailor
The friends that appear in hardship are true fellow travellers
Without night there is no day
Without sadness there is no joy
You are a child of the sunshine
Learn well the lessons of the moonlight
Then you will conquer the universe.

Rajesh Tahil was the then station head, and the most chilled-out boss EVER. He was calm when dealing with *everything*. In all the years that I knew him, I never once saw him lose his temper. He was also the master of content. He always knew what would work even before we tried it and, the best thing was, he was *always* willing to try out an idea even if we weren't sure it would work. If it didn't, he'd brush it off and move right along, but mostly, true to his instincts, it worked. Tahil (as we all called him) taught me to believe in taking chances. In a way, he taught me to take a chance on me. Also, his wife Genesia is eerily my life twin. She's also a Gemini, shares the same birthdate as me, 26 May, worked at Channel [v] and when she left MTV India online, I didn't realize I was hired to fill her very competent shoes running the Romance & Sexuality channel! And get this, she had a show on the same station on the radio and has a blog called bookofgenesia.wordpress.com. Goosebumps much?

RAJESH TAHIL
Former Station Head, Go92.5 FM

I first worked with Malini in 1999, when she with one of India's first city-specific websites for *Mid-Day* (chalomumbai.com). She was the kind of dynamo who brought an incredible level of energy and passion to what she did, the sort that elevated everything else around it as well. She went on to become a popular radio host and we worked together again at Go92.5, which I then headed. She not only hosted a daily show but also handled its busy website in her spare time.

I soon went on to become publisher at *Mid-Day*, and in a chat with the editor (Aakar Patel), we agreed that we needed new voices to write about Mumbai's social scene, which in the newspapers then was mostly SoBo (i.e., both South Bombay and So Boring). Malini was soon writing an early, and extremely popular, version of what would eventually take shape as MissMalini.com

The rest, as the cliché goes, is history. MissMalini became one of the first real success stories from online publishing/entertainment in India. She was popular across media, across platforms and across geographies.

As MissMalini goes forward, my advice to her is to never let people believe they have figured her out. Retain the ability to surprise and reinvent, so that you're always miles ahead of the pack. You can create a brand that is enduring, in a business where everything is fleeting. And that would be a true measure of the success you deserve. All the very best.

Vishnu Athreya, then programming director, taught me to keep it crisp. Brevity, he always maintained, is the secret sauce

to keeping your audience interested and wanting more. He also taught me patience. I'll tell you how. This is an embarrassing story, but I've been meaning to tell him for years!

When I worked at the station, I would constantly badger him with random work-related questions through the day, while he would obviously be in the middle of putting an important pitch together. I think I did it partly out of excitement and partly because I wanted him to know I was working very hard. He would *always* say, 'Just one second,' finish what he was typing and then say, 'Ok, haan, tell me.' He did this every time, no matter how many inane questions I asked. Now, I'm at the receiving end of questions from thirty-five enthu-cutlets, who all have at least one question a day for me. I give you a very grateful student in the lesson of patience! So, thank you, Mr Athreya.

There was also this one time when I had started hosting my show entirely in Hindi (remember the 9 million listener target?). Well, I did alright I thought, but I was once trying to relay an on-set anecdote about Aishwarya Rai in the movie *Guru* and ended up saying, 'Aishwarya Rai cycle *chala rahi thi aur woh deewar se raam ho gayi!*' I think that was the hardest I have ever heard Vishnu laugh at any of his on-air talent. And I suppose rightfully so! (Chetan Kapoor, #raamhogayi.)

Shariq Patel, station head. While we were at the station, there was a policy of identifying the top talent (creatively or execution-wise) and putting them on a sort of 'honour roll'. Shariq gave me immense confidence in my own abilities when he identified me to be part of that list. We got stock options, were consulted for big-ticket items and were closely involved in their execution. He also taught me how to be high-energy in the workplace. The Red Bull kind because *he* was always ON. Also, *anything* I know about cricket is courtesy him.

SHARIQ PATEL
Former station head, 94.3 Radio One

I have been proud to witness Malini's growth from 2004, when we were colleagues at what was then Go92.5 FM.

She was the host of the drive show and was always experimenting with interesting ways of connecting with the audience. Apart from her show, she was also responsible for the station's website and would take great pride in making sure it was updated, not just with show information but also a platform for fellow listeners to interact with each other. Mind you, this was well before social media as we now know it. She had this knack of creating a vibe and building a tribe around the various activities we would do around her show, and on the website. For example, we took a cute on-air idea of connecting singles on air and managed to take it on ground as a speed-dating event.

She always had the entrepreneurial zeal and I remember having a conversation with her sometime in 2009 or 2010, where she very seriously wanted to figure out what would be the cost of acquiring a licence for a radio station and the capital and operating costs involved in running a 24/7 international radio station.

Seeing MissMalini go from a section on the Go92.5 website to where it currently stands truly blows my mind and reiterates my belief that if you love what you do and do it well, nothing can stop you. I would like to see MissMalini now go and conquer Bharat. What New York is to Mumbai, Mumbai is to Aligarh, Bhopal, Dhanbad and Rajkot. There is this huge market waiting for MissMalini, but it needs to be in a language and a tonality they understand and relate to. Without diluting the aspirational brand appeal, she must find a way to reach and connect with every aspirational eighteen-year-old in Raipur.

MissMalini ✓ @MissMalini

@MissMalini: #MMProTip Be real, be present and be yourself. One friendship at a time.

@MissMalini: #MMProTip How will you know it doesn't work unless you try it?

@MissMalini: #MMProTip There are definitely seven people who are exactly like you on the planet. So far I've found 2! @genesiaalves #SushantMukherjee

@MissMalini: #MMProTip Keep It Simple Stupid. #KISSRule

@MissMalini: #MMProTip Be like Red Bull. Use your wings!

@MissMalini: #MMProTip Next stop Raipur!

Blog #21: (Malini's) Mumbai Via Page 3

While I was at the radio station, I was offered a column in the *Mid-Day*. It was titled 'Malini's Mumbai' (just a stone's throw from the digital reboot known as MissMalini.com today) and would primarily cover the Page-3 beat and nightlife in the city. Now, in the Indian context, Page 3 is quite an interesting beast. It is basically tier-two in the Bollywood food chain and consists of socialites, industrialists, the rich wives of South Bombay, some TV stars and such. Don't get me wrong, I'm not dissing them. In fact, I've made some of my closest friends on this circuit after many years of having to attend every soiree in the city. But initially I used to be shy and uncomfortable while covering this beat and would timidly ask people to pose for pictures which I shot on my digital camera and flip recorder. Slowly, though, they started to warm up to me. This was aided by the fact that their fear of me reporting something scandalous wore off over time.

Over the years, I have found three conversations that almost always make an appearance at these parties.

*Disclaimer, these conversations are usually limited to five specific people. I cannot name them in this book, so use the theatre of your mind.

1.

Page 3 person: Listen, I'm starting a new project, but no one knows about it ok. It's off the record haan, off the record!

Me: Sure, no problem, I won't say anyth...

Page 3 person: [Elaborate self-promotion followed by] Actually, chal you can write it if you want.

[Me: *Shit, I wasn't paying attention.*]

2.

Page 3 person: [On the phone the day after a party] Listeeeen, I saw your blog, but my picture isn't there. What happened?

Me: Um, so I asked my fashion blogger and she didn't like your outfit, so, we thought it's better to leave it out since it was your birthday...otherwise I don't stop my bloggers from having an honest opinion...(To be honest, the outfit was a total disaster. Imagine a giant loofah and a zebra in the blender and...never mind, I can't.)

Page 3 person: No, no, post it! I don't mind. Let them say anything. Just post the picture.

Me: *Okay* then.

3.

Page 3 person: Oh, my god! Malini you've lost SO much weight.

Me: Oh, really? Not on purpose...

[1 month later]

Page 3 person: Oh, my god! Malini you've lost SO much weight!

Me: Oh...thanks? (Also, how plump was I really?)

[2 months later]

Page 3 person: Oh, my god! Malini you've lost SO much weight.

Me: By now I should be practically invisible.

But I must give a shout-out here to Ash Chandler and Reshma Bombaywala for being so kind in the early years and for always inviting me to join their table for a drink or two. They did this with no agenda and no expectation of a picture or mention in my column the next day. I have some very fond memories of us laughing our asses off at Dome at the Intercontinental and singing karaoke at Jazz by the Bay after a signature Mumbai 24-hour brunch!

I did, however, in Spider-man style (you know, with great power comes great responsibility) use my column to point out one incident with a notorious, rich adult-child that disturbed me. Here's what I said:

. .

MALINI'S MUMBAI:
10 November 2008

Here's the scoop on my Goa run-in with the notorious Mr AR. After introducing us to his 'wife' Monique (a pretty Australian model he's been seeing lately) he proceeded to make a variety

of wildly inappropriate sexual comments – involving her – for (what I can only imagine was) entertainment value and went on to insinuate that any girl who didn't throw herself at him was probably a lesbian (or just a little out of touch with Page 3 perhaps?) At any rate, for someone considered to be one of India's most eligible bachelors I'm really not that surprised he's single!

*Sorry, can't name names, my editor will have a heart attack. But surely you can hazard a guess! Or go find out on my blog.

. .

The circuit erupted in a series of phone calls to me saying, 'Oh no, you didn't!' Well, it seems I had. A decade has passed and a few years ago we made our peace. I also have to give him credit for having 'calmed down' significantly since then (but don't hold your breath).

So, for many years I would spend nearly four times a week exploring 'celebrity' nightlife and documenting it in a printed column in first person with an individual voice. Sounds familiar? Crazy how the universe works, right?

I also thought it was terribly interesting that so many people agreed to play caricatures of themselves (or each other) in Madhur Bhandarkar's 2005 movie *Page 3*, which was loosely based on the reality, and sometimes murky underbelly, of this 'social' culture.

The only time my column deviated from the glitz and glam of Mumbai's 'swish set' (a term I learned was extremely popular among many other Page 3 reporters!) was the day after the terrorist attacks on 26/11. The column is presented in its entirety below.

26/11

Today I can't bring myself to wax eloquent about the 'who's who' and 'wear's what' of Mumbai glitterati.

Today I need to tell you like it is.

What started out as an average Wednesday in Mumbai (laced with just enough excitement for an evening of disco salsa with new friends) quickly spiralled into a night of total terror as I watched my Mumbai burn. I had plans to meet my friend for drinks at Dragonfly, which happens to be bang opposite the lobby of the Trident Oberoi. Ironically, I had suggested we meet in the hotel lobby at 9:45 p.m. since it would be easier for his cabby to find. By what feels like much more than a stroke of luck I happened to arrive early and decided to head up to Dragonfly instead and told him to stop and call me when he took the 'INOX left'. Literally 30 seconds after he stepped out of his taxi we heard (what I immediately assumed to be fireworks) and saw sparks flying around the main entrance of the Oberoi lobby. I recall my brain trying to rationalize this odd display, cricket celebrations? Perhaps a prank? And I blurted out, 'Haha, it's either fireworks or gunshots, either way maybe we should go upstairs!'

The next 20 minutes were spent learning disco moves with the good-natured salsa crew I've been raving about (with even more reason now). Even two tremors later (apparently, the grenades that set the Oberoi ablaze) we couldn't possibly have imagined what was really going down. I think it only hit me when the owner of the club told me, 'I have bullet-proof glass, come I'll show you.' And whisked me away to the adjoining restaurant and pointed at a freshly lodged bullet in

one of the tall glass windows. From this point on, the night is a blur of frantic phone calls, SMS updates, angry reminders of 'keep-away-from-the-glass, please!', phone-battery lows (or woes), news-channel surfing, friendly sniffer-dogs, tablecloth blankets and two failed attempts to leave. We watched stunned, reports flooded in of explosion after explosion and the death toll kept rising as this mindless conspiracy unravelled itself.

I don't think I will ever be able to erase the memory of the Taj Mahal Palace Hotel dome engulfed in flames or the agonizingly young and bitter face of an AK47-wielding terrorist. Even now, the chilling realization that I remain unharmed while so many lives have been erased in an instant humbles me. At 5:00 a.m., when we finally made our way home full of trepidation and fear, dawn brought us an eerie sense of calm as oblivious joggers made their daily trek up Marine Drive while the battle raged on less than a kilometre away.

I don't know if this qualifies as insensitive or resilient, but I do know this; in times of crisis, when we need it most, a motley crew of Mumbaikers will always pull out all the stops and show you the love. Thank you, Pankhil, Shaneen, Derek, Anshul, Avan, Kaytee, Shyaam, Swati, Sahiba, Nasir, Tarana, Diana, Magalie, Aalia, Andrew, the generous guys who dropped us home, and the life-saver girl with the phone charger. (I still have it!) I feel like I lost a little faith but gained a lot of friends.

And I'd like to issue a clarification for all my British readers, who giggled uncontrollably when I said I write a Page 3 column. It is only *The Sun* (a newspaper in the UK) that carries a large photograph of a topless, bare-breasted female glamour model

on its third page while their gossip is on Page 6. We had the Mid-Day Mate, I forget what page she was on.

MissMalini ✔ @MissMalini
@MissMalini: #MMProTip People who make you needlessly uncomfortable are going to be 'bad news'.

@MissMalini: #MMProTip Chances are they've run out of conversation if they tell you how much weight you've lost.

@MissMalini: #MMProTip Never underestimate the value of a mobile phone charger.

@MissMalini: #MMProTip Don't get excited, England, our Page 3 is your Page 6.

Blog #22: The Abhishek Bachchan Fiasco

As I'd earlier mentioned, the breakfast show hosts Jaggu and Tarana had started doing a lot of celebrity interviews and the rest of the DJs (sorry, I still can't say RJ. Radio Jockey is fine, but not 'RJ'!) would pile on for a bite or two for their shows now and again.

One fine day I heard that Abhishek Bachchan was coming in and I thought it would be great to get him for a quick chat on my show. But I wanted to reveal my rocky start before I achieved a comfortable nonchalance, many years later, when I realized they were human too. As to why this interview crashed and burned the way it did is still a mystery to me. As per my calculations it was 10 per cent: the uncomfortably warm tiny second studio space, 20 per cent: his cool cat demeanour and 70 per cent: my total awkwardness. Allow me to explain.

Jaggu and Tarana had Abhishek in the studio that morning. For some reason, I was lurking around for the entirety of their show; just making some persistently awkward eye-contact with Abhishek Bachchan. By the fourth or fifth time

of aforementioned awkwardness, I'm sure he had pegged me as some weirdo. Finally, after their 45-minute chat with him about *Bluffmaster!*, I ushered him into a much tinier recording studio at the end of the hall to record my links. Now, not only was this corridor a little dingy, the second studio had distinctly jail-cell dimensions. It was decked out with two plastic seats, a small round table and a linoleum carpet that smelt like...well, a linoleum carpet! And to my memory, our interview went something like this.

Me: Hey everyone! I'm so excited! [I said that word too much, I still say it too much] I've got the awesome Abhishek Bachchan in the studio with me and I'm going to ask him some questions!

Abhishek Bachchan: *no reaction*

Me: *nervousness kicking in* Um...so, Abhishek, do you listen to the radio?

Abhishek Bachchan: Ya, I do.

Me: What shows do you like?

Abhishek Bachchan: I listen to Jaggu & Tarana.

Me: What *other* shows do you listen to?

Abhishek Bachchan: *looking a little puzzled* Well, I listen mostly in the morning on my way to shoots.

Me: But do you like any other shows?

Abhishek Bachchan: *now looking at me, slightly puzzled*

Me: *in full panic mode, what was I doing? Was I trying to get him to say he listens to my show? Why? Abort! Abort!*

To recover from this volcanically rocky start I went with...

Me: So, have you ever been in love?

Abhishek Bachchan: Sure, everyone's been in love.

Me: When were you in love?

Abhishek Bachchan: The last time I was in love, I was in love.

Me: Do you like being in love?

Abhishek Bachchan: Yee-ees... *looking at me like I was bat-shit crazy and making eyes at the studio door, which was behind ME and clearly of some concern to him.*

I proceeded to play some demented rapid fire with him about whether he liked coffee better or tea, clouds better or grass, and who knows what else! At this point, my entire ability to recover from a clumsy situation had decided to leave the building. No, scratch that. My ability to recover had taken one look at crazy me, put on a parachute and jumped off this doomed ride, giving me one last miserable shake of its head as it evacuated from my mind. So, ya, it was an utter disaster.

Look, I know it sounds dramatic but I was genuinely depressed for two whole days after this encounter (almost as depressed as I was when someone told me about the Bonsai Kitty, DO NOT LOOK THAT UP, you will also be scarred for life, just walk away, *walk away, I say*). I felt embarrassed, incompetent and stupid, and hoped I never had to interview a celebrity ever again! Well, we all know how that worked out.

The point of telling you this sad story that remains in the recesses of my mind (just like you saw all emotional memories

do – whether brought about by joy or sadness – in the amazing animated movie *Inside Out*) a whole decade later is this: *It happens.* We all crash and burn and that's how we learn. Wait that rhymed! And as we all know, anything that rhymes is true.

This oddly powerful memory has stayed with me, and I always wondered why. I think I finally figured it out. It was probably the biggest lesson I learned about the ability to psyche oneself out, to convince yourself in a moment that you are not capable of something, inadvertently making it a self-fulfilling prophecy. Since that time, whenever I am nervous about talking to someone, I think about two things: Who would they be nervous talking to? And how would I feel if someone was nervous talking to me? These two questions make my nervousness just go away. Because the answer to both those questions – if expressed out loud – would surely be, 'Aww, don't be!' Try it and tell me if it works for you. I have yet to crack a cure for stage fright, however, which I have TONs of (like curl-your-toes type of anxiety of public speaking) but I'm working on it!

Dear Abhishek Bachchan, can I get a redo? I swear I won't ask you what blogs you read, but I'm not making any promises on questions about love!

PS. When I met Junior Bachchan again, a decade later, I wanted to tell him this story. One day I will or maybe I'll just send him this book! But I love that when I was interviewing him and the cast of *Happy New Year*, he said, 'Ooooh, you're MissMalini! I always thought you were the cartoon I see on Twitter. You're real.' Haha, well you got the *cartoon* part right for sure.

MissMalini ✔ @MissMalini
#MMProTip If you're self-conscious around someone, put a smile on your face and introduce yourself. Break the stranger barrier. They might be shy too!

@MissMalini: #MMProTip If you ask a stupid question, stop and admit it. Chances are you can both laugh it off and start again.

@MissMalini: #MMProTip Your embarrassing memories are your most valuable teachers. Find their purpose. You won't hate them so much anymore.

@MissMalini: #MMProTip Abhishek Bachchan has kind eyes and a GREAT sense of humour!

Blog #23: Hello, Radio? It's Bollywood Calling

For the near-decade I spent 'on the air', I had done pretty much every show shift known to man...and radio. I even had some pretty funny show names like 'Tiger Time with MissMalini' sponsored by – you guessed it – Tiger beer! My friends would never tire of saying, 'Hey, Malini, what time is it?' and before I could look at my watch and naively attempt to tell them the *actual* time, they would yell, 'IT'S TIGER TIME!' Thanks, guys. Yup, *that* never got old.

Then, for a while I hosted a show called 'Malini till Midnight' (since I love alliteration so much, you see) and I'd get my friends to host the show with me and attempt to solve people's love problems. I called them the 'Love Crew'. It was good times. But then one day this happened and I believe I have Mihir Joshi, a fellow radio host, to thank for it:

I had already started using Twitter to interact with my listeners (on the recommendation of my friend and sometimes pool partner, Rohit Gupta, who, back in June 2008, one opportune night at the Ghetto, said to me, 'Malini, you should

try out this thing called Twitter, I think you'll definitely like it.' And on 8 September 2009, Imran Khan tweeted to me saying Mihir had recommended that he listen to my show. We got 'tweeting' (I love that, don't you? Hahaha) and I randomly invited him to come and co-host the show with me some night, not thinking he'd ever say yes, *par poochhne main kya jaata hai?* (No harm in asking!) But guess what?.

He agreed to come and host the show with me and play forty of his favourite English songs on one condition, that we call that show 'Pirate Radio'. I didn't know or understand the reference at the time but pirate radio was a term used for a band of rogue radio DJs who had captivated the hearts and minds of Britain back in the 1960s by playing pop and rock music to rebel against a government that only wanted classical music to be aired on the radio. There is a brilliant movie that tells this story (even more delightful is the fact that it has some of the cast of *Love Actually*) called *The Boat That Rocked*.

And so, it began. Week after week I would use social media to invite a different Bollywood celebrity to come and host my show with me, LIVE, and get to know them better in the process. My only rule was that I would ask them nothing about their next Bollywood project. Just me, them and their favourite English music.

You can see their entire playlists and my *very* amateur attempt at vlogging (which wasn't even a 'thing' back then) on my blog and YouTube channel – MissMalinivideos – if you dig up the 2009 archives! But just for your reading pleasure, here are a few of my favourite 'Pirate Radio' conversations.

IMRAN KHAN

Unfortunately, Imran deleted his Twitter profile some years later, citing that he just didn't like the clutter or the trolling, and needed to distance himself from it. But I still have my side of the conversation.

MissMalini ✔ @MissMalini
8 Sep 2009

@1mrankhan Done and done :) Pirate Radio it is!...and you can play ANYTHING no restrictions coz that's the way I roll lol...

And why does Imran Khan love the radio so much? He told me live on the air.

'Everyone has a radio. Anyone, anywhere can listen to it. It kind of unites everyone. I drive a fancy, expensive car and I listen to radio in it, and meanwhile there's a guy going on the train with a little Nokia phone, who's also listening to the same radio. That's what I LOVE about it. It's something that ties us in. We had radio long before we had TV and it has survived.'

He also introduced me to this awesome song called 'David Duchovny' by Bree Sharp who was clearly fan-girling over Duchovny who plays FBI special agent Fox Mulder on X-Files! Check out the lyrics, hilarious.

David Duchovny, why won't you love me?
Why won't you love me? Why won't you love me?
David Duchovny, I want you to love me
To kiss and to hug me, debrief and debug me
David Duchovny, I know you could love me

I'm sweet and I'm cuddly-I'm gonna kill Scully!

My favourite thing ever though was when he told me that he used to make 'mixed CDs' for his then girlfriend-now-wife Avantika and affectionately referred to her as 'The General!'

. .

IMRAN KHAN
Actor

I had been one of Malini's regular listeners for ages, because out of half a dozen radio stations, her show was the only one playing English music. Everything else was a dystopian wasteland playing the same top 40 Bollywood tracks of the month. A chance encounter on Twitter got us chatting, and she invited me to be a guest on her show. I accepted, with one caveat; I get to pick the music, no holds barred.

Surprisingly she agreed, and gave me free rein to put together a playlist that started at 'eclectic' and then went further left...this was a far cry from the radio-friendly pop her corporate overlords would have prescribed. There was only one logical name for our collaboration: Pirate Radio.

We spent about three hours on the air, chatting about life, love, loss, and of course, music. We took live calls and fielded questions on Twitter. It was a blast. I think we touched a dormant chord that evening, engaging with people whose tastes were simply not being catered to; an audience hungry for content that no one was providing. Of course, it couldn't last. We tried to do a few more shows, but there were always suggestions from up high that the content was too edgy, or that listeners might be 'frightened off' by unfamiliar music.

Pirate Radio didn't take flight, but Malini had an appetite for pushing boundaries, for venturing into new and uncharted areas.

Over the years, we've worked on dozens of different projects, but I have to be honest: not one of them came close to the purity and excitement of that evening that the two of us just sat back, put on some killer tunes and chatted.

. .

I was also touched that he remembered the show years later (*three* years later in fact) as he was listening to the CD I had burned him of the show, and sent me this text. (Wow, remember when we used to 'burn' CDs?)

> Imran Khan: Long drive to my location on the outskirts of Chandigarh. Listening to Pirate Radio, remembering the good times. Hope you're well.
>
> Me: How awesome ☺ that show was epic!

RAHUL KHANNA

Mention Rahul Khanna's name and you'll get a collective 'Aaawwww, he's so cute', from all the girls. So, when HE agreed to come on the show, I felt like I was really on to something. Also, I got to hang out with THE Rahul Khanna for 3 hours and have him play me his favourite music, #winning.

MissMalini ✔ @MissMalini
24 April 2010
Don't miss @R_Khanna on 94.3 Radio One at 10 p.m. tonight! Yay :) #pirateradio (pls RT)

Never Gonna Give You Up!
Me: I asked people on Twitter if they want to ask you any questions and we got a couple in. @Nakhrewali...

Rahul Khanna: Superb!

Me: ...wants to know what you read, like what's your favourite book?

Rahul Khanna: I don't have any one favourite book, I like fiction, I've just started *The Moor's Last Sigh* by Salman Rushdie. It has been sitting on my bookshelf for almost 10 years and I decided I should start now. Contact me in another 10 years, I might have finished it by then.

It's 2017, no harm checking in.

. .

RAHUL KHANNA
Actor

I'm ashamed to admit that for some inexplicable reason, TMLS became my great white whale. I could no longer take it taunting me from my bookshelf and recently gave it away so that it could fulfil its destiny of being read by someone. If it's meant to be, it will come back to me at some point and I might finally conquer it. Funnily, not so long ago, I found myself at a dinner party with Mr Rushdie in attendance and because of my inability to finish reading his work, I was too guilt-ridden to even look him in the eye (even though he would have had no idea why)!

Also, MissMalini, I just remembered — that it was fun watching you boss around the all-male crew!

. .

 Rahul Khanna @R_Khanna Haha...you are too kind. It was a pleasure. Thanks for having me & for all the going-home prezzies... :-)

To be fair he still has three years to go to finish that book. Perhaps by the time my sequel is out? Just kidding. But seriously,

I have a two-book deal with HarperCollins, I better get cracking on the next one stat. If you have a suggestion on what it should be about, please feel free to tweet me @MissMalini with the hashtag #MMtothemoon.

FARHAN AKHTAR

Farhan Akhtar
You're friends on Facebook
Director at Excel Entertainment Pvt. Ltd
Live in Mumbai, India

Hi Farhan!

My name is Malini and I host the English Band on 94.3 Radio One Fri/Sat 9 p.m. till midnight. Sometime ago when you were in our breakfast show with Jaggu&Tarana, they mentioned you might be up for coming and talking about your fav international music n mine. I have kicked off Pirate Radio where we play exactly what we would want and would love to have you as a guest any Saturday night (we can pre-record as well if that's easier, basically you pick 40 songs you love and we play them back to back and talk about what you love about these songs, where you heard them first, no Bollywood, no agenda. Sound good?

Malini
98211xxxxx

P.S. Rohan Sippy & Imran Khan have been guests on the show in the last few weeks, I also blog it all so take a look!

11/22/2009
Hi Malini...heading off to a beautiful town in the hills somewhere, to spend the merry week with family and friends.
As for the radio thing, let's do it on Tuesday i.e., the 24th...will cofirm time tmrw morning...is that cool?

Sounds perfect!

Coordination wasn't always easy, but I swear social media made it heaps easier than trying to do this via a publicist. You'd be surprised how chill celebrities are if you have the option to reach out to them directly. As I have learned over the years, it's usually the army that surrounds them that makes it feel like a Fort Knox situation.

Where Do You Go?

Me: Who were you in college? Were you the nerd, were you the tough guy, were you the lover boy?

Farhan Akhtar: I was the absentee.

Me: LOL. Where did you go?

Farhan Akhtar: I'd travel to college of course, so they knew that I'd gone there. I'd attend the first lecture...

Me: Which college were you in?

Farhan Akhtar: I was in HR, for the first two years. I'd go there, attend the first two lectures and head off to watch movies.

Me: Really!

Farhan Akhtar: Yeah, because we had Sterling, Eros...and at that time most English films were only shown in South Bombay. This was the only opportunity we got to watch English movies. I spent most of my time there, and then in my second year of college I was told off for very low attendance.

Me: No way! But you can make up for that with all your extra-curricular stuff, did you do any of that?

Farhan Akhtar: No! I told you I was watching movies!

Me: Had they known it was research!

Farhan Akhtar: Now it depends what your definition of cool is. Some people think being a very studious student is cool... some people thing being a brat and not attending anything is cool. Take your pick!

There you have it, Farhan wasn't too different from you or I, right? I once bunked college to watch *Rangeela* with my friends and that's when I discovered Urmila Matondkar's amazing new wardrobe. Many years later I discovered she'd been styled by Manish Malhotra and that wardrobe alone has been instrumental in catapulting him into the league of extraordinary fashion designers, especially those favoured by Bollywood.

· ·

MANISH MALHOTRA
Fashion designer

MissMalini has been instrumental in starting a positive and forward vibe through blogs and has been the first in taking it to a whole new level of popularity and engagement from different people from different walks of life and ages...the reach has been phenomenal and I am sure she will take all of this to the next level and continue to get many engaged and aware of the changing trends from celebrity spotting to focusing on fashion, art and culture, and I celebrate all of this with the very wonderful MissMalini.

· ·

PS. Earlier this year, for my first season of *Inside Access on Vh1,* I went over to shoot at Farhan's house and he played us an original song he wrote on his guitar called '*If love isn't enough*'. I immediately fell in love with it (I'm emo like that) and I think you will too! Go watch Episode 1 on Voot.com and hear it for yourself. My favourite lyrics from it go like this:

If love isn't enough to keep us together
To keep us protected in the stormy weather
If love isn't enough to ease our sorrow
To smoothen the roads that lead to tomorrow
And yes, life could get tough and sure times could get rough
But no matter what we do, there's no chance we're going to make
it through, if love isn't enough.

MissMalini ✔ @MissMalini
@MissMalini: #MMProTip If you want something to happen, just put it out into the universe. (Or better yet Twitterverse!)

@MissMalini: #MMProTip Destiny is sometimes just a tweet away.

@MissMalini: #MMProTip Finish what you start, even if it takes 10 years.

@MissMalini: #MMProTip If you're gonna bunk college, don't waste it doing nothing.

*Just a friendly pop-up here to tell you that Section 4 of this book is filled with all the business knowledge I could possibly drop. Head right over if that's what you came for.

Blog #24: *The Friday Club and #PartySoulmates*

Before we go 'Off Air' I would be remiss if I didn't tell you about the 'Friday Club'. The genesis of this club is hilarious. Diya and I had started hanging out and were the chief instigators of getting a bunch of people from work to go bar-hopping now and again, and by which, I mean *every Friday*. We were also those people who would order shots and play drinking games when we went out, yup in public! One day we were discussing how it's funny that all these bars were full of people just 'like us', but it was odd that no one ever actually got up to interact with anyone

aside from the people they came with. Was it an Indian thing? (I hesitate to say it, but I feel it's more of a Delhi than Bombay problem.) Pure shyness? Or *what-will-my-friends* think? So, we made up our minds that the next time we were out, we would go up and talk to strangers and make new friends.

You can just imagine how *that* went.

Us: Hey! Nice to meet you; we just wanted to say hello and...

Them: Oookaaayy...*slowly backing away with a look less of surprise and more of horror on their faces*

Some of them laughed uncomfortably and mostly it was a variety of 'Why are you talking to me, you freak?' reactions. Back to the drawing board we went.

We decided that perhaps our strategy was a little *too* ahead of its time and thought we would ease it up a little and do a one-degree-of-separation sort of thing. We'd plan a night out and invite all our friends to come and bring along another friend each. And slowly but surely, we'd have a brilliant pay-it-forward friendship situation.

Yes? *No.*

Our first Friday Club, held 7 January 2005 (yup it was a Friday, obviously!), happened at TGIF. (Cliché enough for you?) It comprised Diya, another friend Tina Hansraj (who is just the most entertaining girl in the world. Her nickname was 'evil' #justsaying.) and me. Not a promising turnout, but I don't give up easy. We persisted and eventually we went from five people to ten to twelve and so on.

The premise of Friday Club was like 'Going Solo': Throw a bunch of people together on a regular basis and you'll love

some, you'll hate some, some you won't remember and others will become a part of your life's DNA.

See the thing is, as we turn into 'grown-ups', we're led to believe that life is not supposed to be fun anymore. You're meant to try and nurture your handful of childhood friendships, throw in those you made goofing around through school and college and then call it quits. Perhaps find a *few* new friendly faces at work, but not necessarily the kind you want to know the intimate details of your personal life. (Or risk having them tag you on Facebook dancing on tables on a Tuesday night, for your boss to see on Wednesday morning!)

But that's just it. The reason why most people describe their school and college years as the 'best years of my life' is because of the people they met and experiences they had with them. From then on, life begins to get progressively *lonelier.*

Have you seen a movie called *The Breakfast Club?* It's the story about a group of high-school students who go on a journey of self-discovery over one Saturday afternoon spent in detention. The key, here, is that while they are so uniquely different from each other, *that* is the one thing that appears to bind them all. And they end their experience with a letter to the villainous Mr Vernon saying this:

Dear Mr Vernon,

We accept the fact that we had to sacrifice a whole Saturday in detention for whatever it is we did wrong, but we think you're crazy for making us write an essay telling you who we think we are. You see us as you want to see us, in the simplest terms, in the most convenient definitions. But what we found out is that each one of us is a brain, and an athlete, and a basket case, a princess,

and a criminal. Does that answer your question? Sincerely yours,
The Breakfast Club

So – Friday Club.

I believe you don't have to stop making close, or even
best friends just because you're past a certain age or stage in
your life. And you most certainly should not be restricted to
making friends only at school or college or the office or in your
immediate neighbourhood. What if there was somewhere you
could go every weekend with no expectations or agenda and
meet new people from various walks of life? Some married,
some single, some 'it's complicated', and get to know them in
an environment devoid of the stressful end-goal of a romantic
relationship. Somewhere that you can keep your inner Peter
Pan alive.

Granted this is probably the side effect of leap-frogging
through my entire life and not knowing anyone for more than
three years. I kept the occasional pen-pal for a few years, with
actual handwritten letters on beautiful stationery at the time, but
unfortunately that never stayed the course and Facebook came
too late for me to find all my middle-school BFFs. I have tried
in vain to locate my middle school Korean BFF In-HyeHyung
on Facebook or my first crush Chris Conner – there are 4,762
of them. Chances are slim. Over the decade that Friday Club
was in action I proceeded to meet some of the most incredible
people I am proud to call my 'framily' today, friends who become
family. (I'm still trying to make that word happen, just like 'fetch'
in *Mean Girls* but still no luck, lol.) Many of them have moved
countries, had children, gotten divorced and married again (like
the Ed Sheeran song – '*Castle On A Hill*').

But the memories we made will stay with me forever and taught me one very important lesson in life about happiness. You can have the best job, a swanky apartment, a six-figure salary, but without emotional satisfaction – which comes from personal relationships – life can be a very lonely ride.

There were no 'qualifications' required for joining the Friday Club. We just had what we jokingly referred to as our 'non-serial killer policy'. Don't make anyone uncomfortable and you're golden. People could join the club by one-degree of separation meaning an introduction from an existing member and enjoy countless fun-filled evenings of bar-hopping, dancing, camping, brunches, salsa, human foosball, Diwali parties, para-gliding sessions, trips to Goa, legendary Holi parties at Rewa Bungalow and whatever else we could think of for that week. It was magic. I will also never forget a conversation my dear friend/brother and fellow FC member Chetan Kapoor had with a young new entrant about the name:

Newbie: 'I'm so glad I joined Friday Club, I wanted to find a place to have intellectual conversations.'

Chetan: 'We named our club "Friday Club" because we go out on Fridays, how intellectual do you think we are?

Nice, Chetan.

I have so many epic memories from those years that would make a book of its own (or perhaps a Netflix show some day?) and here's the kicker; even though we were never a Singles Club per se, six couples met and got married at Friday Club. Including Nowshad and myself. Talk about serendipity and chalk that one up to karma.

To anyone who was ever part of the crew, here's a massive shout-out to you. Thank you for playing and save the date for the fifteen-year Friday Club reunion Holi Party on Tuesday, 10 March 2020!

WHATSAPP WORLD?

Motivational speaker Jim Rohn once said, 'You are the average of the five people you spend the most time with.' And, for me, those people have changed multiple times over the course of my life. The ones I cling closest to now fall under a few different categories (and several WhatsApp groups) but I think the best way for my nostalgia to be of any use to you is if I share with you the lessons each one of them has taught me along the way and then you can follow them on Facebook and watch them post pictures of me dancing on tables!

Here they are, *drumroll please* my BFFs, #PartySoulmates and #MMBirthdayCruisers, #FridayClubbers and #BandraBada$$es through the years and in order of appearance.

*I have left out all boyfriends, heartbreaks and those hearts I broke from this book, out of respect for my husband and because that's just a horse of a different colour.

But thank you for everything and please know that you were loved.

PS. Apologies in advance if I have left anyone out who *tried* to teach me something that I clearly didn't quite grasp enough to document here! I love you, but I blame the Jägerbombs! Come whack me the next time we're at a bar together and I'll pay closer attention.

You've two ways of reading this section:

A. Deep dive into my friendships and the amazing people who make up my world.

Or B. Speed read *the bold* and just take their wisdom and run.

The Pre-WhatsApp Era

A few friends who left a lasting impact on me growing up and two who irreversibly changed my life forever.

In-Hye Hyung: She was probably my first real best friend. We were thirteen and lived in West Africa. She was Korean and taught me how to say 'saranghaeyo' which means 'I love you' in Korean. But her lesson was intense (and boyfriend related of course). She taught me that *if someone doesn't love you, there's no point asking them why.*

Sushant Mukherjee: Sushant is my universal twin. We're both May-born Geminis, left-handed and IFS brats. Also, he writes *brilliantly*, with the kind of exceptional handwriting that no left-handed person in the *world* could ever achieve! Sushant has taught me that *it is possible to find and infuse joy simply through caring and laughter in places where happiness has left the building.*

Tina Sharma Tewari: #SnakeSisters, before there were hashtags. Tina is now a news anchor and author herself. Read her book *Who Me!*, it's fabulous fun. She has taught me that *it is perfectly okay to be your own you and accept that sometimes people will be intimidated by your confidence.* Also, she dated a famous cricket player, which I always thought was mad cool. Lol.

The Game-Changers

Natasha Vohra: aka Nikki, aka one giant beating heart. I practically lived at her house all through college and, as I mentioned before, followed her to Bombay. She taught me that

generosity is best served without ceremony. Never announce that you're doing something generous or let someone feel that they 'owe' you anything in return. I love you, Nikki, and thank you for moving (me) to Bombay!

Ronica Jacob: Ron was the first real badass boss lady I encountered in my life. She ran an entire entertainment empire out of her living room and took us around the world, dancing. Her sheer confidence scared the crap out of everyone but it was good, it taught us discipline and made us all want to impress her (I later discovered she was quite a softie on the inside and cared deeply about everyone she'd ever trained). Did you know that even the actress Gracy Singh from *Lagaan* started her career in her troupe? Ronica taught me that *practice really does make perfect. But attitude is everything.* (One day I want to dance again, Ronnie, I think I can nail the attitude vibe now finally! #Prince.)

The Pre-WhatsApp Era (Bombay)

My first contact with Bombay and the people that pretty much adopted me! #FriendsLikeFamily

Ashok Kurien: Yup, you guessed it, dad to two of my best friends and by far the coolest parent I've ever met. Mr K., as I call him (because Uncle Ashok just seemed too weird!), taught me that *you must always wear your success with humility.* Thank you for practically adopting me and for always believing I'd make it to the moon!

Diya Kurien Kapoor: Or as I see it, the one that got away. Lol. I know this usually applies in a romantic connotation, but you

know how sometimes you wish you had held on tighter to some friends as well? The best thing about Diya – and what she has taught me – is that *true friends can pick up right where they left off, without skipping a beat, no matter how much time has passed.* And in the great words of DK #MoveItShakeItRockIt!

PS. My utterly epic twenty-fourth birthday brunch will forever be dedicated to you, Diya.

Devraj Sanyal: My personal Yoda, also part of the famous five brunch, where I met him for the first time and truly understood the concept of a larger-than-life personality. Devraj has taught me that *it is completely possible to do the impossible every single day, you just must BELIEVE you can.* Oh, and manage five jobs, work your ass off, have your own heavy metal band and live on an airplane! #Boss

Nikita Sanyal: aka Nikki, I seem to have good luck with people named Nikki! She was my first friend at G092.5 FM. On my first day at work, she offered me a ride home for no reason at all and was one of the five people who came to my twenty-fourth birthday brunch having known me for barely a few weeks. Over the decade-and-a-half that I have now known her, I have learnt that *there is true value in never giving up on some friendships, even if circumstance keeps you apart.* Also, that uber-organized people will one day rule the world.

Priyanka Kurien: Often mistaken for Wednesday Addams (from *The Addams Family*) due to her entirely black wardrobe or Elsa from *Frozen* due to her sometimes 'icy' exterior and legendary

eyebrow game. But truth be told, Priyanka has a heart of solid gold and is also pretty hilarious! She has taught me that *everybody needs someone who will be their zero-judgement 'panic police'*. I could call her today and tell her that I'd committed a terrible crime and she'd send me back a *rolls-eyes' emoji and say, 'Okay, so how do we get you out of this?'

Pre-WhatsApp: Friday Club Reloaded

Friends I have made over the 10 years that Friday Club was my entire social world. I am proud to say so many of them went from acquaintances to pieces of my heart in record time.

Marv D'Souza: Marv has shown me, with great courage, what it's like to wear your vulnerability on your sleeve. He has taught me that *the universe shines through the cracks of people who appear broken when it's just their bodies that can't contain the love within.*

Michael Delfs: While Nowshad was at HBS, Mikey was my trusted companion, bodyguard and emotional crutch. Mike taught me that *it's important to stop and spend quality one-on-one time with your best friend on a regular basis*, and ideally do it with a weekend in Goa!

Rashmi Bajpai: My most flawlessly fashionable friend, who went from never having left the country saying, 'I also want to travel the world and complain about Heathrow!' to having become an incredible #bosslady and world traveller in her own right, has taught me that *tough times don't last, but tough*

people do. And that the greatest things come in small packages! #HumKitnaAcheHaiNaRashmi?

Saher and Bavidra Mohan: Bavidra, with a smile that could ignite a room, and Saher, with the uncanny coincidence of having studied at the same school as me in Ivory Coast, have taught me that *sometimes helping someone deal with things is all about floating with them in silence,* preferably in a 5-star jacuzzi! And guys, she looks a LOT like the Khaleesi from *Game of Thrones.*

Shaan Bhavnani: My first new Bombay pal, whom I met playing endless games of pool at our neighbourhood bar – Ghetto. Shaan is one of those people who can organize just about ANYTHING. From a midnight motorcycle convoy to Alibaug to human foosball on the beach! Shaan taught me that *some people can pull of anything, find one and watch closely how it's done.* (I also learnt that it is possible to fit giant rectangular objects into triangular spaces if you just use a little creativity!) Thank you DJ FatBat for making Friday Club the epic-ness it was! I hope you know that we could never have done it without you.

Sheetal Vyas and Navraj Lehl: Are one of the most warm and loving couples on this planet. Plus, they have British accents, so what's not to love? They have taught me the value of gratitude. That *saying thank you and acknowledging someone's love is the best gift you can give anybody.*

Sonny and Preeti Caberwal: I met Sonny and Preeti at a fashion week and we somehow bonded immediately. You know when

you feel like you've known someone for decades even though it's only been a few days? That. Sonny is the reason we raised money for MissMalini to begin with. He's has taught me (and proven!) that *if you are generous with your time and resources, you can make anyone's dreams come true.* You just have to want to. Thank you, Sonny, I am forever in your debt.

Surelee Joseph: I don't think I've ever met a model this un-obsessed with her appearance. Surelee is one of those down-to-earth unicorns that only spreads love and good energy. She has taught me that *you should never let your friendships get entangled in anyone else's beef.*

Sushil Charles and Mahesh Makhija: You know how sometimes you meet people who make you feel like your most fabulous self? Well, Sushil goes one further and makes me look like it too. Have you tried @smashhthesalon yet? Sushil and Mahesh have taught me that *love, loyalty and encouragement are all you need to conquer the world.*

PS. If you're into cake, @weekend__baker is where it's at!

Sujal Shah: Or the OB1 in my world – *what up* Star Wars reference! – came up to me years ago at a fashion week party and told me he was impressed and curious with what I was doing. Since then, he's always been a mentor, believer and BFF. Sujal has taught me that *confidence and networking make for a flawless formula for success.*

PS. I hope one day we can revisit Coco Shambala and let it all go...

Tanmay Bahulekar: Creative cat, awesomely desi and ultra-foodie aka @BombayBhukkad. I discovered him during an Imps improve sketch where he hilariously acted out a day in my life, and I immediately sent him a Facebook friend request. He's taught me that *some people will kill for you.* Just try not to make them do it.

Tom and Rebecca Dawes: Tom 'the Candyman' has taught me that you can have fun and work hard at the same time. In fact, *the more seriously you take yourself, the less effectively you will do your job.* Mrs Dawes has proven this twice over and makes me think that if everyone took themselves a little less seriously, there probably wouldn't be any wars in the world; only giggles.

Sarika Motiani and Avinash Jagtiania: My fellow Bollywood dance junkie, Sarika, and Nowshad's whiskey and conversation buddy, Avinash have taught me that *spending quality two-on-two time leads to the most effortless and active conversations.* And that Labradors are the best. #Sumo #Sativa

Vishal Bala: Someone I met at an oddly popular St Patricks Day celebration in Mumbai and who quickly turned into a lifelong friend. Vishal has taught me that *remembering someone else's special days for them makes them even more special* (and that for some reason some boys can listen to 'Yeke Yeke' on repeat a thousand times and never get fed up of it!)

Some of my closest friends in the world and also at the bar!

Adhuna Akhtar: If you asked me to name a #bosslady I admire the f*uck out of, it would be Adhuna (aka Od). She's taught me that, of course you can literally do anything you put your mind to, but ***what's most important is challenging yourself to have new adventures*** (like climbing Everest base camp for your fiftieth birthday!)

Also, I have never heard anyone who laughs from the soul like she does.

Chetan Kapoor: My brother from another mother (and I mean that #rakhibrother). Che has taught me that sometimes it is perfectly alright to sit in the lobby of a hotel, hold hands and cry. But mostly he's taught me that ***there is immense value in being fiercely loyal.*** And that as far as he's concerned, there is a pun for everyone!

Hiren Kakad: Aside from being the resident Bollywood hero of our tribe, Hiren has taught me that ***it IS completely possible to get through life never having said a single bad thing about anybody*** and still be cool as f*ck.

Huzaifa Lightwalla: He's someone I often describe as a piece of my heart. Huzaifa is the most incredible combination of party central meets socially conscious. He has taught me that ***you can be deeply vested in the happiness of others and still have a blast living***

your life. #PositiveVibes (PS. He's recently met his 'Lightwalli, an adorable blogger herself known as Soul Kari. Congratulation, Huzi and thank you for the unicorn.)

Junelia Aguiar: J is just one of those people who exudes sunshine and warmth. The kind that wraps you up in love and makes you feel 100 per cent whole again. I'm also convinced that she's an angel from another realm altogether. She has taught me that *we all have the power within to heal ourselves, from anything.* In fact, we have the power to heal everyone else too. #Reiki

Nitin Mirani: Mr Mirani is the shyest stand-up comedian I have ever met. But that's part of his charm. He has taught me that *some friends will make your family their family in a blink of an eye, because they care that much about you* and *that's awesome.*

Nowshad Rizwanullah: What can I say about Nowshad – (well, apparently *anything* as per my publisher. LOL) – he's kind, uber smart (hello Yale AND Harvard!), funny, a master chef and a believer and supporter of dreams, even if they aren't his. Hello CEO of our company and my heart. I've always marvelled at his ability to talk to anyone about anything and become truly immersed in the conversation. Nowshad has taught me that *it is very important and immensely satisfying to be completely present when speaking with someone.* He also keeps his promises; so in-your-face anybody who said he'll never come back from Harvard and marry me, HA! PS. He also has EPIC Instagram game, check it out: @nirzwanu #FTW

Parul Kakad: It's hard to describe my BFF/supermom-of-three, all-round wonder woman and eternal partner-in-crime, because you won't believe she's real unless you meet her! She has taught me to_*live like Peter Pan, love unconditionally, and dance with reckless abandon.* You can follow our #maliniandparul hashtag on Instagram if you want to see what THAT looks like! Oh, and I lovvvveeeee yoooouuuu, Parul! (To which she always replies 'Tooooo!')

Reshma Bombaywalla: Re has an amazing combination of poise and drama that I wish *I* could walk around with. She also is the most magnificent dancer – flashback to a '*Kajra re*' performance at her wedding that I will never forget! She has taught me that *if you sit up straight and live your life with confidence, you will surely make heads turn.*

Rij Eappen: My original #partysoulmate, eternal optimist and social twin has taught me that *you can and should reinvent yourself on a regular basis, even if it scares you and even if it means starting from scratch.* Chances are you're already following him on Instagram @kingofclubsin – chief instigator? Yup, he's living the life *you* wish you were! Super power? Inexhaustibly charming. #Legend

Seema and Ajay Jaswal: I met these two at a bar by accident. Someone had yelled, 'Who wants a tequila shot?' and only two people raised their hands. Seema, you will forever be my tequila girl. Thanks for always adding salt to my life. Ajay, I feel like we're the *exact* same person and that is both amazing and frightening at the same time! I believe that Seema and Ajay have

shown me, without a doubt, that as far as possible, **you should marry your best friend.**

Shawn Fernandes: One of the sweetest guys I know (although I'm told he's quite a player in other circles!) has taught me that **you should never undervalue politeness and being attentive to other people's needs.** #shotyaar

• •

PARUL KAKAD

I've known Malini before she became MissMalini. And I've told the world this and it's been an amazing feeling to just watch her grow from where it started to where it is.

I used to do a segment called 'Adventures of a Desi Mom', which some of her readers used to enjoy and I loved seeing the joy on her face when she'd tell me how many hits my segment would get. Initially, I think she'd get 40 to 50 hits, which slowly kept increasing. After this I took a back seat and told her if she ever needed me, I'm right here. And now she gets 20 million hits or more!

It's a wonderful feeling when you're with a person from the start and watch them excel. It's like she was born to do this. She's always been a very disciplined and principled person and I've loved that about her. Her basic principle has been to never write anything negative about a person. But that's worked for her brand only because she is the same in life. She's always been clear and focused on what she wants. And she's always done and got what she's wanted.

She's now become a doorstep to the social media heaven.

Meri MissMalini (it's what I like calling her), never change and go reach for the stars. I love you.

• •

The twenty-three people who dropped everything to celebrate my fortieth birthday on a cruise ship and made memories of a lifetime. (I've put the lessons from my party soulmates above and those from my family in a different blog, but they were very much on the cruise!)

Aaliya Jaffer: I continue to marvel at Aaliya's insane ability to enjoy every moment of life with unparalleled and infectious enthusiasm! She has taught me that *there is absolutely nothing wrong with dancing whenever, and wherever, you feel like it.* (Apologies for the accidental Shakira reference, but I take that as a sign!)

Ami Kothari: Ami is one of those adorable people who makes an effort to get along with everyone. Even though as a single girl this isn't always the most comfortable experience. Ami has taught me that *stepping out of your comfort zone can be very rewarding.*

Amit Keswani: Amit is my world's most posh eligible bachelor. Not because he spends money on yachts and planes, but because he carries himself with a very James Bond-esque ease. Amit has taught me that *whatever you choose do with your life, do it unapologetically and make it grand!*

Arshiya Fakih Eappen: Eternal smiler and another supermom, has taught me that *unicorns exist and Karma is everything.*

Kaizad Bhabha: He has this devil-may-care *chilled-outness* about him that makes you think he knows something you don't know. He has taught me that *it is possible to trip on watching other people have a good time.* Even if it is 11 a.m. *the next day* from your never-ending birthday party and you're sleepy as F!

Katya: My brother's tall, blonde, beautiful heart (and girlfriend) is someone I admire for her kindness and warmth. Katya has taught me that *poets make the best lovers,* and also the other way around probably.

Rashmi Chandra: My sister's college BFF, who also became a cruise-ader with us nutjobs, taught me that *it is easier to be chilled out in your 50s than you think, just don't think so much!*

Rishad Patel: Or 'Uncle' as I like to call him, has taught me that *it's your heart and you must always take care of it, because the world (or the buffet) may not.* He also taught me that there's nothing more satisfying than Sangria and scrabble on a Saturday afternoon!

Suved Lohia: Suved is the kind of person who will drop everything and come to your aid in the middle of the night if you send him a text. He'll also drop everything and come on your birthday cruise! The one thing I've learnt from him is that *the best thing you can do with access to power and influence is use it to help someone who needs it more than you.*

Suj and Kruppa Koshy: What do you get when you combine a ball of crazy energy with a zero-stress personality? This couple!

They're new in my life but I'm keeping them forever! They have taught me that *it is very rewarding to introduce new friendships into your lives no matter how old you are.*

Tina Bedi: Tina started out as my weekend party pal but quickly turned into someone who relentlessly has my back for no apparent reason at all! I will never forget her telling off a random stranger in Starbucks – much to their surprise – who was saying something mean about me. She has taught me that *you should always stand up for your friends, especially when they're not around.*

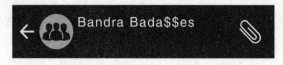

Perhaps my most international crew, ex-pats who chose to live in India (specifically Bandra) for a time and now are scattered across the globe.

Akash and Heena Jain: These two showed me that *it is possible to live in complete harmony, even after turning your entire lives upside down.* From moving to India, to having two kids here, I've seen them embrace it all with zero fear and lots of seven-layered dip. Also, another very important lesson – if you *really* want to leave a party, don't say goodbye; just pull a 'Heena Houdini' and disappear.

Andrea Brown and Chef Kelvin: Andrea and Kelvin have taught me that *it is worth showing your love every day, even if it's in goofy little ways.* Also, that sometimes *all* it takes is a personalized post-it to make someone smile. #10ThousandWatts of friendship!

Caleb and Anisha: There's something about intrinsically happy people that is so infectious you can feel it tingle in your bones. When I am around people like this I feel a giddy sense of euphoria. Caleb has taught me that *if in any given situation you aren't able to laugh out loud, you're in the wrong situation.*

Karan Wadhera: Karan is the one who planted the seed that started the blog. Aside from being an idea factory for everyone, he also sings brilliantly and has Snoop Dogg on speed dial. In fact, he's the man behind the Akshay Kumar–Snoop Dogg collaboration! (Yup, can I get a *Singh is King* anyone?) Karan has taught me that *there really is a way to turn your passion into your life. Find it. Do it. Live it. Carpe Diem.*

Kumar Shah aka Kumi – yup, I'm telling the whole world we call you that now – has taught me that there are still a few good single men left out there and that the biggest mistake we make is looking for something that fits our conventional checklist when *all you need in life isn't someone who's 'perfect', just someone who's perfect for you.* Ladies, if you want an intro, hit me up! @ MissMalini

Mike Melli and Sanskruti Mehta Melli: Mike has been there since the MM HQ was literally *just* my sofa. My favourite thing about Sans and him is an unwavering desire to change the world – one intolerance at a time. Plus, they've adopted a puppy outside our office. Yay Zelda! Mike has taught me that (if you're lucky like me) *there will be some people in your life who want only the best for you* and *your dreams. Trust them as much as they love you.*

PS. Mike also worked relentlessly to get me the perfect agent (Anuj Bahri from Red Ink Agency) and publisher because he knew how much I've always wanted to write this book. #HarperCollins #NuffSaid

Naveen and Geetu Wadhera: All I can say is #couplegoals! Geetu has always given me major arts and crafts envy and I can't get over the fact that Naveen started the a Capella band Penn Masala. How cool is that? Naveen has taught me that *being a grown-up doesn't mean you can't play anymore, just play responsibly!*

Sid and Neera Shah: What I love about these two is their ability to make any occasion feel *that* much more special by acknowledging the moment in meaningful ways. They are insanely fun, hilarious and all-round superstars, who've made me wiser by teaching me that *in order to live life right, you must appreciate the people you love, make all your experiences count and cherish every memory*. #SidShahLive PS. Sid is the only person I know who willingly deleted his Facebook account to de-clutter his life. We make up it for it, however, by flooding him daily on our WhatsApp group.

WhatsApp One on Ones

More wonderful people I have met over the years and grown to admire and love a great deal. We aren't in any WhatsApp groups together and may not even run in the same circles, but I know they will always have my back.

Elton Fernandez: Elton is the most charismatic and quirky person you will ever meet. Aside from being a phenomenal hair and makeup artist he has a pretty deep understanding of the

human condition. He has taught me that *you must live your life unabashedly and never apologize for who you are, because somebody definitely thinks you are fantastic!*

Harpreet Baweja: I mean, we *literally* call him 'Happy'! Besides being an adventure junkie and party animal, Happy has taught me that *you first need to take time out and find out who YOU are, before you let anyone convince you who you're not.*

Roger Williams: Have you ever met someone who's part-teddy-bear and part-badass? If not, you need to meet Roger or Maha Roger as we call him. Roger has taught me that *friendship is the biggest high of all.*

Nonita Kalra: Probably the most elegant person in publishing I know, Nonita has always had an air of Audrey Hepburn sophistication. When I was new on the 'Page 3' scene, she was the first to come up and talk to me and taught me that *your coolness won't diminish by being kind to the new kid on the block.*

Zenith Shah: Zenith and I spend the majority of our conversations talking about outer space and the possibility of life in other galaxies. He has taught me that *it is crucial to respect our place in the cosmos and that the only way to live is to be a supernova.* (Also that guys like girls who wear sneakers.)

And one for the little people...

Noa Eappen: My youngest BFF to date has shown me that children know friendship better than anybody else. That *if you approach children with affection and attention, they will give you*

their hearts in an instant. PS. I'll play Barbie monopoly with you any day of the week, Miss Giggles.

*I encourage you to try this exercise at home. Think about all your closest friends/family and what each one of them has taught you. Then tell them and say thank you #payitforward

Of course, these days *everybody* has those handful of WhatsApp groups that suddenly explode in the middle of the night in a flurry of messages, memes and 4 a.m. selfies. I've always marvelled at it, the proximity this brilliant, billion-dollar app has created. Even for those who are time zones apart. It's a virtual party where people check in and out but never leave...a more evolved version of Facebook, I guess. Here people prefer keeping their circles small and pictures more private. It is the one place we've *finally* figured out how to have an intimate and recurring friendship, even as we drift slowly apart in the chaos of our digitally cluttered lives, just like the ever-expanding universe.

And, as I contemplate what I've learnt from my 'virtual inner circle' that in reality only exists as miles and miles of code, on a cloud, somewhere on the world-wide web, I realize *I've* learnt that there is great solace to be found in the knowledge that even when you are completely alone in a room by yourself, someone *definitely* (yup, you can even check who) heard/read what you said on WhatsApp.

'Because...we need a witness to our lives. There's a billion people on the planet...I mean, what does any one life mean? But in a marriage [and I believe equally true in friendship],

you're promising to care about everything. The good things, the bad things, the terrible things, the mundane things...all of it, all the time, every day. You're saying, your life will not go unnoticed because I will notice it. Your life will not go unwitnessed because I will be your witness.' – Shall We Dance

This concept of finding a 'witness' is something my friend Ashish Sajnani and I talk about often. I sincerely hope you find yours too.

MissMalini ✓ @MissMalini
@MissMalini: #MMProTip Never underestimate the power of emotional satisfaction.

@MissMalini: #MMProTip 'It's never too late to have a happy childhood' – Tom Robbins

@MissMalini: #MMProTip Find your tribe. You will become who you befriend.

@MissMalini: #MMProTip Online messaging is the world's friendship glue.

SECTION 3: 0 TO BOMBAY

Blog #01: *The Wonder Years*

But wait, I just realized I never told you how I got here. As in, life as *I* know it. So, here's the *sort-of* abridged version of 0 to 22 and hopefully this will explain all the key questions you may have about me like, 'Why do you have an accent?' and 'Do you love Mexican food?' (Don't even get me started.)

I am a 'diplobrat'. That's when your parents are in the foreign services and you get a free VVIP ride around the world! And if you happen to be the ambassador's kids, they throw in a Mercedes Benz and a swimming pool, sometimes even a tennis court, with every house. This, by the way, was setting me up for a major reality check about seventeen years from launch, but more on that in a bit...

I asked my mom via WhatsApp what the right chronology was and this is what she sent me:

Mom: Mallo, you were born on 26 May 1977 [thanks, mom, I got that part!] and I took you back to Mogadishu, Somalia, as a one year old. We went to Bonn, Germany, in

1978 and then to Beirut, Lebanon, in 1981 till 1984, and you went to The British school in Delhi for a year. Papa stayed back and then he was posted to Athens, Greece, from 1985–88. We went to Ivory Coast, West Africa, from 1989–92 and Beni went to Bulgaria. We came to Delhi and you went to college. Beni returned to Delhi in 1995 in September after retirement. You left for Mumbai 1999 and Shalini got married in 2000. So, you came to Delhi for a short time. We were in Delhi in 1984 as fighting was going on in Beirut and families came to India via Cyprus on a small boat and took an Air India flight from Dubai to Delhi.

The trajectory of my travels went from Allahabad (for the first six months of my life) where I was born – high-five, Mr Bachchan! – to Mogadishu, Somalia, till I was one, all of which was pretty uneventful to my knowledge. Although my sister says they had to pick out bugs from the bread before they ate it, I don't know if she is just trying to creep me out. Then, it was off to Bonn in 1978 (when it was still the capital of Germany) till age four, where I learnt how to speak fluent German, of which I sadly now only remember a popular children's poem about a duck.

lle meine Entchen
Schwimmen auf dem See,
Schwimmen auf dem See,
Köpfchen in das Wasser,
Schwänzchen in die Höh.

(Translation underwhelming, I assure you.)

We were in Beirut, Lebanon, till I was seven, which turned out to be supremely hectic. I mean I was just about five when the drama started. 'The Siege of Beirut' in the summer of 1982, when the United Nations ceasefire, well, *ceased* to exist. This meant we were trapped slap-bang in the middle of a civil war. But from a five-year-old's perspective, things tend to be a lot more one-dimensional, I guess?

Civil war to me meant we all got to sleep together on mattresses in the hallway every night, or in the basement like one giant slumber party! In the morning, we would run to our rooms to see who could collect the most bullet shells that had come piercing through the now shattered balcony windows (I think we still have some of those somewhere). The streets were littered with actual bombshells, wedged into pavements and countless vehicles that had gone up in flames, leaving behind rusted car-shaped skeletons in charred paint.

My most vivid memory however is of a 50,000-piece puzzle my family and I used to work on together every night, after dinner. You know the kind, two majestic horses frozen in an impossibly elegant pose for all eternity. One morning (after collecting my bullet shells), I walked into the living room to see that it had been blown to smithereens from the impact of a nearby bombshell. I was not pleased about that. The very next day we heard a rumble and ran to the balcony to witness the entire road in front of our building landslide into the basketball court of the American School in front of us. The impact of the tanks crossing over day after day had finally taken its toll.

We were evacuated shortly after that, via a small boat to Cyprus (now that would have been a selfie for the archives!) followed by an Air India flight from Dubai to Delhi. And

although I think the stress is what contributed to my father's diabetes, we all escaped largely unscathed. In fact, since we were 'evacuees', I even got to attend the American School in Delhi for a year, which normally you weren't allowed to without one foreign parent back in the day.

We stayed on in India for a year and I attended Junior Raghubir Singh Modern School; no memorable memories there. I mean, how do you top escaping a war-torn country, right? Next we moved to Athens, Greece, in 1985 where I attended the American Community School till I was eleven – and where I was obviously all about the playground, the beach, visiting the Acropolis, my pet tortoise and a month-long cruise to Crete and Corfu. Sadly, the concept of LIVING in Greece and the romance of sauntering down uneven cobblestone streets were lost on me back then, so I'm dying to go back now.

There are just a couple of major instances that come to mind aside from the happy shiny ones. One, when in my third grade, the Greek teacher refused to believe that my father was the Indian ambassador and made some surprisingly racist innuendo. What lady? 'Third World' countries have diplomats too, ok! #TrumpMuch? As far as I remember, I was also the only brown kid in class. Oh, then there was the time I was playing with Barbies with my Jewish BFF and amongst my toys was a dismantled rakhi – one piece of which was a swastika. I recall very quickly and animatedly explaining to a disgusted fellow nine-year-old that it wasn't what it looked like (oh God no!) and reassembled the rakhi in front of her in record time to prove it. She nodded, shrugged and was cool about the whole thing. Meanwhile, *I* consider that *my* first contribution to the foreign services. Funny the things you remember from your childhood, aren't they?

*FYI, I later learnt that the Indian swastika and the Nazi swastika's arms face in the opposite direction. In case you ever have to explain this to your Jewish friends.

MissMalini ✔ @MissMalini
MissMalini: #MMProTip Travel young and travel often.
@MissMalini: #MMProTip Don't allow yourself to forget a language you once knew.

@MissMalini: #MMProTip One man's war is some five-year-old's sleepover.

@MissMalini: #MMProTip Children would make great ambassadors.

@MissMalini: #MMProTip Relax, parents, children who grow up moving around a lot turn out just fine! (At least I think so. How did I do?)

Blog #02: You Talkin' To Me?

It was back again to India till I was thirteen years of age. I attended Modern School, Barakhamba, where the Republic Day Parade was my favourite thing ever. And, in a school play, I played an evil Cinderella who cons the prince into marrying her – which I must confess I enjoyed very much. (No iPad you see.)

The other thing you should know about Modern School, Barakhamba, is that *nobody* messed with anyone in that blue uniform. It was everyone's off-campus outfit of choice as well. I remember thinking we were all very 'pink ladies' from the movie *Grease* (lightening) at the time (just in blue). The girls would safety-pin their skirts up higher once they got out of class and the boys would un-tuck their shirts and ruffle their hair. Something I recently learnt Shah Rukh Khan likes to do as soon as they yell, 'pack up!' on set. So, hey, don't judge. (The ruffle, not the skirt.) I also distinctly recall two things that forever cemented in my mind the concept of 'thug life' in Indian schools.

1. In the seventh grade we decided to ape the graduating class and wrote all over each other's uniforms on the last day of the school year. This, in hindsight, was probably a bad decision since *we* weren't in fact graduating. The school principal, a rather ironically named Mrs Gandhi – who doubled as the History teacher and liked to *sing* her lessons – felt the suitable punishment for this idiocy was a forehand slap across the face for everybody (they were still allowed to do that back then #corporalpunishment) starting with all the boys. One of my classmates, Rohan, had his glasses fly across the assembly hall upon impact (ruffling quite a few pigeons). I was just petrified but never actually earned a slap, early advantages of being a girl I suppose? #BulletDodged

2. One day, while waiting in line to fill my water bottle at the water fountain, a boy came up and pinched my cheek. I was so shocked I reeled a few steps backwards. I think he was equally surprised because he thought I was someone else, but then instead of apologizing he started to laugh and so did all his friends. I was so embarrassed and upset I went crying to my elder brother Deepak's math class. On the way, some other kid told me the name and section number of the boy who had pinched me. I appeared in the doorway, sobbing, and told my brother what had happened. My brother instantly bolted up, signalled four of his friends, who immediately got up too, nodded at the math teacher (a quirky Sardar named Mr Singh) and there was absolutely no question (teachers included) about what was about to happen to this boy. He was dragged kicking and screaming from his class to

mine to apologize for his transgression. I was horrified watching him get beaten up so badly. Did the punishment fit the crime? I don't know.

But like I said, #thuglife, and thanks for always having my back, bro!

Next stop? West Africa! Abidjan, Ivory Coast, Cote D'Ivoire. From 1992 till I just about hit eighteen, I had the most phenomenal time at The International Community School of Abidjan, possibly my four favourite teenage years. Also, where I got deeply addicted to coloured kajal pencils that I would buy from the local tresh-ville market every week with my mom. I got my first phone – a chunky landline in my bedroom. It was a HUGE deal for late-night conspiring with my Korean best friend, In-Hye.

This was also around the time when I discovered *Star* magazine and pull-out celebrity posters of which I had several plastered all over my walls. Including those of Tom Cruise, Madonna, Paula Abdul, George Michael (may he rest in peace), Milli Vanilli – I was gutted when I found out *they* were a con job – and one of David Hasselhoff (don't judge me) in nothing but his *Baywatch* swim-trunks, inside my cupboard, which my brother told my mom about (okay, now you can judge me).

During this time, I also started a scrapbook dedicated exclusively to Aamir Khan with cut-outs of every conceivable picture I could find in *Stardust*, *Filmfare* or *Cineblitz*, copies of which arrived like clockwork to our house from India. Man, I wish I had that now so I could prove to him I'm *so* not a stalker. Actually, um, scratch that.

For me ICSA was filled with memories of school plays, *Arsenic and Old Lace* and *The Mousetrap* – my favourite performance – where again I played the malicious Mrs Boyle. (Oh dear, I'm turning out to be quite 'the vamp' of my own life story! LOL.) Also, falling in love for the first, second and third time.

I even had my first 'true-blue-listen-to-it-must-have-been-love' on repeat, kind of heart-break. I was fourteen years old and knew that Benoit – the French–Canadian boy I liked so much – was coming over to ask me out. These things were always preplanned and discussed with the larger friend circle at the time before being made official at my school. But as I opened the large wooden gate to my house, I literally *saw* him change his mind. It was these damn gold-rim aviatoresque glasses with the gold bar on top that I was wearing. *I was sure of it.* So sure that I sat in tears in my room with him and my best friend – glasses on the floor – asking him why he had changed his mind, wanting him to admit the shallowness of it all. I remember my best friend In-Hye telling me that I can't ask him that. 'How can you ask him that?' she said, annoyed at me. But all he could say was, 'I'm sorry.' And from that day on I would take those awful glasses off as soon as I got to school and squint through all my classes. (Sorry, mom.) I do think that he realized his four-eyed error eventually because the day I was leaving Ivory Coast to return to India, he bawled his eyes out at my house, all the way up to that wooden gate. He was dating my best friend at the time. #OhLife

What else? Prom, pool and pizza parties at mine, plus the one time we found a snake in the pool and why I decided to take up ice-skating instead. I got good at it too! While half my class smoked cigarettes, and drank beer, I, in true Indian-nerd-

in-high-school-style, went ice-skating instead, often by myself. (Probably why my liver can take so many Jägerbombs now.)

I used to read a lot of Nancy Drew and chic-lit growing up, but then a boy-crush named Chris Conner introduced me to Stephen King. I was immediately enthralled by Mr King's ability to inject slightly surreal, but entirely believable horror into everyday situations. I became so obsessed that I read every novel, short story and non-fiction book he ever wrote. My favourites were *Night Shift, Misery* (a classic), *Cujo, The Tommy Knockers, The Eyes of the Dragon, Four Past Midnight* and *Different Seasons*. I'll be honest, I kind of lost interest while reading the *Dark Tower* series, tried a similar horror-fiction author Dean Koontz for a while and then gave up on the genre entirely.

But I think Stephen King opened my mind about writing reality through all his books. What always struck me about them was, that they sounded more like a narration than a novel. As if someone was sitting by the fireside with me and recounting an *almost* true story. They felt personal, intimate almost. Like I was the only one in the room, like the story was just for me. I also loved that he filled his novels with 'Easter eggs', where die-hard fans would find little crossover moments between his books. As if everything he wrote was happening in the same universe, at the same time. Oddly enough, till this day I can't watch a scary movie. I feel traumatized by it. But his books I would devour voraciously, even though they qualified as horror. Perhaps there was comfort in the thought that my mind would make the clown in *It* look as ominous (or not) as *I* wanted it to be and not some CGI-generated Hollywood blockbuster version that would keep me up at night. (FYI, thanks to *The Ring*, I didn't sleep for weeks.)

I wrote my first short story that year in high school. It had a distinctly Stephen King vibe about it and I was surprised at how easily the words poured out onto the pages. Even though I was using a pretty ghetto typewriter to do it. I remember showing it to Chris and him being duly impressed. So much so that he requested that I swap the villain of the piece's name (Chris) with the hero's (Alex).

I also found one of my first mentors in high school. A teacher named Mr Pratt who taught Current Affairs and was just about the coolest guy ever. I remember distinctly how we listened to *Operation Desert Storm* unfold on the radio sometimes in class and he would explain the politics behind it. He would also make jokes about how I would always turn in my homework early, and tell me a forwarding address I could use during the summer holidays if I wanted to send in anything urgently! (Yup #supernerd)

• •

MR PRATT

Hi Malini, I am honoured that you feel I played a role in your life, but I thought you were great the first time I met you, full of positivity and life! Dianna and I are in Tuscany for a few more days. I hope all is well with you, I have seen a few of your interviews, like the one with Amitabh! If you ever interview Tiger Shroff, you have a connection, I was fortunate to have you both as students.

• •

And finally, in 1994 at age seventeen, I returned to home base Delhi and enrolled in The British School for the last stop on this epic ride. My father went on to Sofia, Bulgaria, for one last posting, but they didn't have a high school for me there, so I was retired early.

1977
India- Allahabad
For the first six months
of my life...

1978
Somalia-Mogadishu
Hello Africa!

1978-81
germany- Bonn
Where I became fluent
in German

1985-88
greece- Athens
Went to the acropolis
and island hopping

1984-85
India- Delhi
Attended the American
School for a year

1981-84
Lebanon- Beirut
I was just about 5 when the
drama started. The seige of
Beirut in the summer of 1982

1988-90
India- Delhi
Attended Modern
School Barakhamba

1990-93
Ivory Coast- Abidjan
High school
and first loves...

1993-99
India- Delhi
Back to the motherland
for a reality check!

2000-to Date
Delhi- Bombay
Bombay dreams and
a life less ordinary
#MissMalini #tothemoon

MissMalini ✔ @MissMalini

@MissMalini: #MMProTip Even fairy tales have two sides to every story. (So said the Grimm brothers.)

@MissMalini: #MMProTip You can't blame your glasses if someone else is too blind to see through them.

@MissMalini: #MMProTip If you tell on someone, be prepared to face the consequences with them.

@MissMalini: #MMProTip Think of the characters in your stories as real people and watch them come to life.

@MissMalini: #MMProTip Some teachers will teach you your lessons while others will teach you about life.

@MissMalini: #MMProTip If you see Shah Rukh Khan with ruffled hair, that means he's done shooting.

Blog #03: My Family & Other Animals

More important information: I have three siblings: a brother, Alyosh, who was born in Russia and hence given the Russian name 'Alyosha' – a version of Alexander. But they eventually dropped the last 'a' because in India it would sound like a girl's name. Now he calls himself Alex anyway, so full circle. He's fourteen years older than me, a financial genius and my hero. I spent much of my childhood riding around on his shoulders for a better view of the world – and easy access to the best fruits from the guava tree at my grandparents' house in Allahabad. In his 20s he started an insurance software company called Innosoft and sold it to for millions! 'Nuff said. He showed me that being self-made is the most satisfying and liberating experience in the world.

I'm gonna put in a side note here to tell you my maternal grandfather, whose house it was, *really* looked like Yoda. Ears and all, so the *Star Wars* force runs deep in my fam. My uncle, Ajay Jain, wrote a book about my grandfather's life recently so I'm proud to be following suit about mine.

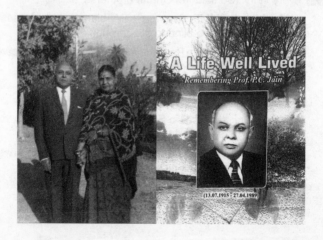

My sister Shalini; yes, we've heard every Shalini–Malini joke known to mankind! Also, my best friend in middle school was Hema and thus we were called 'Hema Malini' for three torturous years. So, you've got nothing on me, nothing! Didi aka Shals, as I now call her, is twelve years older, a hotshot lawyer and my entire giant beating heart. She's always been available without hesitation when I've needed advice, a shoulder to cry on, somebody to vent to, or just something silly to laugh about. I used to be her little baby doll and now she's like my BFF. Shals has taught me that unconditional love is the greatest gift you'll ever receive.

And I have another brother as I mentioned. Deepak, who is five years older than me, a total sweetheart and currently an advertising wiz. He even used to be my pen-pal for all the years we were apart. Dee has taught me that siblings who dance together, stay together! If you've ever seen him blaze across the dance floor you know what I'm talking about! I've never had a better dance partner or someone I can count on to hit the dance floor at the drop of a hat. (Also, don't touch his hat.)

I am the youngest of the four and obviously, so I got away with *everything*. Plus, my older siblings had primed the parents to be okay with whatever I wore, whatever I did and however many school dances I wanted to go to. Thanks for that, kids! #IOweYouOne #SiblingLove #ParentTraining

• •

SHALINI AGARWAL
Sister & BFF

When Malini asked me 'What words of advice do I have for you now?', it got me thinking and then stopped me in my tracks.

Thinking because, well, every older sibling ALWAYS has a word of advice to give, solicited or not. But I hit a blank because when I think about it – Malini, you were almost always the one who had an answer or some advice for me! Whether it was on how to deal with a broken heart, unruly boyfriends, depression, inner happiness...whatever. You almost always had an answer or a solution to wage war on whatever was bothering me at that given moment of time.

Funnily enough I never dwell on those moments much (for obvious reasons) but now when I think about it, it's just such an amazing thing to have in one's life – someone who can listen to you without judging you and heal you without making you feel hurt.

Malz, your EQ is way off the barometer, heading to the moon in its own little rocket ship and your empathy and love of happiness and joie de vivre are all beacons for so many people.

But coming back to advice, now at this stage when we aren't twenty-six and twelve anymore, I would say that make you make time for JUST yourself while you savour life, your success and all the other good things. And whilst running on the fast track, stop to take a breath and pump oxygen into those lungs – heal and regenerate from within. The life you lead, my dear Malini, would have knocked many a folk off their feet a long time ago. You have amazing energy and a zest for life, but I would say throw in the additional recreational weekend, go away and detox in mind and in body, and breathe afresh!

And since I never stop at one round – cherish the close family and friends around you as come what may, those are the shoulders you will always have to lean on and who will always ensure you walk tall.

My parents are Beni Prasad Agarwal and Manjulika Jain Agarwal. They are an inspiration. They worked their way from small-town India to global citizens, which gave me this life and for which I will be eternally grateful. My dad put himself through a bachelor's degree in Sanskrit, English and Political Science and a master's in Political Science. He also has an MPhil in International Affairs from Oxford and a PhD from California. #Brainiac

My mom – aside from teaching elementary school on her travels and being the incredible driving force behind all her four children and their successes – used to, in her teens, watch Bollywood movies along with her cousins in Lucknow and leap daringly from terrace to terrace, enacting scenes from *Hunterwali* (a 1935 Hindi stunt film featuring Fearless Nadia who became a cult icon and Indian cinema's earliest and most popular stunt actress)! Needless-to-say blockbuster movie and no prizes for guessing which parent I've gone on! Also #WhoRunTheWorld? Apparently, Nadia beat you to it, Beyoncé.

My mother has always sat proudly in the front row at everything I've *ever* done, be it a spelling bee or a Bollywood performance. She has also recently discovered WhatsApp and her emoji game is off the hook! My mother has taught me that parents who encourage their children to follow their dreams end up with very successful children! I know I take for granted the freedom and encouragement she has always given me, so let me finally say thank you, mom, you made me everything I am.

Dad – he's a the difficult one. But let's just say, in hindsight, he taught me that you should read the newspaper every day, or you'll feel stupid in conversations. Also, it probably would have

been a good idea to learn how to make an aloo paratha or two because they make a delicious breakfast!

I have five nephews. Andre, Michel, Daniel, Rehan and Ryan. Now it's up to me to provide the next generation of girls it appears.

. .

MOM
Homemaker

Malini was a very shy girl. Whenever we went to parties and she was talked to, she used to hide behind me. I did not imagine that this shy girl would take the whole world to the moon. Am so proud of you. Later, she loved going to parties. She'd be the first one there and the last one to leave. Her one amazing talent was to tell me where the item I was looking for was kept. One advice I would like to give her would be to remain as she is but be alert and not be gullible to people who sweet-talk or are always praising her as such persons are hangers-on.

DAD
Former Indian ambassador and professor of Political Science

Malini is the youngest of our four children. She is what she is today because of her own genius and hard work. We had a feeling from the beginning that she was cut out for something special.

I am reminded of Kahlil Gibran's gift to humanity in the form of his book, *The Prophet*, where one can find guidance on almost all aspects of life. I visited his home in Bicharre in Lebanon, when I was posted there as an ambassador of India. The place had the feel of a garden in heaven. I quote below two paragraphs from his verses on children.

'Your children are not your children.

They are the sons and daughters of Life's longing for itself.
They come through you but not from you,

And though they are with you yet they belong not to you.

You may give them your love but not your thoughts, for they have their own thoughts.

You may house their bodies but not their souls,

For their souls dwell in the house of tomorrow, which you cannot visit, not even in your dreams.

You may strive to be like them, but seek not to make them like you.

For life goes not backward nor tarries with yesterday.'

. .

The other key player in my life, whom I hadn't met at this point in the story, is my husband Nowshad Rizwanullah. (My editor says I'm allowed to use his full name no matter what I say about him. Mwahahaha!) I want to tell you about him here because he's also a diplobrat like me. Although apparently, more diplo, less brat since he's a UN baby and they are less spoilt than IFS babies, I'm told – by him. But we bonded over the fact that we had both grown up tumble-weeding around the globe and even played a game invented by one of his best friends Kanu Gupta called 'Who has the cooler countries?' This consisted of naming the various countries we had both lived in over the years and Kanu playing a human barometer of sorts, deciding which one of us won the 'cool factor' for each destination based largely on each location's exotic/edgy/dangerous nature. Clearly, Canada was out. Sorry, Nowsie. And no offence, Switzerland, it's just that you're too safe and friendly. #NoRiskNoFun!

So anyway, I thought it would be fun to insert our comparative chart here and show you how we fared...

Malini	Nowshad	Score
0-1977 India, Allahabad	1977-1980 N/A (He wasn't born yet, but technically in Nigeria for 9 months)	N/A
1977-1978 Somalia, Mogadishu	1980-1982 UK, London	Malini Wins
1978-1981 Germany, Bonn	1982-1985 Sudan, Khartoum	Nowshad Wins
1981-1984 Lebanon, Beirut	1985-1990 Switzerland, Geneva	Malini Wins
1984-1985 India, Delhi	1990-1993 Senegal, Dakar	Nowshad Wins
1985-1988 Greece, Athens	1993-1994 Canada, Ottawa	Malini Wins
1988-1990 India, Delhi	1994-1996 Iran, Tehran	Nowshad Wins
1990-1993 Ivory Coast, Abidjan	1996-1999 Canada, Ottawa	Malini Wins
1993-1999 India, Delhi	1999-2005 USA, New Haven, Washington DC	N/A
2000-to date India, Bombay	2005-2008 India, Bombay	N/A
	2008-2010 USA, Cambridge	N/A
	2010-2017 India, Bombay	Everybody wins!

And now let's play a round of 'You Know You're Desi When...'

Now in *our* experience, when you grow up as desi kids in the '90s, in *these* many Indian, international, British and American schools, more than a couple of semi-unusual things happen to you. I thought it would be fun to ask Nowshad for his list too, so we could compare. We'll tell you just twenty-six since that's my birth date, but I could go on and on, I assure you.

	IFS Brat	UN Not-So-Brat
1	They let you skip class 8, *and* you still automatically make the honour roll (high honours if you please).	One year you're the best at sports in your class, the next you're getting crushed by kindergarteners. Who knew kids in Senegal run so much faster than kids in Switzerland?
2	You wear gold-framed glasses with the bar across the top but boyfriend repellent at fourteen!	If you're lucky, your travels will take you through various educational systems in a decreasing order of difficulty.
3	You have some ridiculous items in your wardrobe – I'm looking at polka-dotted pant suit and giant-butterfly-clip-elastic-band-belt!	All children are created equal. Until you attend public elementary school in Canada, where apparently, you must choose between being a 'skater, wigger, or jock, unless you're categorized as a 'weird foreign nerd'.

	IFS Brat	UN Not-So-Brat
4	To prom, you wear a baby pink ruffled lace dress your mom made you, plastic pink frames that take up your whole face and a side braid (not the trendy fishtail kind) and generally look like the biggest geek to have ever walked the earth.	One day you're attending school in sub-Saharan Africa, the next you're in wintry Canada. But no need to worry, your uncle's neon green polyester winter coat should do just the trick, especially if you enjoy getting beaten up by jocks (see Point #3).
5	Someone, at some point, asks if you went to school on an elephant in India and you're thinking, that would be f*cking awesome! But alas, no.	You are perpetually labelled an 'American' for the rest of your life, because for some reason all international schools teach English with an American accent.
6	You learn how to spell everything with the letter 'z' and then an 's' and then a 'z' again. (American English v/s The Queen's English).	You kind of wish you were American, because then you would have access to the American Embassy Commissary, which sells Dr. Pepper and Cheetos a.k.a. Liquid and Cheesey Gold.
7	Some mildly racist teacher puts you in detention more than you deserve (okay, jury's still out on that one).	You forget the pronunciation of your own name. Now-shad? No-shad? Naushad? No-shid? Nu-shad? True story.

	IFS Brat	UN Not-So-Brat
8	You crave scratch-'n'-sniff stickers for your collection.	While your friends are summer vacationing in some tropical paradise, you're making the annual trek to visit family in beautiful sunny Dhaka, Bangladesh. In retrospect, this is one of the greatest gifts your parents ever gave you, but try explaining that to a whiney teenager.
9	Some very idiotic classmate in India constantly makes fun of your now completely American accent (Kanika Chaddha, Modern School, Barakhamba, Class of 1990 – wtf).	You think your life is over every 2 or 3 years when your parents declare you're moving to a new country. This is quickly erased by the thrill of discovering new places, new foods and new people. As you get older, add 'new girls' to that list.
10	You know every episode of *ALF*, *Family Ties* and *Shaka Zulu* by heart.	You think *The Fresh Prince of Bel Air* is a French show until you realize you've been watching a dub for all these years. Did you know 'Sherlock Homeboy' becomes 'Sherlock Omlette' in France?

	IFS Brat	UN Not-So-Brat
11	You've also watched every single Bollywood film released since 1998. My first memory of Bollywood being *Qayamat Se Qayamat Tak*, when at age ten I fell deeply in love with Aamir Khan. (I told him decades later, the first time we met, Hello, I've been in love with you since I was ten years old.' He just smiled, somewhat uncomfortably, I think because I made him feel old or because I came across as a stalker. Should have brought my scrapbook, could have gone either way.	You vehemently argue with all who will listen that *The Fresh Prince of Bel Air* is way funnier in French for as long as you can hold out. PS: It definitely isn't.
12	You're forever confused about how to pronounce the word aluminium. Is it 'aa-loo-min-ee-ium' or 'a-lum-inum'? (Please refer to point #7.)	The 'latest Hollywood blockbuster' means the latest pirated VHS tape that one of your relatives has managed to smuggle in their suitcase, usually a good 6 months after release.

	IFS Brat	UN Not-So-Brat
13	You play a LOT of Dungeons & Dragons. (Something Nowshad repeatedly tells me NOT to tell people.) I was Dungeon Master, baby. #JealousMuch?	You are surprised to learn that a local theatre in St Louis, Senegal, plays Bollywood movies. You are not so surprised when they have cut out everything but the songs, dances and fight scenes, and yet this only shaves 20 minutes off the movie.
14	You make and receive a lot of emo 'mixed tapes'. *sigh* cassette tapes, I miss you.	Bread, milk and chicken are occasional delicacies in 1980s Sudan. The first can sometimes be bought in stores, the second is occasionally delivered in canisters on donkey-back, and the third can be glimpsed if you peek above your compound wall.
15	The drama teacher is hot and owns a pool table, so all the cute boys join drama class, hence *you* also join drama class for the hot, cute boys.	You quickly learn that not all diplomats are created equal. Foreign service means mansions and swimming pools. UNHCR means a Toyota Land cruiser and a pat on the head. Yet another blessing you learn to appreciate much later in life.

	IFS Brat	UN Not-So-Brat
16	You go to a LOT of 'pep rallies', even if you don't care about sports.	No two countries make a shawarma the same way. The only thing they have in common is meat and bread.
17	They make you dissect a live beating-heart frog in biology. (Is this a universal thing? Because it's got to stop, *really*. #gross)	Every country (except India) makes a Big Mac exactly the same way, and has been doing so for at least the last 30 years. And they are exactly as delicious today as they were when I had my first taste all those years ago. Meanwhile, the Maharaja Mac gives Maharajas and Big Macs a bad name.
18	You're left-handed and can't write in calligraphy; shattering all your dreams of becoming an incredible artist one day.	Your parents live in perpetual fear for your safety so you spend most of your free time and weekends at home. This may not be unique to international kids, but have YOU ever tried convincing your parents that casual street riots and religious police were nothing to worry about?

	IFS Brat	UN Not-So-Brat
19	Your classically desi parents won't spring for an *actual* flute so you're stuck playing the recorder in music class, again shattering all your dreams of becoming a world-renowned musician. (In hindsight a wise decision, mom and dad, seeing as I'm completely tone deaf and usually lip-sync at karaoke bars, shhh!)	You realize over time that being the weird foreigner as a child quickly turns into a massive advantage as you grow older. Nothing impresses a college girl or university admissions officer more than a passport full of stamps and a few war stories to boot.
20	You think hyper-colour t-shirts are the coolest thing *ever*.	Eating out anywhere other than a major global metropolis becomes very difficult, because nothing tastes as good as the real deal. On the bright side, you get to eat some amazing local food, but you become a real snob about anything else, and that kinda sucks.

	IFS Brat	UN Not-So-Brat
21	Someone buys your brother an Atari for his birthday and you become obsessed with it too.	You don't really know what it means to have childhood friends, a lifelong pet, or why kids on American sitcoms freak out whenever their parents decide to sell their house.
22	Your parents FINALLY spring for a giant whirring desktop that sounds like it's dying every time the dial up connects.	Your two least favourite questions in the world are 'where are you from' and 'what's your permanent address?'
23	You learn BASIC in computer class. Hello geek-dome. (Remember IF, THEN, ELSE?)	Living in Iran for two years amongst some of the most warm, hospitable people you'll ever meet quickly teaches you that what you see in the news rarely gives you the real, complete picture.
24	You don't really know what the pound sign '#' on your keypad is for. (You won't for the next fifteen years.)	Hating on America has always been a global sport, but spend a few years there and you come to understand why it truly is one of the greatest countries on earth. Except for maybe Canada. Those folks have it figured out.

	IFS Brat	UN Not-So-Brat
25	While your academic skills might take a dip down from the Indian learn-the-whole-world-by-rote system, you learn that it is perfectly OK to have an opinion and be yourself. You learn *confidence*.	Live in America too long, however, and you realize it's way too easy to lose touch with the rest of the world.
26	You start a bullet-shell collection and sleep in the basement most nights because of the Lebanese Civil War (one night in someone else's basement because your family misses lunchtime curfew and *Yasser Arafat* is there too). Okay, this one's probably *not* as common...	Growing up travelling your whole life has its trials and tribulations. But nothing instils as strong a sense of curiosity and adventure than experiencing how different peoples and cultures live. And if you're lucky, that urge to discover will one day find you an amazing wife, career, and an incredible sense of accomplishment!

And in the end, you come back home to your tiny three-bedroom apartment in the IFS colony in Mayur Vihar, Delhi, and innocently ask, 'Where's the rest of the place?' and phase one of life as you know it comes to a grinding halt. Goodbye, swimming pool, adios Mercedes Benz.

But then you think OMG (no wait, this is pre-'OMG'), holy sh*t what a FANTASTIC opportunity to reinvent myself. I can be cool and mysterious and I finally wear CONTACT LENSES! You forget the tiny apartment and the dusty rides to school in a #322 Red DTC Bus, which I was told they keep painted red so they don't have to constantly paint over the bloody accident stains, true story. Where you plough your way through your 'A' Levels at The British School (which you almost fail, damn you letter 'z') and then enters the drama team and changes your whole perspective on life. All those years of watching *Paper Chase* and dreams of becoming a criminal lawyer fade away and the curtain rises on ENTERTAINMENT! ENTERTAINMENT! ENTERTAINMENT!

MissMalini ✔ @MissMalini

@MissMalini: #MMProTip It's never too late to get back in touch with family.

@MissMalini: #MMProTip Parents PLEASE don't give your children rhyming names. It's cute for about 5 minutes, then it's a lifetime of cringing.

@MissMalini: #MMProTip Bollywood has been fearless since 1935.

@MissMalini: #MMProTip Marry someone who understands your childhood.

@MissMalini: #MMProTip All good things come to an end, so you can have a new beginning. DON'T PANIC. (Carry a towel.)

Meanwhile, across the world in Bangladesh, another story was brewing.

Blog #04: The Husband Blog – Nowshad Rizwanullah

I moved to India in 2005 in search of adventure. Little did I know that I would find a wife and a company to call my own

in the process, but I guess fortune truly favours the bold...or at least the restless. At that point in life, I had been living in the US for six years, the longest I had lived in any single country. I was feeling stagnant and disconnected from the rest of the world, as tends to happen when you live somewhere as self-contained as the United States. Don't get me wrong – there are few countries as extraordinary, but the predictability and routine of my life weighed heavy on me.

After four years at Yale University and two years working for an emerging markets investment fund, I faced an important choice: accept my place in the North American corporate escalator I had so diligently worked towards my whole life, or take a chance in pursuit of a life less ordinary. Two clichés in their own way, but the answer for me was clear.

As soon as I completed two years on my contract, I quit my job, sold my belongings, counted my savings, and bought a one-way ticket to Bombay. I gave myself 6 months to find a suitable job which would teach me the ins-and-outs of doing business in emerging India, and another 2 years or so to bump into some IIT geniuses with whom I would start a hot, new startup that would one day change the world. It seemed so simple back then.

Bear in mind, my family is from Bangladesh, with no connection to India. Except for the incredible generosity of my college friend Sriram Lakshman, and his parents Nirmala and Lakshman Balaraman (to whom I will be eternally grateful), I had no business being in this town. My only previous experience with Bombay was transiting through the airport on the way to Dhaka for summer holidays. For those who remember what Bombay airport looked, smelled, and felt like in the '80s and

'90s, you'd be forgiven for thinking I was slightly nuts. And yet there was something exciting brewing across the ocean, a long-awaited rebalancing of talent, wealth, respect and opportunity, and I wanted to be a part of it all.

I had spent the last year of my job in DC helping my boss write *The Emerging Markets Century*, a book on the top twenty-five multinationals from emerging markets that were redefining old rules and transforming their industries. My boss at the time, Antoine van Agtmael, was a pioneer in the field, having coined the term 'emerging markets' while working at the IFC in the 1970s. Riding off his reputation and influence, I had the incredibly rare and good fortune of touring the factories and executive suites of some of the world's most exciting new companies, including Samsung, Hyundai and POSCO in South Korea; TSMC, Acer, and HTC in Taiwan; Petrobras and Embraer in Brazil, and various other rising stars from the developing world. The companies I couldn't personally visit I would engross myself in through Bloomberg research, magazine reports, and the time and patience of our portfolio managers. This included deep dives and profiles on Indian companies such as Reliance, Tata and Infosys among others, and this is when the wheels in my head started spinning.

My desire to move to India is not something anyone could have predicted, least of all my parents, who bought a house in Long Island shortly after retirement in anticipation that their three sons would most likely choose New York as their future stomping grounds. Imagine their surprise when my older brother Razi moved to Dhaka, to be joined later by my younger brother Asif, while I landed up in India.

While we had spent our fair share of time in the developing

world – and truly loved it – we were drawn to the long-term allure of Western culture and creature comforts. To the ten-year-old mind, it seemed foolish to pick dusty roads, power cuts and mosquito bites over gleaming highways, cable TV and junk food in every shape, size and flavour imaginable. By the time I reached college and had to start thinking about jobs, Europe and North America seemed like the obvious choices for building a respectable, long-term career. After all, most of the leading companies in the world at the time were based there.

Growing up, I had given some serious thought to following my father's footsteps with the UN or a similar international relief organization. However, by the time I reached college, the critique du jour was that the UN was a bloated, politicized and corrupt organization in desperate need of reform. Having seen the UN at work first-hand in some of the most desperate places on earth, I always found this characterization distasteful and hard to swallow. My father had spent his life housing, feeding and speaking up for refugees, and I had met many generous and dedicated civil servants through his work. But I also knew there was a kernel of truth in these allegations, which my father himself would often voice, and I decided I didn't have the interest to enter such an environment.

And so, as my college years wound down, I jumped head-first into interviewing for predictable consulting and finance jobs. My lack of real passion for these fields must have showed at the time, as dozens of interviews with dozens of firms led nowhere. This would prove to be a blessing in disguise, as Antoine was a bit late in looking for his research associate, and I was a little late finding a job. I'm not a very spiritual person, but I do believe in Karma. I don't know how Antoine feels about this,

but I believe it was Karma that found me that job with him, and set into motion the series of events that find me writing this chapter today.

To go into much more detail about my past would take too much time, and you've not picked up this book to read my story. But I would be remiss if I didn't share two more details: 1) the brief version of how I met Malini and MissMalini; and 2) the lessons I've learned that I believe apply to anyone looking to find their purpose and place in life.

I met Malini thanks to a last-minute drop-out and two very insistent friends. This was in August of 2007, and Phase I of my India strategy was working out mostly to plan. After three harrowing months of job hunting with the aid of an MTNL dial-up modem, a rapidly dwindling bank account (who knew Mumbai was so expensive!), and a fortuitous introduction from my Yale classmate Ryan Floyd, I landed a job at the overseas automobiles division of Mahindra & Mahindra. That first year was spent mostly in expat circles, by virtue of the fact that M&M had just initiated a program that recruited five fresh graduates from the US and brought them to work in India for two years. I was sharing an apartment with this first batch of recruits, through whom I made my first real friends in the city. Although we lived a comfortable life, I eventually moved out with one of those recruits, Mike Delfs, as we both looked to broaden our horizons and experience the side of India for which we had travelled all those miles. Mike had recently stumbled on a social club that organized outings every Friday, called the Friday Club. One fine Friday, Mike and another Friday Club member, Gaargi, were pre-gaming at our apartment when a spot on the club list for that night unexpectedly opened. I was already pretty set on

meeting my friends, but Gaargi and Mike insisted I join them, and promptly added my name to the list. I made a last-minute change of plans, and that split-second decision would forever change my life.

Malini and I shared an instant connection, but I kept my distance that first night on the strict instructions that creepy dudes would not be invited back for future events. Over the next several weeks, between long social media chats and my near-religious attendance of all future FC events, it became clear that Malini was the kind of one-in-a-million person you meet very rarely in life. The kind of person whose energy, enthusiasm and charisma could instantly draw you in, while her kindness and generosity made you never want to leave her side. Before long, we were dating. Eight months later, when I got into Harvard Business School, there was no question that I would do what was necessary to keep us together. Malini started her hobby blog while I was at HBS, and as with anything she puts her mind to, it was clear it would be a success. I promptly returned to Mumbai after graduation in 2010 to work with Nomura, a Japanese investment bank, but I had an inkling that Phase II of my India plan had finally begun to take shape, albeit in an unexpected manner. I would have never guessed a Bollywood entertainment site is how I would eventually expend my entrepreneurial energy, but there was never any doubt that riding Malini's coattails would be the most exciting way to do so. Two years later I joined Malini and Mike in the business full-time, and the three of us have been at it since.

If I were to look back at the story of my life, there are a few recurring themes that I believe were key to my happiness and success. First and foremost, travelling the world and eventually

attending a liberal arts university taught me the importance of keeping an open and curious mind. Growing up, the path to 'success' is too often narrowly defined for us by well-intentioned parents and counsellors. But if my story proves anything, it's that life's joys can come from the most unexpected places. The more you push yourself out of your comfort zone, the more you allow yourself to grow and discover what truly fuels your passions. It's crazy to think you know what happiness means by your early twenties, when you are expected to make so many important life decisions. Take the time to explore, to experiment, and remember – the world is a wondrous place filled with opportunity and excitement, if only you give it a chance to unfold.

The second recurring theme in my life is something I've mentioned earlier, and that is the power of Karma. Early on in life I made a simple observation: that the more 'good' things I did, the more 'good' things came back to me. This could be for other people, for myself, or for no one in particular. Conversely, if I ever did something I regretted, or felt guilty about, it would find its way back to me in one way or another. So, the lesson here is simple, and more important than anything I've learned at Yale or Harvard: be good to yourself, your family, your friends, your readers, your fans, your customers, your investors, your colleagues, your employees, your partners, and everyone else in your life. I am a 100 per cent convinced that most relationships and businesses fail because somewhere along the way, someone simply forgot to be good to someone else, and eventually paid the price in whatever dramatic, snowballed form it ultimately took. I believe that I found Malini and the incredible people that are building MissMalini with us today

because somewhere along the way, we all did something good to deserve each other.

The third and final lesson is to believe in yourself. I look back today at some of the risks I've taken, some of the decisions I've made and some of the situations I put myself in, and still cannot believe I pulled it off. This is not to brag, but to say that we don't give ourselves enough credit for what we can achieve, even after we've achieved it! I am willing to bet that all our heroes and icons could look back at a consequential time in their lives and still not believe how they made it through. We tend to think that these people are superlative, and innately wired for success in a way that we are not. Maybe they are. But we would have never found out if they weren't willing to take a chance and place an audacious bet on themselves. No matter where MissMalini Entertainment takes us (and we still have a long road ahead of us), I sleep easy at night knowing that a lot of good people are giving it their very best shot.

There you have it. Nearly four decades of travelling the world, staying curious, trying to be good and believing. And that's exactly how I plan to spend the next forty. Who's with me?

Nowshad Rizwanullah @nrizwanu

@nrizwanu: #NRProTip It's never too early or late in life for an adventure.

@nrizwanu: #NRProTip There are enough obstacles to overcome in life. Don't make yourself one of them.

@nrizwanu: #NRProTip If a spot opens at the last minute, you should probably grab it.

@nrizwanu: #NRProTip Hard to believe, but Jerry Springer was right all along: be good to yourselves, and each other!

@nrizwanu: #NRProTip If you hope to one day be a published author, try marrying one who lets you have your own chapter.

A word about the In-Laws

All my life I tried to image what the family I would marry into would be like. I pictured big family gatherings, the kind I had growing up where all the grown-ups sat around drinking tea while the kids got up to no good. Needless to say that when I met the Rizwanullahs, I got all that and more. Mama and Baba (Muhammad and Nasrin Rizwanullah) are two of the kindest, most easy-going parents I've met. While we all expected a little inter-family friction owing to the religious differences in our upbringing, I am happy to report that I've had zero issues with my new fam jam. Also, I ended up with two hysterical brothers-in-law, Razi and Asif, who crack me up constantly, and a beautiful sister-in-law Nameera (high-five Jaa!). I wear the 'bhabhi-ni' tag I was given by Asif with great pride.

. .

THE RIZWANULLAHS

When we came to know Malini as our son's fiancée, we did not know about her incredible journey which made her famous with the household name MissMalini. Her move to Mumbai at quite an early age away from her parents, her various media/entertainment careers that led to the establishment of her own blogging enterprise is an amazing journey and very inspiring for women not only in India but internationally. After Malini and Nowshad got married, we had more insight into MissMalini. When Nowshad left his job, and joined Malini in a joint venture, we were not sure whether it was a good move for him to leave the job. But the more we come to know about their enterprise, the more we are convinced that they are doing something creative, which they enjoy and has been quite successful in engaging a team of

some 30-40 talented young people in a range of promotional and media activities. We hope their hard work will bring them more fame and fortune.

. .

Blog #05: Oh, The Drama!

My first real brush with 'celebrity' probably happened in the second year of my A Levels back in 1998 at The British School. I was somehow selected to direct the school's entry for Youthquake, an inter-school competition that everyone took *extremely* seriously.

Our theme that year for the play was 'Wrong Number', and while all the other schools went with the classic cross-connection-telephone-call plot, I decided to switch it up and make the play about a series of blind dates that go 'wrong' until the lead – played by a delicious-looking boy named Jamal – exits stage left head-over-heels in love with a decidedly gay waiter played by Sushant Mukherjee (my global diplobrat twin whom you've heard all about in another blog).

Oh, and guess who else was in my play? Soha Ali Khan! I think I was her very first director and, at one point during the musical interlude (since I was clearly already thinking Bollywood), I tried to teach her the '*Ole Ole*' move and said, 'Do what Saif does na in the song!' Only to realize moments later that he was her elder brother! #Awkward.

On a side note, I don't know if you know this, but Soha was a champ at softball and once took a speeding not-so-softball to the face. I remember seeing her looking at her bloody nose in the bathroom mirror and being impressed with how well she handled the whole thing. #TheBraveAndTheBeautiful Anyway,

I guess the whole avant-garde homosexual love-theme played nicely with the judges and we won second place (clearly a little *too* avant-garde for some of the judges to give us first) but Jamal – bless his chiselled abs – won best actor. He planted a kiss on my forehead on his way to collect his trophy and that was reward enough for me! I must admit here that I used a few cheap 'sexual innuendo' jokes for comic effect in the play and thus I kinda get movies like *Grand Masti*. But Indra Kumar, sometimes you just take it too far.

. .

SOHA ALI KHAN
Actress

I have known MissMalini from way back when she was just Malini, a confident teenager in high school where she was my senior by a whisker. I am so proud to see her huge success over the past few years from a modest hobby blogger in 2008 to heading up a massive company and helming a fun show! Hers is an enviable story of hard work, talent and perseverance, which makes her an inspiration to so many young entrepreneurs – what a long way to come from chasing down celebrities to having them chase after you!

. .

That was probably the first time the school dean – a slightly Cruella de Vil character in my life – acknowledged that perhaps there was hope for me after all and I had finally found my 'niche'. (I'm not allowed to name CDV in this book because my publisher says so, but it'll suffice to say her name sounded a bit like Chicken Tikka.) Well good call, Mrs T, just look at me now!

This was also about the time I had started writing long, emotional essays about the books in our syllabus that nobody else in my four-person English A Levels class really cared about – like *The Death of The Heart* by Elizabeth Bowen. Yup, exactly as grim as the title would have you believe. It had angst, it had pain, it had drama and it also had (a little bit of) hope. I loved it because it reminded me of all the over-the-top emo Bollywood movies I'd seen as a child.

*It's important to know that two things shaped my knowledge and love for Bollywood at an early age:

1. My mother insisted I learn how to understand, speak, read and write Hindi.
2. In the IFS, they had a pretty deft entertainment distribution system where every few weeks or so, we received VHS tapes of the latest film releases. These were rotated among the foreign-service community, based on popularity, two tapes at a time. Every month we got to watch 2 'A' grade movies, 2 'B' and 2 'C'. As to who oversaw the movie rankings back then? I don't know, but I'm sure tomorrow's *Humshakals 15* or *Housefull 22* would have barely made a C! Anyway, as a result, I had watched pretty much every film known to Bollywood from the ages seven to seventeen. I won't lie, my absolute favourites were the reincarnation ones, *'Mere Karan Arjun aayenge!'* Hence my utter dismay decades later when 'Karan' (Salman Khan) and 'Arjun' (Shah Rukh Khan) fell out Katrina's birthday party. *#Nahinnnn*

MissMalini ✔ @MissMalini

@MissMalini: #MMProTip There is no greater classroom than the world and no better teacher than travel.

@MissMalini: #MMProTip The most important thing you'll ever learn in school is who you're not.

@MissMalini: #MMProTip It's ok to be a nerd. In fact, it's awesome. You'll have plenty of time to do all the frivolous things you missed some day and you'll relish them more!

@MissMalini: #MMProTip People might laugh at you because you're different, but you're having the last laugh because that means *they're* just the same as everybody else.

@MissMalini: #MMProTip You never forget the moment Salman Khan exposed his bare chest on a Bollywood screen for the first time (yup, he even waxed it!) #OOJaaneJaana

Blog #06: Life 2.0: Me, Reloaded.

Moving swiftly along, I joined Aamir Raza Husain's theatre company and acted and danced in plays like *My Fair Lady*. Here, I met Kamini (Khanna) Aunty, whom I have since fondly watched in an 'amicable aunty' mode in several 'family films' like *Kal Ho Naa Ho, Monsoon Wedding* and *Chalte Chalte*. For some reason, she took a shine to me and put me in the front row of dancers and even recommended me for parts.

For a couple of those theatre years I dated a boy who called himself 'Elvis' (he had sideburns) and he was the reason I got my first gig as an emcee. What happened was that he was going to try out for the job of a host for a college activity for Pepsi and I just tagged along for fun. I ended up getting the gig and my #PaidToTalk career (a hashtag I'm momentarily borrowing from my pal Kubra Sait) was on its way.

I first started emceeing small events for Pepsi at various colleges (we made Rs 500 a day back then) and standing

uncomfortably next to the new Cielo (again a pronunciation nightmare for some) or the latest Honda Civic for 8 hours with information pamphlets, in questionably short dresses and velvet chokers. Now before you get the wrong idea, we were just ushers at the Pragati Maidan trade fairs with a minimal pay hike to Rs 700 a day. My one odd memory from working there was at lunchtime, when one of the girls I was ushering with sat down at lunch with her tiffin box and said to herself, 'Okay, I'm still hungry, I should stop eating now.' I found it peculiar, but an interesting diet strategy nonetheless.

Priya Sachdev along with her sister Charu Sachdev was also a batch junior to me in Soha's class at The British School. She was on the path to fashionista avenue straight from class 11. #BestHighSchoolWardrobeEver It was funny, they dressed like the cast of *Mean Girls* but they were very nice.

Most of high school was spent in the senior common room 'faffing' as we used to call it, at theatre rehearsals and jumping the fence at the far end of the football field to get off campus and hit up Bengali Market or Malcha Marg or go eat momos at Chanakyapuri. We were even as bold as to drink beer out of steel glasses on occasion! Real badass stuff as you can see. My BFF at the time, Tina, who is now a fabulous news anchor and sports journalist, dated a famous cricketer once and I asked her what THAT was like and she said, 'Like a perpetual state of having a giddy head rush; fun, exciting and almost too much to handle.' I wish I could tell you whom she dated but I'm just going to have to ZZZZZzzzzip it!

The *real* test of my global heart, however, came in college. Since The British School results only come out in August. I had to either wait and waste a year to get into Uni or join Maitreyi

Devi, an all-girls' college, where the principal was willing to understand my predicament and let me join in good faith. Maitreyi it was. No one told me what being in a fully female environment felt like, and especially one that was slap bang opposite what was considered the 'coolest' all girls' campus in town – Jesus & Mary College.

Hence came the biggest culture shock I have ever had in my life! I'm not going to get into details here, but let's just say it was rough going initially. I was back on the honour-roll, though, since I had *just* studied every single one of the same books in the course during my A Levels and had T.S. Eliot coming out of my ears! Except this time...

In the room the women come and go
Talking of...Shah Rukh Khan.

For some reason, I just couldn't relate to any of the girls in my class and neither could they with me. Instead, I made all my friends smoking furiously behind my college (sorry, mom) and a girl called Natasha Vohra became my best friend. She inadvertently changed my whole life one day by being my reason to visit Bombay and falling head-over-heels in love with the city. In fact, I remember we used to eat pastries at a little restaurant called 'Favorite' under a flyover in Delhi and made grand plans of moving to Bombay together one day. We'd talk about having a cool little apartment together and experiencing the world – just like in the movies. Nikki, it's you and me and a much overdue viewing of *Andaz Apna Apna* by the way. 'UNCLE KAUN!' (Tweet me peeps @MissMalini if anyone got that reference!)

NATASHA VOHRA

Here's my advice for the future: You've made a lot of incredible friends on your journey thus far, people who love and care about you. But there will be plenty of people who will love to hate you. Don't ever let them get you down! Just watch out for them, don't be gullible. Also, write more! Keep writing! And then write some more. You've always had a way with words, use it. Don't let go of the incredible person I knew so well.

Love you always.

I also remember gingerly making my way to the college canteen for a bread pakoda and overhearing some girl on the payphone saying how she's going to meet her 'BF at Narula's for an HCF'. That's Boyfriend and Hot Chocolate Fudge, the second-most popular thing on their menu along with the pizza which was essentially pizza bread, cheese and ketchup. Yum!

Once on the bus to college, I overheard two girls from my class having a pretty loud conversation about something and when girl A repeated what girl B had just said, girl B said, '*Toh maine kya France main bolo tha?*' Yup *France*. Because we're definitely not in Kansas anymore, Toto!

I'll tell you this though; the great thing about being an extrovert at the 'underdog' college is that you get to do *everything* you want. Like be part of the fashion team (yup all 5'3' of me), dance in the school performing arts team (THAT I was good at) and be part of a girl gang you name the 'Spice Girls' and nobody's gonna judge. In fact, we even won an intercollege fashion show one year at IIT Flames. I remember this being a *huge* deal as well.

Here's a side story with a message from a more evolved me: Fashion has indeed played a large part in my world. After college, my first brush with the heady hustle-bustle of backstage life happened behind the scenes at Lakmé Fashion Week. Over the years, Indian designers have let me into their hearts and green rooms, revealing their true passion for clothes while telling umpteen stories on the runway. The amount of time, planning and effort that goes into each show is truly staggering.

I have never claimed to be an expert on fashion (which is why I have, over time, cultivated a team of style ninjas who truly know their stuff) but over the years I have learnt that fashion is what you make of it. There are no definite rights or wrongs, just as there are no absolute truths in any creative endeavour. I have been dazzled by the grandeur of shows that involved elaborate sets like J.J. Valaya's cruise liner or Rohit Bal's stunning flower garden and captivated by the soundtrack of Manish Arora's neon parade. I've even been showered in rose petals along with the entire audience at a Manish Malhotra show. And as I inched my way to a coveted seat on the front row, I have learnt a very important lesson and one I would love to share with you.

J.J. VALAYA
Fashion Designer

Malini Agarwal to me is the scriptwriter of the fairy tale that proves that dreams can be made into reality if one has the conviction. When her blogging met Bollywood, it gave birth to a magical forest in which reside many mystical beings widely worshipped by most Indians. Well done, Malini, for creating your fantastic experience for star-struck mortals and for bringing Indians worldwide much closer to their icons!

People, journalists and especially fashion bloggers often seem to feel that the only way to sound legitimate about fashion is to criticize it. I'm not saying you should love everything you see, but there is a very crucial difference between saying 'It's a terrible collection', or 'It just didn't appeal to me'. As influencers, I feel that is our responsibility. I remember one instance when I was sitting next to a newspaper journalist, who before the show quipped that the designer we were about to watch, always did the same thing every time and should try something new. But immediately after the show said, 'She should just stick to what she knows.' Paradox much? I felt compelled to point this out, much to her surprise and possibly added to her confusion when she asked my name and I turned out to be the designer's namesake!

You know, my previous head stylist and life coach, Marvin D'Souza, once told me something useful about fashion. He said, 'Look around, look at people, look at what they're wearing. Think about what stood out to you and why. Make a mental note of that every time it happens and voila there's style!'

To me fashion is an unabashed expression of your personality and what makes you feel good. Albeit what makes you feel good may not always be comfortable. I once told my first assistant blogger, Sue Castellino, at Fashion Week, 'I really love these shoes but they aren't so comfortable.' To which she replied, 'Malini, it's fashion! I can't feel my toes!'

Going back to my original story (as you can see I often digress! #subplot). I was participating in our college choreography for some inter-college competition where we were doing a kind of 'terrorist versus the good guys' interpretive dance. (No prizes for guessing who I was playing!) In fact, we did the plain disgusting

thing of using black shoe polish on our faces once instead of actual face paint. (My beauty blogger Natasha is probably having a heart-attack reading this right now.) The choreographer the college had hired for the job was Ronica Jacob with her own professional dance troupe and the original #bossbabe. After we won the competition, she invited me to join her troupe and become a professional back-up dancer. And so, overnight I became a professional dancer. #GameChanger

• •

TARUN TAHILIANI
Fashion designer

MissMalini has an exuberant curiosity and zest for all the shenanigans of style, entertainment but with a sociologist's understanding of the forces that move and shape our current society – from Bollywood to fashion and the latest that goes on in Mumbai. Being the daughter of a career diplomat, she navigates herself and her team with a dexterity of a skating champion through the perils of the chic savages that comprise society. Fun, light and always informative with a hawk's eye for the next morsel, Malini knows the next trend before it even throbs into life.

• •

I spent the next several blissful years literally dancing around the country (and the world) to every Indie pop and Punjabi song you still have stuck in your head. From '*Made in India*' to Sukhbir's '*Ho Ho Ho Ho*' and life was PERFECT.

SUKHBIR
Singer

I heard you're doing your autobiography I just wanted to wish you all the very best. My earliest memories of us working together is you dancing with me yes, and you are one of the nicest people that I know. Here's wishing you all the very best and I hope that everything goes well and positive for you. So looking forward to us working together in the near future. All the best and all I can say to you is keep positive and keep singing: *'Oh ho ho ho. Oh ho ho ho. Oh ho ho ho. Oh ho ishq tera tadapave!'*

MissMalini ✓ @MissMalini
@MissMalini: #MMProTip Change is good. Even if it scares the crap out of you at first!

@MissMalini: #MMProTip There's no such thing as a job too small. (Just beware the uniforms!)

@MissMalini: #MMProTip Nurture your hobbies. They're just as valuable as any of your classes in school.

@MissMalini: #MMProTip When you meet a #bossylady, you'll know it.

@MissMalini: #MMProTip Sukhbir is one of the nicest people you'll EVER work with.

Blog #07: Dance, Dance Revolution!

Now, bear in mind that all through these years I had survived on about Rs 50-100 a day through college. Bus fair and the daily should-I-splurge-on-a-Pepsi-or-stick-to-the-chai-and-a-bread-pakoda (those things are deadly delicious by the way!) dilemma. Basically, never having enough money to afford both. The highlight of my year tended to be a trip to the Maurya

Sheraton lobby to see their Christmas tree and eat a chocolate pastry worth Rs 400.

So, the prospect of being paid Rs 2,000 a show doing something I *loved* was just about the bee's knees. (I've never understood that expression by the way. Do bees have knees? And, even if they do, what's so amazing about them?)

Anyway, thus began my career as a professional back-up dancer with Ronica Jacob and The Planets. 'Planets' because there were nine people in the troupe when they started and Pluto hadn't been demoted and then reinstated yet. It was 1998 and '*Chhaiyya Chhaiyya*' was all the rage, but the very first choreography I ever learnt was serendipitously set to the song '*Back to Life*' by Soul II Soul. I think I might even still remember most of the routine. I don't know if you know this, but most dance troupes have a system of 'che-poing' aka 'pasting' choreography. That means if the beats match, you can perform the same steps to multiple songs and I think we've done the '*Back to Life*' moves to some awesome ones – like Prabhudeva's '*Muqabala*'!

Let me just say upfront that I must thank my mom for being my #1 fan throughout my dancing career. She'd always sit in the first row with her handy-cam *every single time* and film only me. LOL. When we'd play back the tapes, it would be '*bas meri beti!*' and the rest of the troupe with their heads cut off! She also did the quintessential, 'Do you want to see Malini's dance?' whenever anyone came over, but I won't lie – I secretly kinda liked it.

I think I danced for a total of six years (and on and off, once I moved to Bombay). I used to wear oversized cargo pants and imitation Doc Martin shoes, spaghetti or as we used to call them,

'noodle strap' tops, and absolutely LOVED my 'job'. We would rehearse in Rajouri Garden at Ronica's house almost every day for about 6 hours, sometimes six days a week before a big gig. And I would drive to and from rehearsal from Mayur Vihar where we lived, about an hour each way in my little blue Maruti 800 which we had named 'Basanti'. (Even though *technically* she should have been called Dhanno, yes I know.) I remember thinking back then that I never *ever* want to stop dancing and was always afraid that someday I would have to give it up. There used to be an MTV VJ Ruby back in the day who on TV said how much she missed her dancing days. I always remembered hoping I would never have to give up mine.

And before I got Basanti, we used to hitchhike to and from dance/theatre practice on local trucks. Um, ya. Death-wish much? I guess back then it wasn't a totally unheard-of thing to do in Delhi, but probably risky nonetheless. Sorry, mom!

I remember dancing at things like the MTV Pepsi Dance Connections and some less cooler, but still fun events like Panasonic road shows. (*Literally* six of us dancing in front of a small Panasonic tempo full of TVs on display driving all around the country!) I even met one of my favourite people through dancing – Gaurav Kapur the VJ, anchor, host and actor when he was still a seedha-saadha-looking boy in a powder-blue shirt buttoned right up to his top button and regulation hair! He was the emcee and we were the dancers for a Hero Honda bike event, which we had to end with a flourish on top of the bikes while he encouraged the audience to give us a thundering applause! #Hilarious.

There are SO many crazy memories I have of my dancing days that I don't even know if I'm going to get them in the right

order, but since I consider my dancing years one long dreamy ride, I suppose chronology doesn't matter. Here are a few of my favourite and some, let's just say *peculiar* things about being a professional dancer.

One of the artists we performed behind frequently was Penaz Masani. Essentially a ghazal singer but with the occasional pop ballad to keep things interesting. She had the biggest perm I've ever seen and took us to some awesome places like Khajuraho, Varanasi and Pathankot – places that I would probably *never* have made it to myself. We danced for Daler Mehendi, Anamika, Shibani Kashyap, Shaan, Mika Singh, the works! But by far the most epic performer we danced behind has to be Sukhbir. Off-stage he's this unassuming, soft-spoken guy but once he got on he had the entire wedding community jumping up in ecstasy as he belted out his fan favourites. One of which – '*Ishq Tera Tadpave*' – has come back with a rad remix bang in the movie *Hindi Medium* seventeen *years* since he first sung it. The same number of years since I first moved to Bombay leaving behind that dance routine to pursue *my* Bollywood dream.

I have danced at my fair share of weddings with the man (oh, yes I have)! And one of his class moves was to toss his signature sunglasses into the crowd at some point during the performance. Only I think he would swap his lucky pair for another one just before he went on stage to do his last set! Sukhbir even took us to Pakistan – my first time there – and it blew my mind. Inside, off the streets, in these luxurious opulent houses, the hijabs would come off and the cocktails would flow. I must say, the Pakistani people are some of the warmest, most fun hosts I have ever come across in my LIFE. They spoke elegant Urdu and asked excitedly about Bollywood. Ah, the universal language of love – BOLLYWOOD.

#Meow

When I first started dancing I didn't know what to expect on overnight train rides (no one was flying us anywhere back then) and I got the shock of my life when we boarded a 49-hour journey to Cochin from Delhi with four people and only two berths confirmed. *49 hours.* That's TWO WHOLE DAYS on a train. Of course, that meant I immediately burst into tears and one of the boys in the troupe, Sanjeev, who played the violin amazingly well, serenaded the ticket collector with his favourite Bollywood songs for 2 hours to get me a sleeper bunk!

The reason we had gone to Cochin was to perform for the *'Catwalk'* lady who greeted us there with open arms, big hugs and Rs 1,000 in cash each to make up for our treacherous journey. Which you would of course assume was a bonus for making the trek, right? *Wrong.* She promptly deducted it from our Rs 2,000 paycheque post the gig and I have never listened to her music since. (Well, not unless I was paid to anyway!)

#Video Killed The Radio Star

A couple of epic highlights of my dancing career were the Channel [v] awards, when we swaggered around backstage like a couple of badasses with Shaggy, The Spice Girls and Peter Andre. In fact, after a technical rehearsal of *'Mysterious Girl'* (at which I might have clapped a *little* too loudly), Peter Andre hopped off stage and kissed my cheek! (To put that into context for the millennials, at the time it was just a shade shy of Justin Beiber doing the exact same thing! Yeah, something like that.) I also remember going up to Channel [v]'s VJ Trey and stupidly asking him, 'Where is Muriel?' to which he politely smiled and said, 'Muriel couldn't make it today.' Muriel FYI was a small,

stuffed, purple male dragon he had as a sidekick on his show. At the time, I thought it was a purple hippo, regardless a rather odd thing to inquire given that it wasn't real. Not my finest work.

At any rate, by that time I had seen all these super-cool VJs like Trey, Meghna Reddy and Sophiya Haque. I had all but decided that THIS is what I wanted to be when I grew up. A Video Jockey. *A VJ!* So, I auditioned. I remember I wore a green and yellow tie-dye print spaghetti top, blue jeans, hoop earrings and a ponytail and tried my best to sound as easy-breezy as *they* always did. I never got a call back after my audition but I did see the director's notes and next to my name he had written 'interesting – something there'. I was happy about that. I was interesting; there was something there. Yippee!

#OnAirShenanigans

Next, I tried my luck at the non-visual medium of the same name. I went to All India Radio to audition to be an 'RJ'. I stood in line for 45 minutes, filled in my form and went in for a voice test another 45 minutes later. The lady behind the glass asked me to 'Please stop rolling the "R"s'. I had no idea what that meant and that was the end of that audition. Many years later as a radio jockey in Mumbai I remember someone sending in a message asking, 'Has a plane to New York flown over the radio station? Why does the RJ have an accent?' I mean, you have to admit that was funny and to be honest it cracked me up too, so I gave whoever it was a shout-out and played them '*I'm Leaving on a Jet Plane*'. Kanika C. had taken all the bite out of accent-ridicule back in Class 7. I could finally laugh at myself.

#BrownEyedGirl

One New Year's Eve, we were performing in a farm house up in Delhi and the fog was *so* thick the audience couldn't see the dancers and we couldn't see the stage. We spent the finale slipping and sliding on stage to a Shibani Kashyap song, laughing our asses off. My brother Deepak was the emcee for that gig and no one could see him either. Not even his hat.

You know I always think of Shibani fondly for two reasons; 1.) Her *song 'Ho Gayi Hai Mohabbat Tumse'* which is still one of my favourites (right up there with Lucky Ali's '*O Sanam*') and 2.) Because she once put on one of her coloured contact lenses backwards and looked like she had one green and one purple eye (like a vixen cat!) She was so amused by this she giggled herself all the way back to the green room. I like that she's never changed. Not one bit.

Blog #08: That first dot

Around this time, the whole dot.com buzz had begun and my mother (very sweetly) suggested I get a 'real job'. The first 'desk job' I got was at the now defunct web portal, as they were then called, MyUsha.com, which aimed to provide city listings, reviews, things to do – that sort of thing – and needed writers. I swaggered in wearing my cargo pants, boots and a strappy top (raising multiple corporate eyebrows). I got the job though and spent my mornings writing random lifestyle tips and trends and evenings and weekends at dance practice.

I discovered the social messaging app ICQ (meant to sound like 'I Seek You') and made friends with a boy whose handle

was 'WildThing' (mine was no better, 'ABabeCalledManzil') and contrary to all odds, *didn't* end up chopped into little pieces under his mattress when I decided it was probably a *great* idea to meet this total stranger in person. Karan Chopra, as it turns out, wasn't a homicidal maniac (or at least a dormant one) and KC and I proceeded to become best friends. His father ran a small cosmetics brand called My Fair Lady, which is why KC would often turn up smelling of lilacs or with purple fingers from having messed around in the lab too much. For one birthday, he made me my very own nail polish! We used to hang out and read out loud parts from *Asterix & Obelix* to each other for fun.

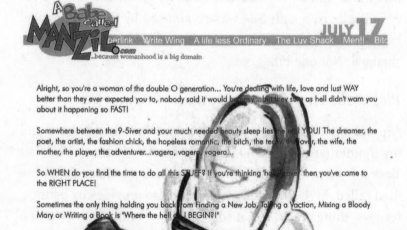

A Babe called MANZIL .com
...because womanhood is a big domain

...berlink Write Wing A life less Ordinary The Luv Shack Men!! Bitc

JULY 17

Alright, so you're a woman of the double O generation... You're dealing with life, love and lust WAY better than they ever expected you to, nobody said it would be easy... but they sure as hell didn't warn you about it happening so FAST!

Somewhere between the 9-5iver and your much needed beauty sleep lies the real YOU! The dreamer, the poet, the artist, the fashion chick, the hopeless romantic, the bitch, the techy, the lover, the wife, the mother, the player, the adventurer...vagera, vagera, vagera...

So WHEN do you find the time to do all this STUFF? If you're thinking 'however' then you've come to the RIGHT PLACE!

Sometimes the only thing holding you back from Finding a New Job, Taking a Vaction, Mixing a Bloody Mary or Writing a Book is "Where the hell do I BEGIN?!"

Supposing there was a place you could FIND out...

WHAT'S the Manzil or, more appropriately, Who's the Manzil... well that! It doesn't really matter where you're going, it's all about how you get there. As cliched as it sounds, you gotta remember happiness isn't a destination it's a journey.

...like you don't need money ... like you've never been hurt and DANCE, like no one is watching!!

Ababecalledmanzil

*Just a little stolen wisdom, but wisdom all the same ;-)

There you go, KC. Now the WORLD knows and you're welcome. #FifthElementZorgLove

A Babe?...Called Manzil?! You ask. Yes, of course you would. Funny story. *In fact*, you would currently have been reading the biography of the world's first Indian internet billionaire had I not broken up with my graphic designer boyfriend at an inopportune time! *A Babe Called Manzil* was my first idea for a website (I didn't know the word blog back then, nobody did) but it was going to be a one-stop shop with everything you needed to know about life, romance, sex, humour, pop culture and style. Umm...sound familiar? This was sometime back in the year 2000. Yup, 6 YEARS before BuzzFeed came to life. I even have the plans to prove it if you'd like to take a peek!

But then, you know, boyfriend drama. Haha. He was the tech and design support behind the project, so when we split I left with the plans on paper and the ideas in my head and stored them away for a rainy day, a day that would come 8 years later.

Meanwhile, I was still *obsessively* listening to the radio at the time and Hirshi Kay used to have a dial-in show for requests where you could call in and leave a voice mail with a song you wanted to hear and maybe the next day he'd play it. One night I asked for Paula Abdul's '*Rush Rush*' with some dorky message about looking for 'the one' and he played it. The next night I managed to hit record on my tape deck just in time to hear Hrishi Kay say, 'SO many people called in, in response to Malini's message,' and he had chosen one fellow Mohit's message to play for me in response today. Mohit it seems had decided to share his phone number on the air and asked me to call him if I got the message, which I thought was marvellous. Of course, I called. I said I'm Malini from

the radio and asked to speak with Mohit to which he said, 'Listen, I'm sick of getting prank calls, I've been getting them all day, please stop.' I was surprised because this part had never occurred to me. I hesitated and said, 'But this really IS Malini.' He was quiet for a little while and then said, 'Well, if it's really you, call back next week.' I can't remember now if I gave him my number or I did in fact call back the following week, but long story short we became friends and then later pen-pals when he went to study in Australia. He would send me long letters and Kodak-printed photos of his travels. It was all very sweet.

Blog #09: Bombay Dreaming.

It was 1999 and we were now getting to the turn of the century; the millennium was calling my name. I had no idea where it was calling from though but I just knew I needed a change. So much so that I once decided to run away from home and 'make it on my own'. I made it as far as the Machaan coffee shop at the Taj Hotel in Delhi and came back home because I couldn't think of where else to go. My mother was not impressed.

That year I also branched out into making more pocket money, organizing games and activities at parties for people. Everything from the paper dance to questionably skilled salsa lessons! I remember this one time I got a gig at this rich South Delhi guy's house, where I first met Koel Puri looking absolutely ravishing doing tequila shots lying on the floor. At the end of the night, the host handed me Rs 10,000 in CASH. Elvis and I couldn't believe it. (He had volunteered to be my DJ for the night, which basically meant carrying cassette tapes and playing individual songs on a fancy double tape deck, one at a time,

often flipping over to side B for the next track!) At any rate, we split the cash 50-50 and spent Rs 1,700 celebrating that night at Machaan!

By this time the BFF I had told you about, Nikki, had already upped and moved to Bombay and I decided to use some of my new-found savings to visit her for a weekend. I got off the plane and instantly fell in love. I mean I'd been to Bombay once or twice before with the troupe (and gone shopping furiously at Fashion Street) and occasionally come to emcee a gig or two for ESPN, but this time I was here for no reason at all and had all the time in the weekend to take it all in. I remember landing at night and it was drizzling and the air was cool but friendly. The neon lights flashed past my black and yellow Fiat with the windows rolled all the way down (something you can never accomplish in an Ambassador taxi in Delhi, mind you) and the rain made the whole visual almost movie-like.

I should probably tell you up front, *or rather should have*, that I live my life in the movies. I have in fact in my possession a checklist of twenty-four things I want to do in my life before I die that are all directly inspired from scenes in a movie. (Not-even-joking-a-little-bit.) If you like, you can see my list at the end of this book, I've put in the customary check boxes just in case you want to use my list for yourself. Do let me know how it goes! You can follow my updated checklist on MissMalini.

So, Bombay and I met properly for the very first time and immediately became best friends. I liked everything about her. The beautiful chaos, the people, the noise, the thrills, the taste of adventure. This was as close as I was going to get to Jay Z's 'Empire State of Mind' and in just 48 hours I had made up my mind that I was coming back here. For good.

MissMalini ✔ @MissMalini
@MissMalini: #MMProTip Moms are the best cheerleaders in the world.

@MissMalini: #MMProTip Never give out your phone number on the radio.

@MissMalini: #MMProTip Somewhere in the world there's a city with your name on its heart.

@MissMalini: #MMProTip Your bucket list doesn't *just* have to be about jumping out of planes.

@MissMalini: #MMProTip Why did the Mexican throw his wife off the cliff? Tequila! Tequila!

'In a nutshell, you will find one nut.'
– Malini Agarwal

I'd like to admit something right now. I'm a great believer in 'signs' and I feel like my life (thus far) has wrapped up really nicely in twenty-four blogs, which as you can plainly see is the reverse of 42. Coincidence? *I think not.*

At the risk of sounding fairly cuckoo I'd like you to know that I have *always* believed that the universe leaves you little *Hansel and Gretel*–style breadcrumbs along the way, to reassure you that you're on the right path. These could come in the form of uncanny coincidences, a chance meeting or even déjà vu.

Look for them, pay attention and I'm sure you'll find yours too.

SECTION 4: HOW TO BUILD A BRAND

SECTION 4. HOW TO BUILD A BRAND

I'm sure it's been swell hearing me tumble down the memory lanes of my extraordinary adventure – or at least I *think* it's been extraordinary – but now let's cut to the chase! What happens next? The 'Whodunnit?' or rather, 'How did she do it?' part of the story. People often ask me how I built my brand – or 'empire' as I like to call it. I don't mean to sound boastful, I just like the *Star Wars* feel to the word 'empire' – and this is what I have to say.

First up, I had absolutely *zero* clue that I was building a brand at the time I started. But once I did, I did it *carefully*, with all my heart and soul. And most importantly, and I cannot stress this enough, with people who believed as much in my dream as they believed that they wanted to be a part of the ride. So, remember three things before you read on:

1. Like super-YouTuber IISuperwomanII says in her book *How to Be a Bawse*, 'There are no escalators, only stairs. There is no substitute for hard work.'

2. Fill your rocket ship with a happy shiny crew that will *always* have your back and still be your fabulous front-women (or men).

3. And in the eternally wise words of Yoda, 'Do or do not. There is no try.'

Blog #25: Find Your Purpose, Find Your Soul

Ikigai – Finding Your Purpose

I recently came across this fascinating Japanese concept – Ikigai (生き甲斐) – that describes in detail how to identify your reason for being or 'purpose' in life. It maps out the key aspects of your life through passion, vocation, profession and mission: what you love doing, what you're good at doing, what you get paid to do and what the world needs. Essentially amounting to emotional, intellectual, financial and spiritual happiness, and helps you zero in on the sweet spot that should be your ultimate goal.

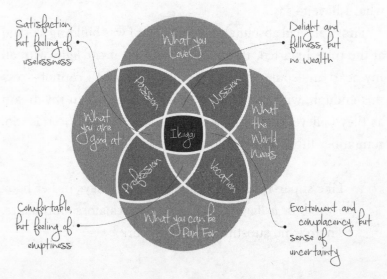

Clearly the Japanese have been thinking about this a lot longer than I have. It's brilliant, right? Try filling in the things that apply to you here and see what you come up with. But don't worry if it doesn't come to you all at once; finding your Ikigai often requires some deep and lengthy soul searching.

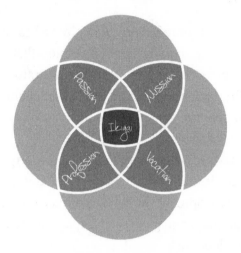

I decided to fill in mine just to see if I'm on track myself and I'm happy to report that my Ikigai is on point!

What I love: Writing, movies, the internet, the concept of 'love', socializing, inspiring

What I'm good at: Writing, coming up with ideas, hosting shows (audio and video), connecting people, communication, social media

What I get paid for: Blogging, content creation, influencer marketing, TV and radio shows

What our world needs: Positive energy, community with a cause, love and empathy – so *that's* what I need to focus my mind on next!

Side bar: Since 1978, the Japanese also have a word for 'overwork death' Karoshi (過労死) and over-work induced

suicide Guolaosi (过劳死) due to an alarming number of deaths that occur each year from depression or poor health attributed to too much work, especially the unfulfilling kind. Which ultimately means the Japanese recognize the importance of emotional happiness and job satisfaction, which go hand in hand really.

In fact, I wish more governments looked to Bhutan as well for a life lesson in happiness. It is a nation that has brilliantly evolved its focus from only creating a lucrative GDP (Gross Domestic Product) to an infinitely more satisfying GNH (Gross National Happiness) coined by the fourth king of Bhutan, King Jigme Singye Wangchuck. What a guy!

As per Oxford University's Oxford Poverty and Human Development Initiative, the concept of GNH 'implies that sustainable development should take a holistic approach towards notions of progress and give equal importance to non-economic aspects of well-being.'[1]

Now we're talking! An Ikigai for the collective human race. Anyway, there are many great examples of evolved thinking in this matter. Case in point read what internet sage Jason Silva says, 'The scientist and engineers who are building the future need the poets to make sense of it.'

But I'll try to put it as simply as I can:

Find Your Passion. Something that keeps you up at night (in a good way) or energizes you to leap out of bed every morning. Be it makeup or martial arts, parties or puppets. *Find. Your. Passion*. THAT is step one. A step that can one day become the giant leap that makes your life extraordinary.

[1] grossnationalhappiness.com; Gross National Happiness Survey, 2010

In case you don't quite know what your passion is, here's a little advice on how to find it.

'Passion exists at the intersection of three or more things you're really curious about.' – Steven Kotler, author

In his YouTube video 'How to find your passion', Jason Silva explains Steven Kotler's theory about this too. 'The first thing you should do is make a list of all the things you're curious about, all the things you wonder about; be as specific as you can. And then create kind of a Venn diagram (just like the Ikigai diagram) and try to figure out where the things that you're curious about, three or more, intersect, and that's the sweet spot. That's where there is energy, that's where there is dopamine and neurobiology, multiple streams of curiosity intersect at a place called passion. Once you've identified your passion, then you can figure out how to turn that passion into a purpose.'

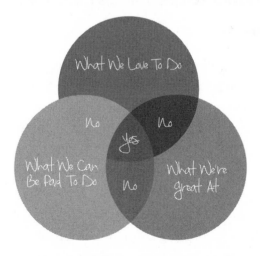

Silva even gives a step-by-step breakdown to doing this. He asks the audience to make a list of fifteen things in the world, fifteen

challenges they'd like to see solved and then figure out which one of those challenges can be served by their passion. He says this is how we'll see that multiple streams of curiosity lead to passion. Silva ends the video with a quote by Kotler: 'Identifying problems in the world that can be served by your passion leads to purpose. Then you've impregnated your life with a sense of significance, with a sense of meaning and then you can go forth.'

Which brings us back to solving your Ikigai!

Now hold on, I know you have a billion questions about this and how does one take passion to the piggy bank, etc. Hence I'd like to approach this blog in an FAQ fashion. I'll ask myself the questions that are probably going through your head and you tell me if I've missed anything. (I'll put that in my next book, or at the very least my next blog!) Ready? #HereWeGo #MissionPassion

Q. Fine, I have passion! But how do I make that my *profession*?

A. Mind the Gap.

The key to transforming passion into a pay cheque is honing your skills and figuring out a USP (Unique Selling Proposition), aka what makes you and your brand or business unique. You clearly have a passion for something, which means you take a deep and meaningful interest in it. Now think about what you could *add* to it that would improve the experience for everyone else who has a passion for it? What 'gap' could *you* fill?

I'll give you the example of my favourite macaroon queen in the city. After graduating from Le Cordon Bleu in Paris, Pooja Dhingra started a classic French patisserie called Le 15 in Mumbai in 2010. She's not the first one to ever open a pastry shop or offer delicious cakes made to order BUT she's found her niche

by focusing her aesthetic on style and simplicity. Everything about her packaging and the Le 15 experience oozes French sophistication. She has gone from being a home baker to an entrepreneur, made it to *Forbes India*'s prestigious 30 under 30 list, written two cookbooks and opened five of her own patisseries in the city! All because she followed her passion. Exciting, isn't it?

Mumbai's most reputable chef, Chef Kelvin Cheung, has this to say about her, 'I'm very lucky to call Pooja a friend and co-collaborator. She's an absolute powerhouse when it comes to business and I'm always in awe of how she's found a way to make her passion for pastry into a multifaceted, international business. There's truly no one like Pooja. She's fearless, focused and never settles. If she has a goal or idea, she will not just complete it. She will crush it! I think what makes her stand out is her heart. Everything she does is with kindness and that shows in her work, from macaroons to books. Pooja and Le 15 are truly made with love.'

When I asked Pooja what it took to make *her* passion a successful profession, this was her answer, 'When I moved back from Paris there was a big gap in the pastry industry. There was no standalone store focusing on French style dessert and there was no attention to detail. It almost felt like every restaurant had the same chef because all that was available was Black Forest, brownies and cheesecake! I fell in love with macaroons in Paris and my intention was to introduce them to the city. One piece of advice – follow your gut, only you know what you're capable of achieving!'

Q. Okay. I love food, but I can't cook! Then what?

A. Sure you can. Because you're cooking the dream!

See, the beautiful thing about having a passion is that you don't have to be the one who does *everything* yourself. Perhaps you love South Indian food and want to open the most magnificent dosa joint your city has ever seen. Now, learn everything there is to learn about the business, use *your skills* to build a brand, find the right mentors and team and plug into your passion as the captain of your ship! Starting a business doesn't always mean that you *must* be the CEO. I chose to be the creative director of my business and have Nowshad be the CEO and Mike the CRO based on our most powerful skill sets, but that doesn't make me any less of a boss lady now, does it?

Like I said, think about your USP. What makes you, *you?* Having a brand identity and personality that stands out and speaks for itself will always be the ticket to your ultimate success. Never settle for being a 'me-too' entrepreneur. That means, there is a difference between being inspired by something someone has created to give it your own unique spin or just doing the exact same thing with zero heart.

Q. But what if I don't know enough to start my own business?

A. Then learn.

Nowadays the internet is available 24/7 to teach you, in unimaginable detail, *everything* you need to know about *anything*. Do your research, then do your homework. Research is knowing all the nuts and bolts of the enterprise and homework is assessing the market for it where you live.

In that process you will also discover whether you're passionate about something just as a hobby or with a far greater 'Ikigai' manner of investment!

Q. But what if my passion is something silly, like puppets?

A. First up, puppets aren't silly and neither is anything you're passionate about.

I was thrilled to discover how Apeksha Trivedi turned her love for puppets into a career. Here's her story:

'My passion for creativity led me to become an entrepreneur in puppetry despite being a post graduate in science. Being a mother, exploring creative and innovative ways of learning for my baby was my priority during his early growth years, which led me to creating puppets. Puppetry became my most favourite passionate pursuit. With my personal experiences, I decided to use puppetry in early childcare and holistic child development. I started experimenting and exploring hands-on puppetry with kids and young children in various forms. Finally, in December 2016, my own company, Duduz House: The House of Education and Recreation, came alive. Along this whole journey from nowhere to where I'm today, I have learnt that there is no passion to be found playing small, in settling for a life that is less than the one you are capable of living.'

And that's just my point – and the most exciting part about living in the twenty-first century – you can legitimately make a career out of *anything* today. Especially with the advent of social media and the vast reach of the internet, rest assured if there is something you do well, someone *will* want it and be willing to pay for it. Now it is up to you to figure out what that is!

Of course, when I went digging for more examples I used the tools of *my* profession to find my passionate tribe. Here are some fantastic stories, from my Facebook post, of those who followed their dreams.

Khushboo Gupta: I love gifting and not just gift personalized gifts. So, now I run a gift store with full back-end related to all sorts of printing and branding.

Kavita Bagga: Corporate rat turned into farm rodent! I gave up on my golden handcuffs after twenty-one years and got into organic farming and launched Kara Organics. My love for food, aversion to allopathy, an urge to give back and pangs to return to the basics were easy-enough triggers.

Rayna Jhaveri: Growing up, I was always crazy about cooking, and count the last Tarla Dalal as a family member. Now, I'm a co-host on a new US national cooking and radio show alongside a bigwig in the American home-cooking niche.

Rita Verma: I studied to become a hardcore programmer. Little did I know that I would fall in love with makeup. I love making people look great, it truly is my passion. I'm a media makeup specialist effectsartist and have worked for iTV, BBC (London) and have my own international academy coming up soon!

Rashmi Uday Singh: From income tax commisioner to foodwriter; from assessing india's largest companies and raiding filmstars to revieweing India's restaraunts. I've written India's first city restaurant guide and the first vegetarian guide to Paris. It's been a fun ride and now my vocation is my vacation.

Tom Cherian: Drinking is my passion and then I opened my bar – Ghetto.

You can feel the energy brewing, right? How's *that* for inspiration? These are just a fraction of the comments I received, and I assure you, all their journeys were riddled with the same

questions you are asking yourself today. I wish I could feature them all in this book but then I'd run out of pages. So, please visit the blog to read them all in the Lifestyle section. But they decided to jump anyway. If you were to ask them what it took, they will undoubtedly say lots of hard work and raw PASSION. Besides, everybody knows this universally true adage: 'If you do what you love, you'll never work a day in your life,' Marc Anthony.

Q. Will my 'passion profession' be sustainable? Will it be scalable?

A. Well, answer me this: How good is it? Or rather how good are you at it?

Look, sustainability and scalability go hand in hand. For instance, to create a scalable brand, *it must* be sustainable. (But that's not even the real concern here, because if you ask me, it's up to you to decide how far you want to go. To my mind, it's perfectly alright to decide that you want to run a boutique operation and not shoot for the moon.) But to have even a *sustainable* business you MUST maintain *quality*. I have witnessed so many entrepreneurs start companies with all kinds of gusto and excitement and then, as soon as they hit pay dirt, they let the reigns go and it is all over.

Unless you are continuously offering a quality experience, you will disappoint your consumer. Someone who trusted *you*, came to you and drank your Kool-aid, and left unsatisfied. Because remember, in the world of modern entrepreneurship the consumer attitude is, 'Fool me once, your bad; fool me twice, my bad.' Which means there is very little wiggle room for a sub-par product and absolutely none for insincerity.

Think about how many times you have gone back to your once-preferred restaurant or ordered something online and were dissatisfied with your experience. Suddenly your emotional rating for the brand plummets because you feel *let down* by someone you trusted. (It's basically like a giant invisible game of Uber ratings!)

So, focus all your energy on creating the best possible product and experience. Then figure out how you can keep them coming back for more. Maybe expand your first product so that it comes in different colours, flavours, shapes or sizes. Maybe it's the first item in a future collection that becomes a must-have set. Or maybe it's just one product that you find ways to distribute far and wide.

In my case, I started out with a blog covering just my adventures in Mumbai and my love for Bollywood. Sensing a growing audience interest, I branched out into regular Bollywood news, which quickly bled into celebrity fashion, beauty and lifestyle content. Before I knew it, I had a small team helping me write stories, publish on social media, and edit short videos filmed on my way-ahead-of-its-time Flip camera. What started out as a personal online journal has today grown into a multi-category, multi-format, multi-platform media and entertainment brand, with still a lot more to grow into. But it all started with my words pouring out onto a WordPress page with heartfelt stories about my experiences in the city I loved, in a uniquely relatable voice, and it grew from there.

Of course, like I said, not everything has to scale into a behemoth. And to be honest, not everything can. But if you're able to carve out a name and a niche for yourself in something, I sincerely believe it will give you the confidence, experience

Q. Okay, you've convinced *me*, but how do I convince my parents, spouse, friends, siblings, kids that I'm not crazy or stupid, or both?

A. Show them your passion, for your passion.

The tricky part here is that, especially in South Asian families, our parents have been raised to believe *that* there is nothing more important than securing a 'decent' job *that* will pay the bills for the foreseeable future. How 'happy' it makes you was never part of the equation. It just had to be a secure job that ideally fell into the doctor, lawyer, engineer or accountant bucket. But it's a new world and there are now *countless* examples of young entrepreneurs just killing it on the scene!

But first, you must warm up your nearest and dearest to the idea that you are considering following your heart, and letting that occupy *all* your mind space going forward. The best way to show them that you plan to do this responsibly, however, is to *be* practical and soundly informed. As opposed to just saying, 'Mom, Dad! I'm going to start a biryani truck!'

Talk them through your idea and get their input and advice. You'd be amazed at all the things you can learn from their experience. In fact, use them as a mini test group to see what they think about the idea before you tell them you're going to launch into something or jump ship from a secure place.

Remember, their greatest concern is for your future and how you will sustain yourself on a career path they are not familiar with. So, if you do your homework and show them some industry comps (in this case, the Bombay Food Truck perhaps?) plus your plans, in detail, they will feel a lot more comfortable and be more likely to support your ambition.

The more you show them you know, the more they will begin to believe in you. Let them ask you all the challenging questions they want to, in fact it'll be great for your business to have a good, hard look at the model and a perfect dry run for your first investor pitch!

Q. But what if I fail?

A. The fact that you tried means you didn't fail.

I firmly believe that businesses fail, people don't. Just because your company tanked it doesn't mean *you* as a person are a failure. Pick up the pieces, learn from your mistakes and move on. As the wise lyrics of '*Chumbawamba*' go, 'I get knocked down, but I get up again. You are never gonna keep me down.' (This song plays often in my head like songs tend to, as explained in the movie *Inside Out*.)

And if you're still not convinced check THIS out:

Evan Williams developed a podcasting platform called Odeo, which folded in the shadow of Apple's iTunes podcast section. He then went on to co-found Twitter.

Walt Disney was fired from a newspaper because his editor felt he lacked imagination and ideas. He went on to become the man who redefined American childhood!

Reid Hoffman created SocialNet, an online dating and social networking site that ultimately failed. He co-founded LinkedIn.

Vera Wang started out as a figure skater but failed to make the U.S. Olympic team. She was even turned down for a promotion to editor-in-chief for *Vogue* before she became a famous fashion designer.

Milton Hershey tried to start three different candy companies, all of which failed, before starting the Hershey Company that makes Hershey's chocolates, one of the most recognized chocolates in the world today.

Jeff Bezos created an online auction site that failed but he repurposed the idea that would eventually become the Amazon Marketplace.

Fred Smith got a poor grade on an assignment in school because the professor didn't think the idea would work. That idea eventually became FedEx!

Before launching The Huffington Post, Arianna Huffington had trouble getting people to read her work. Her second book was rejected by thirty-six publishers.

Jay-Z couldn't get a record label to sign him. He and his friends sold his first CD out of the boot of his car. Now he is worth $550 million as per *Forbes*.

J.K. Rowling was a single mom on welfare when she started writing her first *Harry Potter* novel. She is now an internationally renowned author for her seven-book series and became the first billionaire author in 2004!

And my favourite –

Oprah Winfrey was fired from her first job as a TV anchor for getting 'too emotionally invested' in her stories. She went on to become the undisputed queen of television talk shows and built the Harpo media empire. According to *Forbes*, she is worth $3 billion today.

Now, I know at this point you're probably wondering *'but how will I pay the bills till I take over the world?'*

And here's my solution: no one said you can only do one job at a time, right? If you're passionate about something it won't

feel like work anyway. Even two years into having started my blog, I still worked three other jobs. I had a column with the *Mid-Day*, a radio show on 94.3 Radio One five nights a week and I was the channel head for digital content at Channel [v]. All these jobs paid my bills and then some, even while the blog did not. My husband (now CEO) was also working at Nomura every day and burning the midnight oil on the blog every night. This way we both continued to learn useful skills that would be gold when we dove in full time with Mike Melli.

Think of it like this: all through school and college you pay someone to teach you things. And then, when you go out into the real world and get a job, *someone is paying you to learn!* Use that. This way you have financial security while pursuing your dreams until the time comes where you are confident that you can let everything else go and fly! No parachute required.

Also, sometimes it helps to set a goal or deadline. When I chose to do the blog full time, we decided to give it a year where I'd quit everything else and Nowshad would support us. That year has turned into a decade, and of course the business, now profitable, fully finances itself and there's been no looking back!

Footnote: Remember, there will also be passions that aren't about a fat paycheque or any paycheque at all. And that's great too. Going back to Ikigai, *what does the world need?* If you're pursuing a passion that fills in that circle, you're still winning. (But in this case, don't give up your day job!)

Q. Wait, MissMalini, what was your passion and how did you make it a career?

A. You're reading the book, aren't you? But funny you ask because it's time to cue in blog #26...

 MissMalini ✔ @MissMalini

@MissMalini: #MMProTip Your ideal purpose in life is the assimilation of what you love doing, what you're good at doing, what you get paid to do and what our world needs

@MissMalini: #MMProTip 'Passion is energy. Feel the power that comes from focusing on what excites you.' – Oprah

@MissMalini: #MMProTip There are no silly passions.

@MissMalini: #MMProTip Quality is everything.

@MissMalini: #MMProTip Start watching *Shark Tank* with your parents on a regular basis before you pitch them your 'big idea'.

@MissMalini: #MMProTip Believe in your brand and people will believe in you.

@MissMalini: #MMProTip The more human your brand feels, the more it will connect with people.

@MissMalini: #MMProTip Tell a good brand story to build a legacy.

@MissMalini: #MMProTip Be you, don't be a 'me too'.

Blog #26: Blog, What's A Blog?

Note: I may be telling you the story of how I built MissMalini Entertainment but remember, a lot of my learning applies to all kinds of enterprise; one girl's blog could be another boy's candy shop.

In 2008, chances are only a handful of people in India even knew what a blog was, and much less considered it a viable career. Even I stumbled upon the idea over a very serendipitous conversation with friends while on a trip to Dubai.

I remember distinctly standing around my friend Kanu Gupta's den, talking about random things and the topic of my *Mid-Day* gossip column came up. I was talking about how I loved doing it but the editors always chopped it down due to space constraints, which often compromised the essence of

my writing. At this point, another friend, Karan Wadhera (and clearly the *Wizard of Oz* in my case) said, 'You should start a blog!' to which I replied, 'What's a blog?' He described it as a personal online journal, or as would be in my case a 'gossip blog' akin to PerezHilton.com – a notorious international blogger who blogged celebrity gossip all the way to his own personal stardom. Little did I know that this conversation was going to change my life forever.

Karan is the kind of person who loves coming up with new ideas and is amazing at it. He's also supremely effective at getting you jazzed about it to the point that you feel like you simply must do it. And I, being an enthu-cutlet was raring to go about 5 minutes into the conversation. The first order of business – what should we call it? Taking a cue from Perez Hilton's blog, Karan suggested why not something simple, like my own name? Because we all agreed that something like BollywoodItGirl.com or MasalaBollywoodBabe.com would sound cheesy AF. So, something with 'Malini' it would be. My column had gone by the name 'Malini's Mumbai', as did my various radio shows: 'Tiger Time with Malini' (obviously sponsored by a beer company, not just for the random love of tigers) and 'Malini till Midnight'. And then it dawned on us – 'Miss' Malini was perfect! Not to mention the delightful alliteration. And so, with my brand-new moniker in place, I was all set to step into the World Wide Web with my very own 'publication' of one, to tell the stories that were a shade shy of Page 3.

Here's the original email from 1 May 2008 when Karan set up my WordPress account almost a decade ago.

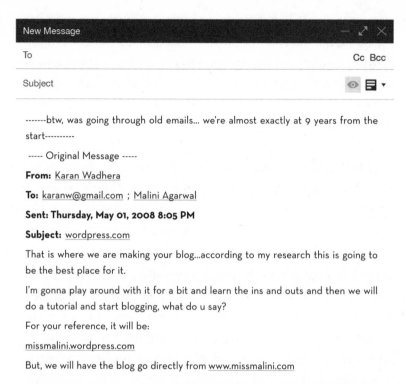

New Message

To Cc Bcc

Subject

-------btw, was going through old emails... we're almost exactly at 9 years from the start----------

----- Original Message -----

From: Karan Wadhera

To: karanw@gmail.com ; Malini Agarwal

Sent: Thursday, May 01, 2008 8:05 PM

Subject: wordpress.com

That is where we are making your blog...according to my research this is going to be the best place for it.

I'm gonna play around with it for a bit and learn the ins and outs and then we will do a tutorial and start blogging, what do u say?

For your reference, it will be:

missmalini.wordpress.com

But, we will have the blog go directly from www.missmalini.com

Send

Wow, right? Who knew? I must give mad props and a giant hug to Karan Wadhera for planting the pixel that has turned into my virtual reality.

KARAN WADHERA

The only advice I can give MissMalini is to go with your gut. This media empire has been built in large part by your intuition and creating what you felt was compelling content for your audience. I remember, when we got things going in May 2008, you were

ready to soak in all the advice, but you also knew what you did
and did not want for this 'project'. Your instincts have served you
well so make sure you continue to rely on them. This business
is so much bigger than just 'Malini,' but at the core are the
foundations and principles that you have set. Stay true to these
and congratulations!

· ·

I LOVE to write, and now that I had this exciting new place
to publish my own writing – and no editor looming over my
head – I dove into it and decided I would blog incessantly about
everything. I wrote my very first blog on 1 May 2008 at 11:30 a.m.
(it's still up there on missmalini.wordpress.com) and from then
on out, blogging became my greatest, and needless-to-say, most
satisfying addiction. I just couldn't get enough of blogging my
life away: people, Page 3 parties, a pair of shoes I just bought, a
movie that made me cry, songs that were stuck in my head. And
then one day the most wonderful thing happened. Somebody
left a comment.

I've since migrated the site and thus lost some of the
comments (boohoo) but it said something to the effect of 'Hi
Miss, nice blog. I like your shoes. Keep blogging, I like your
style.' I cannot tell you how utterly delightful that was! Someone
somewhere out there, across billions of pages on the internet
had stopped to read something I had written and found it
interesting enough to leave a comment! (I was probably also
equally delighted that people still *do* read, not just *can* read.)

The next thing that happened – almost 6 months into
blogging – truly cemented my faith in the fact that *this* is what
would bring me happiness and joy for the rest of my life. It was
a night at the Ghetto, which clearly plays a large role in the story

of my life. It had been a few weeks since I had said goodbye to my decade-long stint at Radio One and left the station for good, and I was truly blue about it. I remember the last song I had played was '*Woh Challi*' by Bombay Vikings and putting the faders up for the last time it had felt like a large piece of me, that I so enjoyed sharing with the world, was left behind on the airwaves forever. I seriously thought I'd never again find a job that brought me such exquisite joy.

Cut to, we were standing around near the bar and I got introduced to someone who asked, 'What do you do?' and I offhandedly said, 'Well, now I'm a blogger' and this girl said, 'Oh, what's your name?' and as I said, 'Malini' her face lit up as she said, 'Oh! You're THAT Malini! I love your blog.' My mind went *What? How did that happen?* And I remember feeling the exact same gush of joy and elation that I felt when someone appreciated or connected with my show on the radio. I knew this was going to be my next great love affair with entertainment.

When I started my blog, it was all about me and my own experiences, and then later it became an online 'magazine' covering Bollywood, fashion and lifestyle. But over the years it has evolved into what we aspire to be – India's most influential media network for millennials. In fact, MissMalini.com itself has grown into MissMalini Entertainment and is no longer just a blog at all. We have a full-fledged production house (Agent M Creative), a Blogger Network (Ignite), TV shows on networks like TLC (*MissMalini's World*), Zoom (*Kya Scene Hai*) and VH1 (*Inside Access* – Season 2 on air now!) and we create digital radio content for apps like Saavn (Bollywood+). Tomorrow who knows, I'm thinking, virtual reality?

But no matter what form our digital content takes, we have tried to remain true to the essence of the blog. Keep it personal, keep it relatable and err on the side of happy shiny!

Footnote: For the longest time my mom thought I was a 'celebrity internet blocker'. The logic being, that she, as a layman, gets a lot of email SPAM; hence it naturally follows that celebrities must get a lot more SPAM and so my job was probably to 'block' their SPAM. The logic is sound as much as it is hilarious, don't you think?

Now if you're ready to become an entrepreneur, I'm willing to share some secrets. Make way for MissMalini's business advice including: whom NOT to hire!

 MissMalini ✔ @MissMalini
@MissMalini: #MMProTip When you leave the office excited to come home to your hobby, it's time to make that hobby your job.

@MissMalini: #MMProTip When you've found your calling, the universe will give you a sign.

@MissMalini: #MMProTip Your blog is your voice, keep it real.

@MissMalini: #MMProTip Before you publish anything, ask yourself one brutal question – would I read this?

@MissMalini: #MMProTip All you need to connect with people is the right medium and some people.

@MissMalini: #MMProTip Multimedia is the language of today just like virtual reality will be the language of tomorrow. Communicate where you feel most comfortable.

Blog #27: The Chosen Ones aka #TeamAwesome

I have always maintained that the secret to my success has been the love and support of an increasing number of incredibly talented people. The team we have today consists of those who believe in building the best product with the most heart and that is the secret sauce to success.

I'll be honest with you – my hiring strategy is what some might call fairly 'unorthodox'. I go completely on the vibe I get in our first interaction and a large part of that has to do with the amount of energy and passion I see in the person. As a result, the running joke in the office is that I take about 5 minutes to interview and offer you a job if I like you, while the rest of management probably does a much more thorough assessment. In my defence, however, I can happily report that every single person I have hired my way has turned out to be an ace employee who gets along famously with everybody else.

For instance, I hired several of the team's first bloggers over social media alone.

My first employee, aka assistant, Sue Castellino tweeted me one day back in 2010.

Sue Ellen Castellino @SueCastellino

@MissMalini hey..your tweets have been flooding my wall! haha..great work..really love the energy and vibe you bring to your blog

Sue Ellen Castellino @SueCastellino

@MissMalini ohh, I love your life! haha any chance you need an assistant?

I replied to her saying...

MissMalini ✔ @MissMalini
@suecastellino actually I do! Are you Bombay based?

And then, one weekend I ran into her at a nightclub called Trilogy and we hit it off. And there you go. Boom. MissMalini.com's first-ever hire!

SUE CASTELLINO

Even as Malini and I both sat in her Bandra apartment typing away, I don't think either of us ever doubted the heights that MissMalini would reach. It has been a great privilege to not only be her first employee, but to also be part of her brand and her story.

In fact, Rashmi Daryanani who has been with me the longest (6+ years!) was basically hired off a tweet, a blog comment and one email. I have always called Rashmi 'the glue' at MissMalini because she has the uncanny ability to make new people comfortable and feel included from the get go and I have seen her do this time and time again. I asked her to write a note on her experience at MM for this book just for you. Over to you, @tehrashminator!

RASHMI DARYANANI
Executive Scriptwriter/Video Content Strategist

I remember the first time I met Malini, back in 2011. She was sitting on her sofa at home, a Band-Aid on her forehead from a partying-too-hard incident. This, believe it or not, was my interview for the job as a Bollywood blogger – an interview I secured after an exchange of just two tweets. I walked out of the room 10 minutes later with a then-fancy video recorder and a job.

It's been over 6 years since that job interview, and a lot has changed since then. For one, formal cover letters replaced tweets, and conference rooms replaced sofas.

I'm lucky enough to say that I was with the company since its very early stages. As such, there's a lot that I've seen: not just

the growth of the company, but also the growth of digital and social media in India overall, and its influence on Bollywood; an influence that I'm confident to say MissMalini played a part in.

When I first joined MissMalini, the scene was very different. For one, digital and social media was just becoming an acceptable medium for film promotions and reaching out to fans – there were only a few celebrities who had a digital (read: Twitter) presence, and almost all of them were there thanks to Karan Johar. Blogs were for hobbyists mainly, so film and celebrity PR reps needed to be convinced to let us attend. And once we did manage to attend, it was another battle altogether. Many of my early days were spent in media 'pits' battling photographers and cameramen from TV channels, who were very resentful of the girl who invaded their space to take video and photos on her 'mobile'. (These were the days when social media coverage hadn't yet become a thing and taking photos on your cell phone was the mark of a fan who had gate-crashed an event – not someone just doing their job.)

To be fair, a lot of my early days were peppered with fan-girl moments. It was the ultimate dream job and I was kicked to have landed it. It wasn't all fun and games, though, something that no one seemed to believe at that point. As far as anyone was concerned, I was paid to hang out with celebrities. But back then we had to do everything ourselves. While most entertainment journalists just had to attend events and then file their stories, we had to attend, record our own video, take our own photos, write, format, Photoshop, edit and upload our own videos it was a four-in-one job, and every day was a new challenge. It was stressful, but exciting.

In a few short years, we've changed four offices, and are currently in a super-cool one. We have different teams dedicated to doing the things everyone used to do individually. We play

beer pong on Fridays, and sometimes on Wednesdays if it's a particularly difficult week. For me, personally, I've switched about three different designations, and much of the fan-girling has faded over the years, except when I meet Shah Rukh Khan, but I don't think there's anything to be done about that.

But there are so many things that have remained the same: the sense of family, everyone's willingness to go above-and-beyond their call of duty, celebrating things big and small, Malini's uncanny instinct and her ability to still hire someone in 10 minutes or less, the overarching motto of 'to the moon' - constantly striving for more, no matter how much we've achieved. And, of course: the endless supply of cupcakes.

In some ways, this journey of several years feels like the journey of a lifetime. And as the company, the film industry and social media continue to grow, I can't wait to see what other journeys it takes us on, maybe even one to the moon.

. .

In fact, almost the entire Bombay Bollywood team was hired in a similar fashion. Priyam, Swagata, Divya – 5 minutes, 4 questions and shaadi pakki!* My go-to question – what is your ultimate goal? The answers have been fascinating and Shreemi I'm waiting to read *your* book next! One of my favourite stories is how I found Meriam Ahari, our director of fashion and beauty. I have a friend Puja Chand in New York, who introduced me to Meriam saying via email that she was looking for a potential editorial position in fashion and beauty at a magazine in India. Needless to say, I staged an intervention and lured her over to the digital side.

The rest as they say is history. Merm is one of the most glittering members of Team MissMalini. She has infectious energy and has – throughout my arduous book-writing journey

– chimed in 'Ooh, you should put that in your book!' whenever something cool happens at MM or when I tell her a story from my past. Thank you for the encouragement, it has been vital. May you always be this much sunshine and may all your skirts have pockets!

Side bar: I saw a movie once called *The Fish that Saved Pittsburgh* in which the coach helps a fledging basketball team by hiring people of zodiac signs that complimented each other. (The fish being Pisces.) Luckily I haven't gone that far, but being a Southpaw myself, the fact that there are several left-handed people in the office is probably no coincidence!

The thing about lefties is that we have this unspoken understanding about our own awesomeness, which we communicate silently across the room when in the presence of another left-handed person. Obviously, it sounds too obnoxious to say out loud, so there's never a 'right' time to bring it up, but if you're a southpaw, you know exactly what I mean. I recently met this awesome makeup artist who is not only a leftie, but an Allahabadi (like me), which meant that we immediately bonded for life. (Thank you Elton Fernandez for the intro.) Manjari Malik gave up a desk job at a popular TV station to pursue her love of make up a year ago and is finally living her dream. Her next stop will undoubtedly be Bollywood where she's looking to make her left-handed mark! #GottaLoveLefties

Funny thing is, I was watching a documentary on Netflix recently about the comedian Seinfeld called *Jerry Before Seinfeld* and he revealed that the first joke he ever told on stage was about being left-handed.

'I'm left-handed. Left-handed people do not lie that the word "left" is so often associated with negative things: Two left

feet, left-handed compliment, what are we having for dinner — leftovers. You go to a party, there's nobody there, where did everybody go? They left.'

I thought that was awesome. And now, just to prove my point, I feel compelled to share a list of some of the most awesome left-handed people in the world. Amitabh Bachchan, Barack Obama, Narendra Modi, Laxmi Mittal, Hugh Jackman, Sachin Tendulkar, Karan Johar, Angelina Jolie, Tom Cruise, Oprah Winfrey, Prince William, Robert De Niro, Justin Bieber, Julia Roberts, Jim Carrey, Lady Gaga, Lewis Carroll, Kurt Cobain, Michelangelo – yeah like the painter, Kermit the Frog, Marylin Monroe, Ratan Tata, Yuvraj Singh, Bill Gates; do you see my point? #LeftiesRule

But seriously, it is crucial to build a team that works well and plays even better together. Because teamwork makes the dream work! I have been fortunate enough to find people, who despite being completely unique and different from one another, embrace each other fully without judgement. And that brings me to company culture.

Over the years I have visited several large companies around the world from H&M to Gillette and been impressed by two things each time. The fact that they have an extremely well-defined set of corporate values, and that every single person in the company (down to the janitor) knows what these are. I would encourage you to define what your values are, write them down even and share them with everyone who joins your enterprise. In fact, H&M conducts an interesting exercise globally where they ask each new prospective employee to share their own personal values to see if they align well with the company's.

Here's something I always ask, 'What is your dream job, what do you ultimately want to be?' The answer to this question will not only give you a great deal of insight into the person and their level of ambition, but it will help you define a role for them at your company that should eventually pave a way for them to get there. Reason being this: *I'm living my dream, but this may not be your dream, so how about I find a job for you at my company that eventually gets you to your dream?* That way you will greatly enjoy working here knowing that you're on your way to your own ultimate destination and I will get the best possible value out of you as an employee. Everybody wins! Besides, EPIC karma points if you help somebody fulfil their life's dream, right?

I believe this also solves the problem of the 'inherently unemployable millennial', something you hear thrown around a lot these days. In fact, I saw this amazing video of Simon Sinek – a motivational speaker and marketing consultant about millennials in the workplace. (Particularly important because by 2030, millennials – people born in 1984 and after – will represent 75 per cent of the global workforce.) He addresses the question: are millennials unemployable?

In his interview, he said, 'Millennials are accused of being entitled and narcissistic, self-interested, unfocused and lazy,' which as you would imagine makes them unemployable, but then he explains how they got there.

1. '*Parents* that told their kids they could have anything they wanted, just because they wanted it.'
2. '*Social media* that is all about putting filters on things and pretending your life is amazing even when you're

depressed leading to an entire generation growing up with low self-esteem.'

3. 'They've grown up in a world of **instant gratification**. You want to buy something; you go on Amazon and it arrives the next day. You want to watch a movie, log on and watch. You want to watch a TV show, binge. You want to go on a date? Swipe right. Everything you want – instant gratification. Except, job satisfaction and strength of relationships; they are slow, meandering, uncomfortable, messy processes.'

4. 'So we're taking this amazing group of young, fantastic kids who were just dealt a bad hand and it's no fault of their own, and we put them in **corporate environments** that care more about the numbers than they do about the kids. They care more about the short-term gains than the life of this young human being.'[1]

And so, I say, ask them their dreams and they'll help you make yours come true on the way to theirs.

Personally, I must say we've been very lucky in the millennial department. The millennials of #TeamMissMalini are sharp, enthusiastic, hardworking, motivated and FUN. (Not to mention 'ridiculously good looking' – what up *Zoolander* reference!) I love that they each have such unique and entertaining personalities (I'm looking at you, Priyam).

When it comes to the pre-millennial management crew (I

1 https://www.ochen.com/transcript-of-simon-sineks-millennials-in-the-workplace-interview

think they used to call us Gen Y?) I have the most incredible business partners you could ever imagine. MissMalini.com started in 2010 in my apartment in Bandra when 'the office' was my sofa and I had one assistant blogger (Sue). Since then Mike Melli has been a founding member of the business and played the role of everything from my business manager to body guard in the years that followed, up until he took on the role of Chief Revenue Officer a few years ago. Nowshad jumped ship from his investment banking job and became the CEO in 2012, and I know for a fact the business would not be where it is today without these two crusaders.

It is hard to put into words how much I love and respect Mike for all the life he has poured into this dream to make it his own. We always said we would look back one day from a legit office on our pink sofa and see how far we've come. Now the dream is much bigger and our rocket ship that much more sparkly. I thought you would like to hear from my favourite Italian–American (who often gets mistaken for a Punjabi) on what the ride has been like for him. Over to you, Mike!

E= MCBlogged

For the last eight years, I have called Bombay my home, and I have lived here longer than any single place since childhood. In three more years, I will have lived here longer even than my birth city in Connecticut, USA. I am a Bandra boy through and through, as evidenced by my chappal to shoe ratio. There was no job waiting for me, I didn't speak Hindi, and I am not ethnically Indian, (a fact that has become harder and harder

to convince people of over the years), so it is no surprise that every single person I meet asks me some version of, 'Why did you move here and how have you stayed for so long?'

It's a hard question to answer because there is no solitary reason why this vibrant, frustrating, electrifying, maddening city, is still the only place I want to be eight years on. The complete answer for me, and I'm sure for many Mumbaikars, is a complex, non-binary, mishmash of factors that no matter how you add them all up, you just want to be here. We make it work, and we take pride in that! We work hard, play hard and cling to the hope that today's frustrations are outweighed by tomorrow's successes. We take all our personal variables and craft them into a mental formula that makes sense of it all.

The rent is high...but the nightlife is great.

The city is safe...but the infrastructure is horrendous.

Jobs options are great...but, good god, the infrastructure is so bad!

The pollution is bad...buuut it's not as bad as Delhi.

I'll be a small fish in a big pond...but there are so many interesting creatures swimming about.

And it's those interesting people that I think factors most strongly into our calculations. Of all the millions of personal variables that go into all the millions of mental formulas we craft to make sense of our lives; the most important consideration is often the people who surround us.

Enter, **Malini Ex Machina** – the marvellous variable that has brought equality to countless, seemingly unsolvable, equations.

((Bustling city * Business opportunity) / (Cost of living - friend's couch to crash)) + Malini's Mumbai = 'Mom, I'm moving to India...no I.N.D.I.A., the country.'

There tends to be one person in every friend group who brings everyone together. That one person who puts in the effort to check all the options, make all the calls and relentlessly insists that you come out, and stay out. Without that person, we would surely spend even more nights at home binge watching TV or Netflix than we do already. We love this person for getting us off our butt and filling our Facebook pages with new memories. It didn't take me long to realize that Malini was that person in Mumbai. Actually, it only took the first time I hung out with her and her friends. It was on my second visit to India in 2008.

She had this tiny studio apartment with room enough for only a few people inside, but it opened into a beautiful garden that overlooked the ocean and Haji Ali Dargah. She called everyone over to her place to pregame and since I had not yet been acquainted with IST, I was of course the first person there. We had met only once before through our mutual friend Karan, but it was at a noisy club so she didn't know me. But that doesn't matter much with Malini. She talked me up and told me all about Bombay and her life until her other friends started to arrive. There wasn't a moment of awkwardness in more than 30 minutes of talking to some random friend of a friend visiting from America who showed up at 9:00 p.m. And even after her friends started to trickle in, she kept me engaged with all the conversations and introduced me to every guest, as she did with everyone else who joined. After an hour or so there were at least fifteen people hanging out on the terrace and garden. A few people, like me, were only there visiting and didn't know anyone else, but with Malini at the helm, everyone was jiving!

Malini worked at MTV and was an RJ on the side, one person was a theatre actor, a few were producers/directors, a

few were PR/Marketing consultants, one had founded a start-up tech business, someone else was a dancer/choreographer who had her own studio, a few were singer/musicians, a fashion designer, a stylist, a photographer, and one had her own bakery and brought us all treats. What a mix! And almost everyone was working for themselves, doing their own thing. Back in my hometown, a group of fifteen people would typically be comprised of a few teachers, a few accountants, a few in sales/retail, and a few bartenders or waiters. The contrast was stark, and since it was my first time at a Bombay house party meeting real Mumbaikars, I could only assume that this was an average cross section of the city's inhabitants.

After a few rounds, and a few classic Malini ice-breaker games, everyone felt like they knew each other, and when we later went out (to the Ghetto in Breach Candy), we all had a blast. That's when I first knew there was something special about Malini. It was obvious that the thing she cared most about was making sure everyone else was having a good time and being included, and that's a special quality. A quality that manifests today in the virtual world to millions of people.

√ (Malini House Party)/*Hodgy Podgy GameGhetto) * Awesome people = Next round is on me!*

With someone like Malini as an exciting new friend, I shed any apprehensions of moving to a new city half-way around the world. Our mutual friend Karan was working on some interesting projects in the entertainment space that I was going to help with (in exchange for helping myself to his guest room), and I thought it would be a nice little adventure. Just a little break from the American corporate grind. Six months,

maybe a year, and then I would probably go back to a 'regular' job in the U.S...that was the plan.

In those first few months living in Bombay I observed there are two types of non-NRI expats (fancy terminology for white people) who come to India. The first type realizes early on that they do not want to be in India for any extended period, and many of them aspire of moving somewhere else in Asia with bigger business and luxuries, like Singapore or Hong Kong, after a short stint on the sub-continent. For this group, the problems and challenges of functioning and working in India outweigh the opportunity, and their personal equations don't add up. The second type of ~~white person~~ non-NRI expat sees India as the final destination. They face the same problems and challenges of the first group, but to them it's a small price to pay for the experience and the opportunity. Their equations add up. That's why you don't meet many foreigners who are here for a 'middle amount' of time. They're either in and out, or you're stuck with them.

I knew immediately that I was in the latter group, and I was amazed by what that meant for my life here. I fell in love with India, and I felt that India loved me right back. Due to the sheer volume of how many cool people Malini knew, my circle of friends grew exponentially in that first year. I was welcomed everywhere, and invited to three or four different outings every week. During the day, I would go on meetings looking for new opportunities, and making business contacts, and at night I would cut loose with the gang. It didn't matter that I didn't have a fancy wardrobe, or a car or a full-time job, or any semblance of dancing skills (although my sangeet game is now on point). No, in Bombay it seemed that the only thing that mattered was if you're a fun, nice person...even if you didn't know the words to all the Bollywood songs.

*f (xBollywood Song) * π - Mouthing fake lyrics / Put your hands up [x]! + Malini's encouraging smile = I think this is my new home*

By 2010, Malini's passion project – a hobby blog called MissMalini.com – had begun to amass a loyal following. People would organically share and comment on her content because there was no one else bringing a relatable, friendly voice to the world of Bollywood and entertainment, especially not in the digital space. She had social media followers way before it was cool (I remember vividly when we threw a party at Hard Rock Mumbai to celebrate reaching 1,000 Twitter followers, because that was a big accomplishment back then). She was a 'digital influencer' before the term was known to most marketers in India, and because of that influence she soon had consumer brands reaching out to her for endorsements.

Malini never liked having 'business-y' conversations, so towards the end of 2010, when there were more brands reaching out to her than she had time to respond, I asked if she would like some help. I remember before I interacted with the first brand as her representative, she laid down one rule – 'I only want to talk about brands that I like.' Her guiding principles were to put the reader first and to never compromise on our values. Putting out positive, quality content, with proper grammar, and accurate information was paramount. We would be grateful and positive with any celebrity who gives us their time, and we would work ethically with brands, on our own terms.

From day one we determined to not publish unsubstantiated rumours, and to not be intentionally mean or negative in covering any celebrities. We knew that certain rumours

or false stories could bring us millions of page views and thousands of new followers, but that was not worth journalistic integrity and we did not want to cause any celebrities duress. From day one we clearly alerted our readers whenever a brand was sponsoring content, years before the social media networks started making it compulsory. We knew that the brands would push back because maybe a few less people would read it knowing that it was sponsored, but that was not worth misleading any of our readers.

We were the first independent publisher in India to offer content marketing, so in a way we invented the market. We were in this for the long haul, and were willing to be patient. We had no problem turning down money from brands if we didn't like the content, or if they refused to disclose that it was a sponsored post. Malini's instinct was just always correct. She knew that if something rubbed her the wrong way, it would probably rub her followers the wrong way. We always did what we thought was right and fair, and whichever brands were willing to take our lead, we were happy to have them. We earned a reputation on the business side of being honest and hardworking, and a reputation with our audience of being authentic and engaging.

(400 ft2 / 5 team members *∑coconut= Welcome to MM World Headquarters

It was clear to myself, Malini, and her then-fiancé Nowshad, that there was a real business here, and that was validated by way of an early acquisition offer that Malini wisely turned down on my and Nowshad's advice in early 2011. Her conditions to turn down the deal were that I come on full

time right away, and that Nowshad would help every night after his day job until and join by the end of the year, after hopefully securing some investment money for expansion. By the second half of 2011, we were earning enough revenue to hire a small, full-time staff of bloggers, and open our first office in a little run-down building that was awaiting redevelopment. Later that year, Nowshad joined us as planned, and the three of us haven't looked back in more than six years.

In early 2012, we secured our first investment funding with a wonderful group of angel investors, and we were off to the races! No matter how big we would grow, we committed to each other that we would never cast aside our values, never stop working to build a reputable, successful, game-changing business. Over time we could attract amazing young talent, and train them to work in the restless world of content marketing. We even attracted one not-so-young, amazing talent, Sujal Shah, to become our fourth partner and guide us operationally (just kidding, Suj!). He is an industry veteran with a wide network of contacts, and with him on our side, along with the group of young rock stars who had joined the team, the business grew to new heights.

As an entrepreneur, it can be hard to remember all the old milestones and accomplishments in your business, because new goals and targets are constantly being set. But some stand out. I remember the first time we organized a big event, our first professional photo shoot, the first time we got partnership status at fashion week, each time we moved into a bigger office, the first time we pitched a TV show idea, the first time we watched our own TV show on air, the first time we closed a 1 crore deal, the first time we produced an ad film, the first time we won a major industry award for content marketing, the

times we crossed 500K, and 1 million, and 2 million followers on our different social media pages, all the times Sujal drilled 'process, process, process!' into our heads to help us mature as managers and leaders. A dozen things out of ten thousand are what stand out after almost seven years in business, but every step along the way we did what all of us do, we just tried to make it all add up. We made the equation work.

$$T + L + C - NDTV \pm Zoom / 3 \text{ sponsors} - \text{Kickass Director friend} = \textit{MissMalini's World, Season 1}$$

If we had to lose a little money to make a great video, we did it. If Malini needed to make an extra appearance so someone else would make an appearance for us, we did it. If we had to creatively figure out a barter arrangement so that our logo would appear somewhere, we did it. We knew we would never compromise on our values, but everything else was on the table as we swam through the ocean that is Bombay (sometimes literally during monsoon season).

So, for anyone who is an aspiring content creator here's my advice – be relentless, be passionate, do what you feel is right and fair no matter what, and most importantly, find your **Malini Ex Machina**. Find people that make you feel better about yourself and who appreciate you, and take their help to solve all your tricky equations. Forty employees, eight years, five business visas, four offices, two rounds of investment funding, one wife, and one adopted puppy later, and it hasn't failed me yet. I found my home here, I found my career calling here, and I fell in love with my wife Sanskruti, the only woman in my life more instrumental to my happiness than Malini (okay maybe our puppy daughter, Zelda, too).

Don't get me wrong, it's not going to be all peaches and sunshine. If you stick your neck out to do something great, you're going to be beat up along the way...that much is inevitable. You can plan out your life and your career all you want, but as the inimitable Mike Tyson once said, 'Everybody has a plan 'till you get punched in the face.' It will happen more than once, maybe even when you're at your lowest point when everything feels like it's crashing down, but you can get through it. You will come to see that our failures teach us more than our successes, and that nothing can stop the power of positivity + passion + work ethic. With this outlook, you can get yourself to anywhere you want to be, even the moon.

Loving wife + puppy + Malini and Nowshad + the best content team ever = Happy Life

And on a final note on teamwork, here's who NOT to hire.

1. Anyone who bitches about their previous employer.
2. Anyone who thinks they have nothing left to learn.
3. Anyone who says, 'That's not my job.'

MissMalini ✔ @MissMalini

@MissMalini: #MMProTip Find your core crew on the platforms where you want to create content.

@MissMalini: #MMProTip Twitter can be the world's quickest job (Tw)interview!

@MissMalini: #MMProTip Find out what someone's dream is before you give them a job.

@MissMalini: #MMProTip Millennials with passion will rule the world one day.

@MissMalini: #MMProTip Never say, 'That's not my job.'

@MissMalini: #MMProTip Start off small and then expand; just like the universe.

Blog #28: #OverheardAtWork

I cannot stress enough the value of listening. Richard Branson rightly said, 'Listen more than you talk. Nobody learned anything by hearing themselves speak.'

One of my favourite things to do is to sit around the office and listen to what people are talking about. The hilarious thing about doing this at the MM HQ is that you will often hear conversations like these:

When discussing a meme

Rashmi: Give me a literal translation of these lyrics, '*Honthon pe aisi bat mai dabaake chali aayi, khul jaaye wohi bat toh, duhaai hai duhaai.*'

Shreemi: I have such a big secret in my mouth that if I tell anyone it will be a duhaai. So, it's just at the tip of my tongue.

Rashmi: What does Ned Stark have to do with it? *five-second pause* Oooohhhhh! It's like when you first start reading *Harry Potter* and say Dumbledore is your favourite character.

When prepping for a shoot

Meriam: Does anyone have earrings I can borrow for a shoot right now? Like big earrings?

Shreemi: No, but I have big ears.

When discussing typos

Blogger A: I almost wrote 'celebrity spitting' instead of 'celebrity spotting'!

Blogger B: Well, I just wrote 'whore wore' instead of 'who wore'.

Extracurricular Activities

Ambika: Anyone interested in trying a pole dancing class?

Divya: We should have a pole in the office.

Harshad: We already do!

During server maintenance

Nowshad: Server maintenance is happening today, so there will be no new posts going up after 4 p.m. Please submit everything that needs to be posted by 3 p.m.

2 mins later

Nowshad: No exceptions will be made even if Shahid Kapoor is spotted at Gloria Jeans with his shirt off.

Community

Blogger A: I'm dancing to '*Daru Desi*' at a Gujrati wedding.

Blogger B: I'm Gujrati and I've never been to a Falguni Pathak concert.

Blogger C: I'm sorry, I'm SINDHI, I'm supposed to know my diamonds.

Twitter Goals

Blogger A: Your new Twitter profile picture is hot. You'll get lots of rishtas now.

Blogger B: I don't want rishtas; I want followers!

Vocabulary

Blogger A: I don't know what adjectives I'll have to pull out of my hat to describe these clothes.

Blogger B: Look at her nose! It looks like she sharpened it with a pencil sharper.

The one about Mamata Kulkarni

Priyam: Can I please do a blog about Mamata Kulkarni detained for drug trafficking?

Malini: Yes.

Marvin: Mamata Kulkarni is that same chath pe soya tha chick, right?

Rashmi: Right!
5 minutes later

Priyam: What! Mamata Kulkarni was married to a drug lord?! *Bas mein hi reh gayi hoon, kunwari.*

The KRK offer

Priyam: Malini, Kamal R. Khan tweeted you!

Malini: Oh, God, now what?

Rashmi: The Sonakshi Sinha smack down post, of course!

Malini: Ah.

Rashmi: I think this means he's going to take back his offer to cast you in his movie *Deshdrohi 2*.

Malini: Bummer

Salman Khan's Hair

Anushka: I'm doing a post on how middle partings are THE hot, new hair trend.

Rashmi: I hate middle partings, they suck.

Anushka: But everyone is doing it!

Swagata: Salman Khan in *Tere Naam* did it.

Shreemi: Make sure you mention that Salman Khan was way ahead of his time.

Online Shopping

Anushka: Presents!

Marvin: Presents or shopping?

Anushka: It's like I'm getting myself a present

Mike: It's not 'like' that, it's exactly what it is.

Anushka: Presents!

Obscure Bollywood References

Pocket Stylist: *Khaa le bete.*

Swags: *Mein kaunsa gamla bhar ke khaa rahin hoon!*

Pocket Stylist: *Gamla nahin,* vase. #K3GReference

Things You Thought You'd Never Say

Nowshad: *to Shreemi* You'll need to learn Photoshop if the quality of your hearts on Paint aren't good enough.

Priyam: Did you ever think you would say that sentence out loud?

Astute Observation

Blogger A: I always believe, the smaller the star, the bigger the ego.

Grammar Goals

MissMalini: Every time I use a semi-colon, I think of you Rashmi.

Rashmi: That is the nicest compliment anyone could ever give me.

Shreemi: Every time I see something weird on the internet, I always think of you Rashmi.

Rashmi: That's also a great compliment.

Impatience

MissMalini: Did you ever want to be a teacher?

Anonymous: I don't have the patience for it. I like judging people, not teaching people.

Bigg Jokes

Swagata: This year the *Bigg Boss* house is filled with randos.

Rashmi: As opposed to?

This happens on a daily basis, I kid you not. Just come and be a fly on the wall at my office for a day and you'll not only hear a ton of gossip – 80 per cent of which we can never blog about – but you'll be massively entertained by the motley crew of adorable nut-jobs on the team. Which brings me back to listening.

The reason I brought this up is because as an entrepreneur of any kind, listening is going to be your biggest asset. Here are a few ways to improve your listening skills:

1. Give the other person your full attention and maintain eye contact, let your body language communicate your interest.
2. Encourage the speaker with nods and affirmations so they know you are paying attention. When appropriate, smile.
3. Rephrase and repeat their remakes when they are done speaking to ensure you understood correctly.
4. Stay focused on listening without starting to think of your response. If you are formulating a response in your mind, you stop listening actively and you may miss important information.
5. Resist the urge to interrupt. When the speaker finishes or pauses, ask questions or make comments.

Effective listening enhances the quality of your communication. It encourages optimism and team participation. You make better more informed decisions when you listen. Effective listening is directly related to our ability to do team work. And get this, we listen at about an efficiency rate of 25 percent maximum, and we remember only about 50 percent of what is delivered during a ten-minute speech/lecture/communication.[1]

Here's something else I found interesting. The reason for poor listening is because we think faster than the other person can speak. Most of us speak about 125 words a minute but the

1 managementstudyguide.com

mental capacity to understand someone speaking is 400 words per minute! So, when we listen to the average speaker, we are only using 25 per cent of out mental capacity, leaving 75 per cent unused, and so our minds wander.[1]

If you're the one doing most of the talking in your meetings, it's time to change that. I'll be honest with you, it's something I struggle with myself. But over the years, I have realized that a lot of the time I was talking to show people how much I thought I knew and for validation. Now, I try to listen more and talk less. (Unless I'm in the room pitching my brand, then it's a different story!) Remember: you will always have chances to share your opinions and thoughts. What you might not get again is the opportunity to listen to someone saying something fantastic.

Martin Zwilling, a leading start-up advisor, puts it best: 'Listen as though the other person is about to reveal a great secret or the winning lottery number and you will hear it only once.'

MissMalini ✓ @MissMalini

@MissMalini: #MMProTip If there is one communication skill you should aim to master, then listening it is.

@MissMalini: #MMProTip Very often listening is more important than speaking.

@MissMalini: #MMProTip There is a difference between listening and waiting for your turn to speak.

@MissMalini: #MMProTip Learn how to become an 'active listener'.

@MissMalini: #MMProTip There's never a dull moment at the Team MissMalini HQ!

1 extension.missouri.edu

Blog #29: How People Give Me Gossip.

'Ask me no questions, I'll tell you no lies.' – Oliver Goldsmith

Okay, let's be honest here, you were waiting for this one, weren't you? I know how it is. It's just like any birthday party, dinner or even IT conference I go to. 'Soooo, give me some gossip!' Go read my blog, you freeloader, haha. I'm not standing here asking you for free software, am I? I'm kidding. I've never thought about it that way. Until NOW.

But the truth is the gossip I've received (the really juicy stuff) has always come to me in the most curious ways.

Years ago, when I had just started doing my blog full-time, I went to dinner with Nowshad and his college friend who was visiting from the US. Although he grew up in India, this friend doesn't look very Indian because he has a foreign parent (this is integral to the story, and I'll tell why you in a second). So, we're sitting at a restaurant called Blue Frog in Bombay, and about 45 minutes in, this friend chimes in, 'Oh by the way, I have some gossip for you. I saw Katrina on my flight and she was getting cozy with some guy.' Now this was 2011. Way before the RanKat relationship was common knowledge, even though speculations were rife. I immediately dropped my fork and said, 'Oh my God, who was it?' And then I heard this story:

In-flight Access

Ranbir and Katrina were sitting in first class on a flight from Frankfurt to Mumbai. Ranbir had that 'I'm a movie star' vibe and was blocking the aisle, and my friend didn't even put it all together until he caught a glimpse of Katrina sitting in her seat.

He didn't recognize Ranbir, so he Googled Katrina to figure out who she could possibly be dating. All the international business travellers were also wondering who they were until the two started reading scripts, making it obvious there was some movie star aboard their plane. Ranbir got them both blankets to get cozy and Katrina had no makeup on until they were about to land. Eight hours of coochie-cooing convinced my friend that they were *really* into each other and voila – rumour confirmed! But imagine the odds.

My friend happened to be on the same flight in the *same* row. He doesn't look very desi, so they probably didn't take him for a potential informant to a celebrity blogger. And had we not met for dinner, I would never have heard this story.

This was the blog that cemented MissMalini as a place to confirm celebrity gossip. Bam! Thank you, Bollywood gossip *Hunger Games*, may the odds be ever in my favour!

An Apple a Day

One night I was on a flight back from Delhi and sitting uncomfortably in the middle seat with my headphones on, grouchy and tired when the lady at the window seat next to me tapped my arm. At this point I was not interested in making small talk, but took off my headphones and tried to be polite. She asked me what I did because she had noticed the cover of my laptop with my MissMalini anime and 'Exclusive' pasted across the front. I explained that I was a celebrity blogger and she proceeded to tell me this story.

She had been working at the Taj Lands End for many years and a yesteryear superstar would often come there to work out. (I had heard this before so nodded.) Then she said, 'Nobody

knows this but when actress-ji goes into the spa, no one else is allowed inside and she always leaves with a few hand-towels and free apples.' What? First off, I didn't know you had apples in your spa, but I guess that's not the point. I found it oddly endearing that this Bollywood diva was a hand-towel klepto. Harmless and so humanizing at the same time. I lost that lady's business card but I wish I could tell her that was one of my all-time favourite stories.

Village Privileges

Another time I was sitting at a salon and overheard a conversation about how a recently 'it' couple (who couldn't be seen canoodling in public because one of them is spoken for) would often get the doors of a quaint little restaurant in Pali Village opened at 4 a.m. to meet for a romantic dinner now and again. I should spend more time in salons. People there know *everything*.

Tricks of The Trade

But here's how you can get your gossip even if none of the above ever happen to you. When it comes to Bollywood, the people to grease are maids, drivers, watchman, bartenders even – who (within reason) are happy to keep you clued in to the goings and comings of the celebrities they service.

The other golden network that exists are the photographers who are forever on the prowl for celebrities from airport to residence, and somehow know before anyone else does who's going to be where and exactly what time. For us, it's the power of networking at a higher level with PR, publicists, movie promoters and the celebrities themselves. Plus, the fact that

we keep it happy shiny makes it easier for the stars to trust us without worrying about guerrilla verbal attack just for a controversial headline.

Social media has also become a very useful place to gather gossip. You can tell a lot by doing just a little detective work about who un-followed whom and the often-cryptic tweets and Instagram posts of the lovelorn. Celebrity fan clubs are so good at this in fact that they often beat us to the chase! Like the time Ranveer Singh liked Deepika Padukone's Instagram picture, the #DeepVeer fanatics were all over that. Here are a few more times social media spelt out some celebrity love–hate stories for us...

The time Deepika Padukone commented with a heart on Ranveer Singh's photo. Awww.

When after the great nepotism debate Karan Johar tweeted, 'Dear talent...I wish you would stay away from overconfidence and delusion...they are constantly conspiring against you...don't you see it?'

Anushka Sharma and Virat Kohli un-followed each other on Twitter after they broke up.

Arbaaz Khan's rumoured girlfriend (since his separation from Malaika Arora Khan) Alexandra Camelia shared a sketch of a couple, presumably of her and Arbaaz on her Instagram with the caption, 'One year ago. Too beautiful not to post. Stars aligned and heavens opened...for one moment. #skybound #differenthug #youhadmeathello #lovemelikeyoudo.'

Hrithik Roshan's tweet about dating the Pope was taken as a snarky retort to the Kangana–Hrithik drama that unfolded over their affair. Unfortunately, this tweet caused its own little religious furore on the internet and he then tweeted an apology.

KRK's multiple Twitter wars trolling celebrities. Top of mind are

the times Bollywood stars have slammed him for making lewd comments about fellow actresses. Sidharth Malhotra lashed out at Kamaal R. Khan when he made a nasty remark about Alia Bhatt's bikini picture from her joint magazine photo shoot with him. Sonakshi Sinha's KRK takedown when he started rating Bollywood actress by their bottoms, proving to the world yet again who the real ass is.

Rumours about Farhan Akhtar and Shraddha Kapoor's romance when she shared a picture of clouds with the caption, 'Up above the world so high! #AirplaneView #Magical #WhenItsJustYouAndTheClouds' and Farhan commented with a smile and kiss emoji saying, 'Oh give me a parachute and push me out...hehehe...'

Sonam Kapoor's boyfriend (rumoured at the time) posted a Will Smith meme on Instagram that said '50 bucks I could take 25 women out to dinner!' on which Sonam commented, 'Which women?' and some fun banter with some of their friends ensued.

Rangoli Ranaut supported her sister by calling out everyone who spoke against Kangana on Twitter, including Aditya Pancholi and Zarina Wahab. When Aditya said that he was the one who gave Kangana her first break, Rangoli tweeted that he should use his contacts to give work to his jobless children too. She also had a Twitter war with KRK (who hasn't!) and he tweeted about her acid attack. She called him a crow in return.

Rishi Kapoor has been in the news because of his Twitter feed too. First, for a posting an inappropriate 'meme' which had a naked child in it (an FIR was filed). Next, when Rishi defended nepotism and dynasties in every industry in India. A woman made a meme ridiculing him about Ranbir getting multiple movies despite his flops to which Rishi direct messaged her saying, 'f*ck you bitch.' Yikes!

Lisa Haydon's Instagram account is full of pictures that documented her whirlwind romance with Dino Lalvani. But she even went on to announce her engagement with a picture and the caption, 'Gonna marry him.'

So, what have you learnt from me then? To keep your ears open, your shutterbugs close and your social media active! #GossipGirl

Also, if you have an appetite for social media drama then there are two things you simply MUST watch. A movie called *Ingrid Goes West* about a realistic portrayal of Instagram obsession, which is the truth of our times. And a Netflix show called *Black Mirror*. Every episode blew my mind because Charlie Brooker explores the manipulative power of technology all the way to the dark side and back.

PS. Do you know why it's called *Black Mirror*? Because when your phone is on sleep mode it looks like – yup – a BLACK MIRROR! #Boom

MissMalini ✔ @MissMalini
@MissMalini: #MMProTip A good gossip blogger is an even better social media detective!

@MissMalini: #MMProTip Don't believe everything they tweet.

@MissMalini: #MMProTip When someone trolls Bollywood, Bollywood trolls back.

@MissMalini: #MMProTip A Bollywood diva stealing apples makes me think of the movie *Snow White*. What an epic evil queen she'd make. I'd watch that.

Blog #30: The A-Z of DigitalEntrepreneurship

What's next? The A-Z of brand building – in my virtual playground. Maybe one day they'll publish this instead of the 'A – for Apple' version and hand them out to little internet prodigies everywhere. (Hmm. Shall we discuss a #geekchic pop-up book perhaps, HarperCollins?)

A Is for Apple (Macintosh)

When it comes to tools of the trade, I could simply not function without my legion of Apple products. To be honest, when I started blogging I was a Windows user and thought I'd never switch. But it's so true what they say; once you go Mac, you can NEVER go back. I find the MacBook Pro interface and software intuitive. It even allowed me to teach myself how to edit my own videos on iMovies for the first few years of my blogging career. (Plus, I find that little magnetic 'click' sound that my computer makes when I plug in my charger oddly satisfying.)

But now that we're here, lets learn a little something from the late Steve Jobs (CEO and co-founder of Apple Inc.) Here are two of my favourite quotes by Mr Jobs and what they have taught me.

1. 'Be a yardstick of quality. Some people aren't used to an environment where excellence is expected.'

 Now, take a moment to think about this. As the leader of your troops, it is up to you to consistently reiterate the importance of quality and the pursuit of excellence. Nobody but you can do that job.

2. 'Innovation distinguishes between a leader and a follower.'

Yet again. Mind the gap. Think differently. Don't be a me-to entrepreneur. Take the time and make the effort to find your identity and what it stands for. Then shape your brand message accordingly. It is the only way you will stand out in the crowd.

I know I've said this before and I'll say it again. There is no business without passion and there is no passion without heart. You simply MUST be rock solid in your belief and intent when building your brand and all its assets. And eventually, heart boils down to identity. Who are you really? What are your values, what matters most and how do you ensure that everything you do (whether at work or at play) reflects that in some significant way? I know that is a tough question to answer so try this:

When I went to the Malaysia Social Media Week back in 2014, I came across a fascinating and beautifully simple way to identify your core values. Or as Evan Carmichael, a Canadian entrepreneur and author, described it – your one-word bio. He said identify the one word that you find in common between the books you love, the movies you watch, songs you listen to, companies you admire, friendships you nurture and even the quotes that inspire you. That is your bio. That is your heart. And once you know where your heart is, you can use that filter to shape your brand, apply it to your campaigns and even tailor all your social media messaging to reflect who you are, leaving no risk of sounding insincere or all over the place.

No prizes for guessing that the word I came up with was 'Love'. I hope it shows.

PS. Did you know that the frequency of love is 538 Hertz? I learnt this at a design forum in the band Bhavishyavani's

Backyard (also architect Ashiesh Shah and Tejas Mangeshkar's then office). I was astounded by Nandita Kumar's installation called 'Notes from Nowhere Land', which showed the concept that broadcasting the right frequency can help open your heart, prompt peace and hasten healing.

> *'We now know the love signal, 528 Hertz, is among the six core creative frequencies of the universe because math doesn't lie, the geometry of physical reality universally reflects this music.'* – Dr Horowitz[1]

Amazing.

B is for Blogging

In the online Oxford dictionary a blog is described as: A regularly updated website or web page, typically one run by an individual or small group, that is written in an informal or conversational style.' Several other descriptions I found online went like this:

- Blogs generally represent the personality of the author or reflect the purpose of the website that hosts the blog.

- A blog (a truncation of the expression web-log) is a discussion or informational website published on the World Wide Web consisting of discrete, often informal diary-style text entries (posts).

- Blog definition, a website containing a writer or group of writers' own experiences, observations, opinions, etc.

1 churchofthecosmos.wordpress.com

- A blog, or weblog, is often a mixture of what is happening in a person's life and what is happening on the Web, a kind of hybrid diary/guide site.

- Definition of blog: A website, similar to an online journal, that includes chronological entries made by individuals.

If you notice, all these definitions have one thing in common; they say a blog is informal, personal, conversational and a collection of the writer's own experiences, observations and opinions. A blog therefore must have a personality, and ideally that personality should be yours.

If you ask me what it takes to write a successful blog, I'd say the most important thing is to be real. It doesn't matter what you're blogging about as long as it is evident that you are blogging with interest and passion and not just for the sake of putting something up. I always ask myself this question when I write a blog. Would I read this? And if the answer is a lukewarm 'maybe', I scrap it and start over.

There's a great Hollywood movie called *Julie & Julia* about a blogger who documents her trials and tribulations of ploughing through a French cookbook as she blogs about her experiences of recreating all 524 recipes in it. I loved how she used the blog to share her experience, and often her frustration, with empathetic strangers across the globe who were following her journey with a great deal of camaraderie and support. That's an amazing example of how one blog can bring together so many people over a common interest – their love for food. And probably the healthiest form of voyeurism!

C is for Competition

I'm often asked, 'How do you feel about all the competition that's coming up in blogging?' And my answer is always the same – 'It's great. That means we've paved the way for an actual industry where one previously didn't exist.' I mean, think about it, if I was the only blogger in India, what could the potential for blogging as a career in our country ever become? The more bloggers there are the bigger the industry. The bigger the industry, the larger the advertising market. The larger the advertising market, the more chances you have of making a living by blogging.

Plus, we're all basically geeks who love to play in the same virtual playground. The fact that we're also into fashion and Bollywood just makes us #geekchic, that's all.

I think the best thing about the millennial generation is that we are finally learning how to play together nicely. Gone are the days when everyone existed in a silo and refused to even acknowledge their competition. In fact, millennials on YouTube have taken things to the next level by turning their competition into collaboration! I mean think about how often you've seen your favourite YouTubers do a TAG challenge or a video together and been thrilled to bits. Meanwhile, in the process, both are tapping into each other's audiences and thereby growing their own. It's brilliant.

Taking off from that idea, we at MissMalini Entertainment have launched our own blogger network called IGNITE. The premise of IGNITE is that 1) we want to give back to the blogging community, and now that we have the means and expertise to do so, it's time to share the love. So, bloggers who join the network have free use of our studio space, tools and training, and access

to office resources when they need it. And 2) There are so many brands out there that want to work with the top-tier bloggers in India but it's almost impossible for them to keep track of their increasing numbers, as well as the quality and reliability of their work. Not to mention the challenges of finding the perfect mix of influencers to best represent their brand. We do all that homework for them thereby bringing large-scale campaigns to bloggers in our network. The bloggers benefit financially and don't have to deal with any of the client servicing aspect themselves, and the brands get an infinitely better reach across the audiences they are trying to engage. Everybody wins! I must give credit to Mike here because this has been a true labour of love for him and we are all proud to see it finally taking shape exactly the way we always envisioned.

D is for Dopamine

Here's one for the nerds in the house. Did you know that social media engagement and action on our cell phone releases a chemical called dopamine? Simon Sinek explained, 'That's why it feels so good when you get a text. Harvard research scientists released a report in 2012, which showed that talking about yourself through social media activates a pleasure sensation in your brain that is usually associated with food, money or sex. That's why we trip on the number of likes we get and go back a hundred times to check the count. When you get the attention, you get a hit of dopamine, which feels great and which is why we keep going back for more.'

But on the flipside, he cautions of the dangers of dopamine as well, 'Dopamine is the exact same chemical that makes us feel good when we smoke, when we drink and when we gamble. In

other words, it's highly, highly addictive,' and just like any other drug has, as you can well imagine, a very unpleasant withdrawal. He says, 'The trauma for young kids to be unfriended [and I would imagine even trolled] is it too much to handle.'[1]

Now, as people and brands it is up to you and I how we leverage this social media addiction in a way that is both successful but at the same time, responsible. Remember what Spiderman said, 'With great power, comes great responsibility.' I believe we must draw a line where anything we are creating propagates hate or ridicule. This is why I am personally opposed to negative press and promoting things like fairness creams. I feel they send the wrong message to legions of our youth by manipulating their insecurities. To this day suffer people all over our country from poor self-esteem because their own mothers told them they were too dark to be beautiful. I'm not buying that.

Thus, remember to apply one more filter of moral goodness to your content and ask yourself honestly if what you are selling and how you are selling it is at the cost of someone else's sense of self-worth.

E is for Emoji

The first-ever emoji were used by Japanese mobile operators. Per Wikipedia, emoji were first used by Japanese mobile operators (of course it was the Japanese, must have been some guy's Ikigai!) The first one was created in 1999 by Shigetaka Kurita. His inspiration were weather forecasts symbols, Chinese

1 www.ochen.com/transcript-of-simon-sineks-millennials-in-the-workplace-interview

characters, street signs and manga stock symbols to express emotion. Even things like the lightbulb that signifies inspiration. Kurita created the first 180 emoji based on expressions he observed people making and other things in the city.

And if you're as old as I am you probably remember 'emoticons'. The difference being that emoticons were facial expressions made by using punctuation marks like :) and now we can do a full-toothed grin. Oh, how far we've come.

Anyway, I recently came across a cool article called 'The Psychology of Emojis'[1], which explains how emojis have taken over our communication. Apparently '74 per cent of people in the United States regularly use stickers, emoticons or emojis in their online communication sending an average of ninety-six emojis or stickers per day. If you add it up, that is about six billion emojis flying around the virtual universe every single day! Fifty per cent of all captions/comments on Instagram have one or more emojis in them.'

The article also explains how 'today emojis are doing what your tone of voice did on the telephone and what

1 thenextweb.com/insider/2015/06/23/the-psychology-of-emojis/

expressions or gestures did face-to-face. Emojis are even getting rid of internet slang. Who's saying ROFLMAO anymore, right?'

The part that struck me the most though was this, 'What's interesting is that emojis are not only changing our language, they're changing our brains! Humans, it seems, mimic each other's expressions and emotions while talking in order to build relationships. But until emojis came around that was the crucial element of communication that was missing online. There was no empathy. Or at least no way to really show it.' Scientists now say that looking at a happy-faced emoji activates the same part of the brain that it would when looking at a real human face – it changes our mood. And we weren't born this way, our brain patterns have evolved over the past few years to accommodate these new methods of visual stimulation.

According to the list of top emojis on Instagram, it is clear that it is a platform where we go to laugh, encourage, be inspired and share beautiful pictures. MailChimp decided to map the network of emojis people use together. The map shows how emojis that are near each other, when you're typing, tend to get used together more often, but there are several emojis that connect to tell visual stories like the earth, travel and planes. People often use the heart emoji along with fashion emojis and the soup emoji is often consumed alone! Cool, huh?

F is for Facebook

Probably *the* most inspiring tale of entrepreneurship of our generation. Everyone knows the Mark Zuckerberg story (and if you don't, please Netflix the movie *Social Network* tonight) but did you know that Zuckerberg is colour blind and that's why Facebook is blue?

Back in 2010, he told the *New Yorker*, 'Blue is the richest colour for me. I can see all of blue.' In a happy coincidence, it turns out this worked out great for Z because per designmantic[1], there is a reason social media sites prefer blue logos. It just so happens that blue can emit a sense of calmness, security, honesty and trust, which is useful when you want someone to sign up and give you all their personal information. (I truly feel like that was the universe giving Mark Zuckerberg a sign by the way.)

But can you even remember what life was like before Facebook? It completely revolutionized how we interact with the world and our relationships in it. (Not to mention proved to be the best birthday reminder of all time!) I'll give you the skinny on what you need to know about Facebook and all the other social media platforms for better engagement metrics in my next blog but for now, ponder this:

Millennials don't use Facebook like we used to. Heck, I don't use Facebook like we used to. I remember a time where the first thing I did every morning was try to come up with a clever 'Facebook status' that I would change several times a day.

Now I use Facebook as a magazine feed of my friends lives and a place to create a whole lot of fun-filled entertainment content. Content that is increasingly becoming video. One of my favourite things about Facebook is the Live Video feature and you've probably seen our weekly series out of the Facebook office called 'Friday's At Facebook' where either a Bollywood star or a fashion/beauty expert comes and chats live with our followers and it is heaps of fun. Other uses for Facebook:

1 designmantic.com

stalking exes (come on, admit it, we've all done it) and I must confess, requesting lives on Candy Crush. There I said it. #GuiltyAsCharged

But I came across a very interesting article[1], which explained why Facebook is good for you. Apparently, Facebook boosts your confidence. 'According to a Cornell University study, spending just 3 minutes on Facebook can make you feel better about yourself, possibly because you're able to choose the information you put out there.' Bonus: Editing your own profile during a Facebook break yields the biggest confidence boost, researchers say. Your heart rate lowers and so do your stress levels. In fact, Facebook, can even help you fight pain! A UCLA report says that people reported lower levels of pain while viewing photos of a loved one. (Remember that the next time you go to the dentist!) Facebook breaks can even boost your productivity. In a study at the University of Melbourne, workers given a 10-minute break to read Facebook were 16 percent more productive than a group that wasn't allowed to use the internet during the rest, and 40 per cent more productive than people who didn't receive a break at all. And finally, a University of Arizona study found that older adults who used Facebook experienced a 25 per cent improvement in their working memory, possibly because it requires you to process so much information – photos, status updates and comments – at once. It's a mental workout.

So, I guess Facebook is awesome.

P.S. Did you know? Facebook's 'Like' button used to be the 'Awesome' button?

Facebook engineer Andrew Bosworth explains in detail, on Quora the history of the 'Like' button. But the part I found

1 www.menshealth.com

fascinating was the fact that even though he and other engineers at Facebook were enthusiastic about the 'Awesome' button, Zuckerberg vetoed it in 2007. Facebook eventually settled on the Like, Andrew says, 'Something that got a lukewarm reception from the team at the time.'

I think it's time to re-introduce the Awesome button Mark. I think it's time.

G is for Google

I believe there are no wrong answers in life, just poor Google searches.

Google was invented on 4 September 1998 making it now young adult, but the impact it has made in its young life has been immeasurable over the years (Goodbye Encyclopaedia Britannica). Everyone is familiar with the term 'Google it' and the search engine is the single most-visited page on the internet, revolutionizing the way we browse, learn and connect with the world. Not to mention how our day-to-day lives are made so much more efficient with Gmail, Google docs, Google calendar – the list goes on and on.

David Koller from Stanford University explains the genesis of the name Google on a Stanford college web page I found and clarified the various incorrect accounts all over the internet. He says his source is, 'A colleague from Wing 3B of the Gates Computer Science Building at Stanford University, where Google was born.'

'Sean and Larry were in their office, using the whiteboard, trying to think up a good name – something that related to the indexing of an immense amount of data. Sean verbally suggested the word 'googolplex,' and Larry responded verbally

with the shortened form, 'googol' (both words refer to specific large numbers). Sean was seated at his computer terminal, so he executed a search of the internet domain name registry database to see if the newly suggested name was still available for registration and use. Sean is not an infallible speller, and he made the mistake of searching for the name spelled as 'google. com,' which he found to be available. Larry liked the name, and within hours he took the step of registering the name 'google. com' for himself and Sergey (the domain name registration record dates from 15 September 1997).'[1]

And that's how we got Google!

A serendipitous typo, isn't that all kinds of amazing?

Kind of like the 'I'm Feeling Lucky' button on Google's home page. I looked it up and according to *Phillip Remaker* a Google user since the beta days, there's a story behind that too. There was a Clint Eastwood movie called *Dirty Harry* in which the line, 'Do you feel lucky, punk?' became legendary as kind of a bold challenge if you will. The button dates back to when Google was starting out and 'I'm Feeling Lucky' was their swag way of saying we're confident about this search engine finding you *exactly* what you're looking for from the very first hit. And so 'I'm Feeling Lucky' takes you to the best result/highest ranked site. Have you tried it?

Did you know?

The name 'Google' is derived from the mathematical term 'googol' which is basically 1 with 100 zeros after it.

1 graphics.stanford.edu

No part of a Google office is allowed to be more than 150 feet away from some kind of food.

And my favourite, as part of their green initiative, Google regularly rents goats to mow the lawns of their mountain view HQ. The employees claim they find it calming to see goats outside the windows.

H is Hesitation

I'm sure you weren't expecting this word to feature in my happy, shiny vocabulary, but I wanted to share an epiphany of sorts that I had some years ago. I think we've gotten to a place where we think of brands and consumers in this very 'transactional' fashion, but I urge you to zoom out for a moment and think about *why* people buy things. People buy things to feel good, to impress their friends, to express themselves. And on the flipside, what *prevents* someone from making a purchase? The fear of ridicule for an off-trend purchase, or perhaps not knowing how to use a product, even buying something that doesn't do what it says it will. Purchase hesitation can be both frustrating and depressing for the consumer and a veritable death sentence for the brand.

Enter your digital BFFs! Someone who can be your friendly neighbourhood guide through the messy world of on and offline shopping. Where there is so much sensory overdose and so many brands trying to peddle their wares that it is almost impossible to decide. Imagine if there was someone you could turn to for the latest fashion advice, for beauty tips and tricks they have successfully tried on their own skin. Advice ranging from the best gadgets to buy to the ultimate holiday destinations to visit but all told through the voice of a

real human being. Someone who understands you and your needs and is ever so aspirational but *never* condescending. THAT is the secret sauce of influencer marketing and the cure for purchase hesitation.

I is for Instagram

Ah, the window into the world of the lives everybody wants you to think they're living! But I love Instagram. I feel a sense of community and adventure whenever I log in. In fact, I often think about how it's almost a waking inception of sorts. A dream within a dream? I'll start browsing a friends feed, click into another life from there and before you know it, I'm 9 lives deep! (Sometimes watching cute cat videos by the end of it, which I admittedly find oddly calming.)

But the story of Instagram is no less inspiring. On 6 October 2010, Kevin Systrom and Mike Krieger launched their photo-sharing app. Just two years later they sold it to Facebook for $1 billion dollars along with its thirteen employees.

Now how about I uncharacteristically give you a few statistics that you might find very useful in your own pursuit of tweaking your Instagram strategy and everybody's favourite word – monetization. But mostly fun facts that I thought were just plain cool.

1. Eighty per cent of Instagram users are outside the US.
2. Most Instagram users are between the ages of 18-29.
3. Twenty-six per cent of Instagram users make more than $75,000 per year that's almost 49 lakhs a year!
4. Of the 600 million (and counting) Instagram users 400 million are active every day.

5. Sixty per cent of the top brands on Instagram use the same filter on every post

6. The most popular filters are Clarendon, Gingham and Juno/Lark.

7. Instagram posts with at least one hashtag average 12.6 per cent more engagement than those without.

8. Posts that include another handle gain 56 per cent more engagement.

9. #Love is the most popular hashtag and the most used emoji (remember E is for Emoji?) is the heart <3.

10. The most widely Instagrammed food is – you guessed it – PIZZA! Right above steak and sushi.

11. The world record of most Instagram followers within 12 hours of opening an account is held by Pope Francis who took half a day to get one million followers (eat your heart out, Kim Kardashian).

12. The first Instagram post with the hashtag #selfie was posted on 27 January 2011 by Jennifer Lee.

13. Kendall Jenner's Instagram posts are currently valued between $125,000 and $300,000 for a single post! (Between 50 lakhs to over one crore).

14. Instagram photos featuring faces get 32 per cent more likes.

15. Facebook has the right to sell your Instagram photos to third-party advertisement agencies.

And you'll love this:

16. Elliot Tebele (@fuckjerry – named while watching *Seinfeld*) makes a living purely by reposting pictures to Instagram. (I bet you want that job, right?)

J is for Job Satisfaction

Roshan Abbas has a great concept he shared at a panel we were on together for Insight Storm where he said every company should have a CFO – Chief Fun Officer! Someone who is constantly in charge of making sure the employees in your company are having enough fun. I think that's brilliant and I encourage you to hire one immediately. Especially in the day and age of the millennial worker, company culture plays a huge role. Even I can tell you for a fact that three of my employees returned to the company for this reason alone (and I'm never letting them go)!

Whether you're working for someone or people are working for you, the things that give everyone a sense of genuine joy and contentment at the workplace are pretty much the same. I urge you to both look for these in your work and enable others to find them in theirs.

1. *Respect, praise, and appreciation.* I cannot stress enough the value of positive reinforcement. We are all quick to criticize or blow up when mistakes are made, but are we as fast to recognize accomplishments and celebrate even the smaller victories? Unfortunately, this tends to get overlooked. Make it a point to 'high-five' your co-workers for a job well done. At MissMalini, we even have a special chat group on Slack called 'high-fives', purely for this purpose. The impact a little appreciation for hard work will make will multiply exponentially and drive others to follow suit and work harder. Plus, if you do it on a public chat group you get the added kick of dopamine for full effect.

2. *Motivation.* For people to feel charged about a dream, you need to take the time to remind them what that dream is. Do it and do it often. Whenever there is a new development in company growth or expansion plans share those with your team so they feel energized and part of the plan. This is also a great time to ask for input and suggestions and bank ideas for future growth.

3. *A creative workspace.* In the age of the millennial this is an extremely compelling factor. People spend 8-10 hours of their day at the office. Do not make them sit facing a wall! Gone are the days of the office cubicle cutting people off from personal interaction and putting them in an invisible cubicle cage. Drop the barriers, try to have an open plan, malleable office space that lets people walk around when they need a break. There will be times in this environment where getting a little peace and quiet to think alone becomes tricky, but try to have enough quiet corners where people can retire for solo time when needed. (I swear team, I'm working on it!)

4. *Developing skill and potential.* One of the things I always try to do is understand what an employee's ultimate dream goal is. Is it to write a book? Make a movie? Become a badass CEO or something just as passionate? As I've said before, once you understand someone's motivation you can help them hone the skills they need to reach their full potential. Chances are that on the road to their passion they will light up your way. Very often it could even be about nurturing a hobby that excites them (shout-out to my travel-grammers, I'm excited @thetrippintoes!) and you will see boundless energy emitting from them which will find its ways in to everything they do.

5. *KRAs (key responsibility areas).* In an age where we have invented all sorts of new job roles and titles it can become a little hazy what an employee's actual job *is*. This can lead to a lot of dissatisfaction and confusion. Assigning KRAs gives you and them a concise picture, of not only what is expected of them but also a clear understanding of their goals. That makes it much easier to perform an annual assessment, provide feedback and decide the milestones upon which a reward or raise should be based. Creating a complimentary collective of KRAs (sorry too much alliteration there!) will also help shape the company's long term vision and road map of success.

And finally,

6. *Just ask.* You'll never know how satisfied someone is unless you ask them. No amount of corporate statistics can teach you what a one-on-one, in person conversation can. Be prepared to not always have the solution or the answer, but you'll be surprised how much difference just listening to the question can make.

K is for Knowledge

'The only true wisdom is in knowing you know nothing.'
– Socrates

While I wouldn't be as hard on yourself as Socrates suggests, I do caution you against ever assuming you know *everything* or more importantly, that you know better than everyone else. That is just simply not true.

Learning is a huge part of the entrepreneurial process. Your company's greatest asset will always be the intellectual

capabilities of your team. Again, this doesn't mean you all m͛ be a bunch of rocket scientists (although I could use one for my rocket ship to the moon, if you're looking), it means that the more ideas and knowledge that flow through your enterprise, the bigger and better the business will become.

So, learn. Learn from your team, learn from your peers, learn from your competition and learn from your mistakes. (I'll tell you mine in a blog up ahead. Oh, you better believe I've made my share of mistakes, but at least I can say I learned something from them.)

A couple of years ago I met this fascinating twenty-something Prakash Ranjan and if you were to ask me what his super power is I would say its curiosity. At such a young age, he knows so much about all sorts of things. From people to politics, @ monsterprak is a sponge. He soaks up the human experience and has taught me that *curiosity is the currency of evolution.*

There's a fascinating book by James T. Mangan called *You can Do Anything*, in which he highlights fourteen ways to acquire knowledge. Practice, ask, desire, get it from yourself, walk around it, experiment, teach, read, write, listen, observe, put in order, define and reason.

And this is my favourite part, 'There are only two kinds of experience: the experience of ourselves and the experience of others. Our own experience is slow, laboured, costly, and often hard to bear. The experience of others is a ready-made set of directions on knowledge and life. Their experience is free; we need suffer none of their hardships; we may collect on all their good deeds. All we have to do is *observe*!'

Ergo, watch and learn from everything!

L is for Leadership

Being a leader is one of the most difficult but rewarding experiences. Make it count. Over the years, I have learned that being a good leader isn't about telling everyone what to do. It's more about inspiring people with your ideas and saying, 'now follow me!' before bounding in the direction of your dreams.

I like to think of leadership for millennials as more of a Peter Pan project. They're not interested in being told what to do, they'll do it, but they won't care why they're doing it if you don't inspire them and that's no good at all. Try it this way:

1. *Practice what you preach.* If you want your team to exude positivity and enthusiasm, be the first enthu-cutlet out the door! Especially if you have a young team, they will mimic their management and follow your lead assuming it is the best way to get ahead.

2. *Be someone they admire.* It is only ever exciting to follow someone who has accomplished so much that you want to grow up to be like them.

3. *Be clear.* Be friendly with your team but make your rules and expectations crystal clear.

4. *Be open.* Be open to input, be open to feedback, be so open you don't just have an 'open door policy', don't even have a door!

5. *Be liked.* Now this is where you walk a fine line between being who you are and trying too hard. One is how you genuinely develop kinship and the other is how you end up as the boss they roll their eyes at over after-work drinks! I believe the secret to being liked as a boss is a combination of having their backs when required

and trying to having normal human interactions that you would when nurturing any real-life relationship or friendship. A lot of 'leaders' forget to be human at the workplace and end up feeling like some machine that just gives you orders and pays your bills.

Take a lesson out of Salman Khan's muscle-tee and remember it's all about Being Human.

M is for Mission

A mission and a mission statement tells everyone what is the core purpose of your organization. Why do you exist and what are you hoping to achieve?

Over the years I have learned that it is very important to have a mission statement. Whether it's for your personal resume or for the business you're planning to begin. The purpose of your mission statement is to define the 'what and why' of your business (or in the case of your resume, your personal goals), in one concise sentence that serves as an 'elevator pitch'. While it is easy to just come up with a generic throwaway sentence, I urge you to spend some time and effort putting this one together, otherwise you might find it to be useless. If done well, your mission statement could very well define your business so accurately, it could serve as an effective strategy.

When it comes to a mission statement you'd be surprised how important every word and its placement in the sentence can be, so here are a few tips on how to come up with yours.

Make sure that your mission statement answers these five questions:

1. What do I do?
2. How do I do it?
3. Who do I do it for?
4. What's my value proposition? (What value do I or my business bring?)
5. What image do I want people to have of me/my business? (What defines my character?)

PS. I love that when I was doing my research Google threw up, 'use radiant words' as one of the things to do. I love that, radiant words.

I also came across a great article by Jim Berry[1] in which he suggests a great way to test your statement once you're ready, 'Test it by asking yourself, honestly, whether your competitors could use exactly the same statement. Does it distinguish you from all other businesses? If you gave an employee or customer a blind screening test, asking them to read your mission statement and four others without identifying which is which, would they be able to tell which mission statement was yours?'

Now strike a pose and let's get to it!

Here are ours:

1. *What do we do?* Create all kinds of entertainment content.
2. *How do we do it?* Using multi-media.
3. *Who do we do it for?* The global Indian millennial.
4. *What's our value proposition?* Dynamic, high quality, trustworthy content.
5. *What image do I want people to have of me/my business?* Human, friendly and happy shiny!

1 articles.bplans.com

6. *MissMalini's Mission Statement:* Building India's most positive and dynamic millennial media network.

N is for Networking

In all my experience of being an entrepreneur, I have found the one thing that has garnered insurmountable value for my business, especially when building one in India, is network. Cultivating, nurturing and refining an ecosystem of a wide variety of people; entrepreneurs, friends, colleagues, and in my case celebrity relationships, has created immense value for MissMalini and been incredibly rewarding at a personal level.

The only way to do this though is by investing genuine heart and a whole lot of time. There is no shortcut to creating these relationships. Just like any personal connection in your life requires the values of trust and mutual respect, so do those in the business world. Take the time to get to know people at a human level, find out what inspires them; listen. Remember they're on the same ride as you are and have their own mission in life. Identifying the best way to complement each other on your mission to the moon will not only benefit both of you, but you'll be uplifting the overall energy in the universe.

In world of six billion people, there is more than enough room for everyone to grow together. And enough eyeballs and demand for products and services to go around. At least I think so! Aside from that, respect your competition. Everyone brings some value to the world and it is far better to learn from them than disregard their effort. Follow this golden rule: think of others the way you would like them to think of you.

Now, go play!

O is for Opportunity

In today's digital landscape the opportunities are endless. As I've said before, you can literally make almost *anything* you love to do into your career. I mean, you can even eat or play videos games for a living! #TrueStory

But identifying the right opportunity for yourself and continuing to evolve as you grow are equally important. Your job does not stop at picking a career. You must continue to follow the yellow brick road and in fact pave your own new path sometimes. Just look at how the opportunities online have changed and grown. A few years ago, there was no concept of 'influencer marketing', now some digital superstars are taking over the world. In some case even eclipsing traditional influencers in their wake. Who knows what tomorrow holds?

Be prepared and on the lookout for new opportunities that your brand can benefit from. Is it time to prepare yourself for the immersive world of virtual reality? Is there a new social media app bubbling up on the millennial radar that you can get to first? How do you find the densest population of your consumers and penetrate their sub-conscious? Simple. You learn to adapt to your digital ecosystem and go to where the party is. It's basically the theory of Darwinism 2.0.

> 'In the long history of humankind (and animal kind, too) those who learned to collaborate and improvise most effectively have prevailed.' – Charles Darwin

What stands out to me the most from what he said and how I believe it can be applied to the virtual world today is this: The brands and business that will survive the evolution of technology

are the ones that will learn to adapt and improvise in their ever-changing environment on and off the internet. The ones who also learn to effectively collaborate with each other will eventually rule the world.

P is for Personality

It has become abundantly clear over the last few years that having a brand personality in virtual reality is particularly key. Humanize yourself! It is so ironic that we created the 'social network' to bring the world closer together and stay connected to more people, but somewhere along the way, left our unique identities outside the web.

I say this a lot, but find the part of your brand that *feels* the most human. And try to identify the feelings you will in turn evoke from those who engage with it as a result. Are you bold, daring, imaginative, adventurous, healthy, cheerful, lovable, playful? The list goes on.

Having a brand personality makes you relatable to people. Here are a few great examples of strong and easily identifiable brand personalities (some I came up with and some from careeraddict.com), so you get what I mean:

Nike's personality is athletic.
Harley Davidson is a rebel.
Victoria's Secret is seductive and sexy.
Johnson & Johnson is soft spoken and caring.
Lego is colourful and creative.
Apple is curious and imaginative.
Porsche is a leader and confident.
The Discovery Channel is adventurous.

Business Insider is intelligent and informed.

M&Ms are fun-loving and cute.

Don't you like them more already?

I like to think of MissMalini's brand personality as friendly and optimistic. Does it show?

The single most important way to show off your personality is with your voice. The way you communicate with the people who interact with you. All your messaging on and offline, even the look and feel of your logo. Be consistent in that or you'll feel like a brand with a multiple personality disorder and that's only fun if you're Kurkure – *Tedha hai, par mera hai!*

Q is for Quality

Quality should be your number one priority. This is what will eventually cement your relationship with your consumers and make you BFFs for life. Be as diligent as you possibly can about everything you create and put out into the world.

The only way to maintain quality is to constantly evaluate and improve yourself. The hardest part of quality control comes with expansion. Make sure that the people who join your team are as obsessed with quality and consistency as you are. Only you can set the bar for this and make it a mandate for everyone on team awesome to keep a close and critical eye on this.

A few key factors that will play an important role in quality control are:

1. Benchmarks and Goals – set your priorities and expectations.

2. Process and Communication – make sure everyone is completely in sync.
3. Consistency – do it and do it well, every time.
4. Growth trajectory – be realistic about how you can scale *without* compromising on quality.
5. Feedback and Evaluation – listen and improve.

And always check your spelling!

R is for Risky Business

Let's be honest. There's always risk. But it's worth taking to live your dream, isn't it? The important thing is to be aware of the risks in your business and try to stay one step ahead of the game.

Depending on your business and the market, your risks will vary and change over time. If you are aware of both the personal and professional risks, you can evaluate your situation and often mitigate the risk before it hits you like a tornado.

I found that the best way to handle risk is by being flexible and willing to pivot when you need to. If, for instance, the risk is that you're going to be made redundant by new technology or the fact that now people are watching more videos then reading text, expand your repertoire to service their needs so you don't lose your consumers.

Google throws up a great definition of successful entrepreneurs from monster.com's career advice and it seems risk is an important part of the mix!

'*Nine characteristics of successful entrepreneurs*. Entrepreneurs are enthusiastic, optimistic and future-oriented. They believe

they'll be successful and are willing to risk their resources in pursuit of profit. They have high energy levels and are sometimes impatient.'

Sounds about right! And since I'm all about those quotable quotes, here's another.

'The biggest risk is not taking any risk...in a world that is changing really quickly, the only strategy that is guaranteed to fail is not taking risks.' – Mark Zuckerberg

You tell 'em, Mark.

S is for Snapchat

Now here's a great example of a social media platform that snuck up and took us by surprise. Snapchat was created in 2011 by a bunch of clever students at Stanford University and gave millennials a chance to send each other disappearing image and video messages. And therein lies the key.

Us older millennials (or gen Y is it?) are so used to the idea that once you post something online it is there for all eternity, that disappearing photos, lost forever, makes some of us sad (#guilty). Why make the effort to post it at all if it's gone in 10 seconds? But today the concept of disappearing content is much more alluring. I still haven't quite wrapped my head around it, but I'm guessing the rise of sexting might have had something to do with it. Throw in various bunny filters and free hand- drawing options and you've got yourself a winner. The platform received such a roaring reception by millennials that other social media giants were quick to replicate the Snapchat functionality and offer the concept of fleeting 'stories' on Facebook and Instagram too.

Can you believe this was originally part of a class project and initially named 'Picaboo'? With one sole mission – to create a selfie app for self-deleting, often explicit images with a very short shelf life. Well played Evan Spiegel, that's how you become CEO of a 30-billion-dollar company and marry a Victoria's Secret model.

Oh, Snap.

T is for Twitter

I have always amused myself with the thought that if *only* the creators of the Tweety Bird cartoon back in 1942 had *known*, the Twitter bird might well be yellow today!

I joined Twitter in 2008 and didn't use it much for almost a year when suddenly it became the central hub for virtual conversations with celebrities and as I mentioned, the very beginning of my social media career.

. .

RISHI JAITLY
Former Twitter India Head

When I first arrived in Mumbai, in 2012, to set up and expand Twitter's presence across India and Asia, job #1 was to immerse myself in people, ideas and culture. And Malini immediately stood out. In fact, she represented what I and many aspired for: entrepreneurial, fast-paced and millennial, to be sure, but also trusted, insightful and availing a natural gravitas across institutions that matter. Malini quickly became a hub for Twitter's early efforts to immerse in the Zeitgeist of India. From our earliest hotel-lobby rap sessions to her well-deserved recognition as one of India's most influential leaders, I'm so inspired by her journey.

. .

By the way, I think it's funny that Twitter was almost called 'Friendstalker' (which, let's be honest is a pretty accurate way of putting it) but Twitter management decided *that* might sound a little 'creepy'. (You think?) They also vetoed the options 'Twich', 'Twicher' and 'Jitter' before we got Twitter, because the happy bird chirping analogy seemed a lot less serial killer-ish. Did you know by the way that the blue Twitter bird also has a name? His name is Larry, named after the NBA player 'Larry Bird'.

The very first Tweet was sent on 22 March 2006 by Jack Dorsey.

And there's been no looking back since. Twitter has become the 280-character window to an epic world full of news, gossip, jokes, fan clubs, drama, death, outrage, and everything else that plagues or delights the human conscience.

There came a time in my life where before I checked my messages I would check my Twitter feed. (I just realized that was also when I had a Blackberry. Wow.) And so, for a large part, a lot of the days 'breaking news' reached me via short little virtual telegrams. But Twitter causes chaos too, especially in the form of RIP or fake death tweets. Come to think of it, 'RIP' tweets are so rampant that they cause a trending swarm within seconds of the news breaking that someone has passed away. In some cases, fake deaths have created major chaos, with Tweeters killing off everyone from Shah Rukh Khan to Barack Obama.

User Experience (UX & UI)

(If you've always wondered by the way, UX stands for User Experience and UI for User Interface.)

When it comes to any brand – digital or not, user experience is *everything*. This is also your opportunity to shine. The two most important factors of the user experience on a blog for instance,

are content and navigation. How your visitors discover and navigate your world will determine how long they spend in it. If someone is clicking through from social media, ask yourself – are there enough clear and enticing places for them to go further down the rabbit hole? Or are they likely to 'bounce' after they watch one video or read one blog?

Check, are your images the right resolution? (My number one pet peeve is skewed or pixelated images, if you can't get that right you need to go back to Photoshop 101.) Do your posts have punctuation and language errors? I mean everyone makes a typo now and again (and I BET someone's going to find one in this book and troll the F out of me for it)! But there is absolutely ZERO explanation for consciously putting extra spaces after commas and before full stops or exclamation marks! This for instance would drive me crazy and rattle my OCD bones, 'Welcome to my blog ,I love fashion , don't you ?!' Nada. Nein. Don't do it.

The Interaction Design Foundation has broken down the 5 most important elements of the user experience into:

1. Usefulness of the Website
2. Adherence to Functionality
3. Usability
4. Influence
5. Visual Design

And while these are all quite self-explanatory, the one I feel makes a world of a difference is visual design. We are intrinsically visual people. If we like what we see, we are drawn to it. Make your packaging pretty and you've won half the battle, the rest of

your concern is this; how to *really* test the user experience. I say put yourself in the users' shoes while you beta test your product. Be objective and be brutal. Essentially ask yourself the question put so well by the Interaction Design Foundation, 'Does it do what the label says?'

V is for Value Proposition

First up, what is a value proposition? Investopedia defines a value proposition as 'a business or marketing statement that a company uses to summarize why a consumer should buy a product or use a service. This statement convinces a potential consumer that one particular product or service will add more value or better solve a problem than other similar offerings.'[1]

Basically, why pick me?

We consider our value proposition high quality entertainment, across platforms, using a unique voice that connects with people in a positive manner. For us that means paying extra attention to visual design, the quality of content and ease of navigation. And since we offer a positive experience, we always run this check before we post anything. *Would I say this to someone's face?* If not, it's not going on the blog.

I think because of that benchmark our relationships have blossomed into one of trust and good energy, resulting in access to content that nobody else gets. Access inside celebrity homes and hearts in a world where most stars are hyper-wary of the press. (As you will see in blog #37!)

I know it is easy to accuse someone who is intrinsically positive about most things of being a 'sell out' or sucking up

1 www.investopedia.com

to the industry. But I'll tell you this; I have found it abundantly more satisfying to feature the things we love and give no spotlight to the things we don't. That way we're sieving out the subpar content that you shouldn't be wasting your time on anyway and giving you just what you love about Bollywood and in turn dropping the negativity.

I have always loved Bollywood. It represents a dream, a hope, an alternate universe if you will. And the reason people love to see what their favourite Bollywood stars wear, what they eat, who they date, where they go is because it is simply an extension of that dream.

The value we bring is a whole new perspective of the industry. A chance to get a fly-on-the-wall perspective and watch Shah Rukh Khan and Abhishek Bachchan play charades at the press junket of *Happy New Year* (there's a video on my blog!), or take a vlogging tour of Kangana Ranaut's house, which she has proudly decorated and curated with her favourite furniture and art. Or catch Ranbir Kapoor feeding Karan Johar chips off his plate between interviews in Goa, or playing 'what's on your phone' with Deepika Padukone and one day (hopefully) going bowling with Ranveer Singh.

And the best part? You're only ever one tweet away from your favourite celebrities because your digital BFF reads your messages and relays them too! Every time we do a #CelebrityLoveFest blog we print out as many of your messages as we can and hand them to the stars. The smiles on their faces say it all, they love your love as much as YOU love loving them! Now isn't that heaps better than criticizing someone ad nauseam? Besides I like the fact that we choose to spotlight

the voices that spread love and positivity and drown the ones that troll and hate. #goodbyeinternetbully

On MissMalini.com, and all our extension properties, like TV and digital radio you will see and hear celebrities like you've never witnessed them before and you'll do it from a happy place. I can promise you that! #likeyouneverseenthembefore

W is for WordPress

For bloggers, the most important 'step one' is finding a blogging platform you are comfortable with and that suits your needs. We to this day use WordPress because it offers all the tools and ease of use for a multi-blogger outfit and is highly customizable – perfect for a professional blog. I also find the interface highly intuitive and bug free. It is in fact the most popular blogging platform out there and powers more than 25 per cent of the entire web, that means one in four websites is built on WordPress! In fact, their homepage claims they're powering 28 per cent of the internet and that's a pretty astounding figure; they're clearly doing something right!

Having said that there are several other blogging platforms out there you can use if you're looking to start a blog of your own. The top eight are WordPress, Blogger, Tumblr, Medium, Ghost, Squarespace and Wix. I've heard good things about Druple too.

X Is for X-Factor

I keep coming back to this because it plays such a critical role in your brand identity. Let's assume your business or content isn't something exactly path-breaking. Chances are there are other kids in your class and on the playground. So, what gives you that *je ne sais quoi*? What sets you apart from the pack?

Very often it's something as simple as visual identity, other times it's your process or the kind of people you hire. Maybe it's your values and how you have enabled everyone in the company to adhere to them. It could be a number of things...

I believe that for MissMalini our X-Factor is that we built a brand from one voice that has now evolved and expanded into many voices and channels creating content for the millennial by the millennial. But that first voice that could reach out and connect to people is forever ingrained into the DNA of the company. MissMalini is a name I call myself. And the running joke is that, 'Oh MissMalini, you're married now so shouldn't you rename your blog MrsMalini?' Haha, very original and for the hundreds of times I've heard it and attempted to laugh as if it was the first time anybody cracked that joke, I have finally developed a personal understanding of our evolution, that I can use as a response.

Yes, my name is Malini and I will probably always be referred to as 'MissMalini' for the rest of my life. I'm quite okay with that, to be honest I love it. It means my brand has stuck. But to be honest MissMalini is all grown up now (or at least she likes to think so) and become Malini Agarwal. A #bosslady that built a brand from a blog and is sitting here writing this book.

Who is MissMalini now? I believe MissMalini represents the Pied Piper of the droves of young Indian bloggers, influencers and YouTubers that are growing in numbers at an exponential rate. I am proud to say that MissMalini paved the way in an industry that didn't exist in India back in 2008 and stands for young digital creators who have found a way to express themselves and flourish in a way they probably never thought

was possible when they were in school or college; wondering where their degrees in science, engineering or the arts would take them.

In fact, we recently on-boarded a young law student to write for our nightlife partner King of Clubs. Ameya Chaudhari is in his final year of law school, but his affinity for men's fashion and lifestyle has brought him here. Ask him why he made the leap and he says, 'I realized it's very important to do what you love and not what you're supposed to do, or asked to do, or expected to do! Do what makes you happy, do something you don't mind waiting back in Office for, do something that doesn't make working on weekends feel like a punishment, do something that you look forward to when you wake up every morning. I think this is the key to being successful in life and more importantly to be able to live happy and satisfied life. Fashion is that "something" for me, and I realized this when I was scrolling through Pinterest and Instagram instead of drafting an affidavit for a client.'

And it's not just the millennial that's making this leap. Rij Eappen, who runs King of Clubs jumped ship to become a nightlife and fashion influencer at the age of forty-one.

. .

RIJ EAPPEN
King of Clubs – Fashion & Lifestyle Influencer

I've known Malini from when she was still in her RJ avatar, before she added the 'Miss' to her name and created a digital marketing revolution in India. She and her merry band of friends, from her offline social network, Friday Club (which was brilliant) used to be regulars at my bar, and her enthusiasm would fill the room. The brilliance about the MissMalini brand is the way in which it was created, as a reflection of herself, an extension of a person

who lives her online life exactly the way she lives it offline, with genuine interest in people, their stories and bringing a little sunshine to everybody's life.

We co-founded King of Clubs with the intention of creating a brand for the aspirational Indian male and, for me the association with MissMalini was perfect because there aren't many people in the country who understand the millennial mind like she does, or have the kind of reach and influence she does. I strongly believe that she has only just scratched the surface, the best is yet to come!

. .

I believe that 'MissMalini' represents every voice that has emerged from a generation that spans decades of pent up desire – to live a life less ordinary. In fact, to live one that's extraordinary. Living the dream, doing the things you love. If that sounds like, you then you're part of the MissMalini crew too.

Y is for YouTube

YouTube has become such a normal part of our lives now that it doesn't even occur to us that it didn't exist before 2005. Three former PayPal employees got together and started it and just a year later sold it to Google for US$1.65 billion.

You won't believe this but according to Wikipedia the actual inspiration for the creation of YouTube came from Janet Jackson's Super Bowl incident. Remember when her breast was 'accidentally' exposed during her performance? One of the founders, Jawed Karim, says he couldn't easily find that clip online so he thought why not create a video-sharing site. How insane is that?

And clearly the founders haven't lost their sense of humour because every April Fool's day they play a YouTube prank. I'm

guessing you've been the victim of 'rickrolling' for sure, when in 2008 all the videos on the YouTube home page took you to the Rick Astley music video '*Never Gonna Give You Up!*' Just a reminder to always keep having fun, no matter what you do!

Obviously having good video 'game' is the way of the future but how do you stand out of the clutter with 100 videos going up every minute? You must have a combination of personality, X-Factor and geek blood. Case in point YouTube creators like iiSuperwomanii, PewDiePie, Jenna Marbles, Smosh – the list is very long!

I remember the first YouTuber I ever started following was iJustine. I thought it was so cool that she lived her life online. A one-person reality like I'd never seen before. And then it struck me. YouTube was the voice of the *world*. Suddenly you didn't need to have tons of money or connections or even blind luck to get a shot at stardom. All you needed was a free YouTube account and a video camera. Talk about changing the world. India's the world's largest democracy but I'm guessing YouTube is biggest democracy on the internet.

Now excuse me while I go check out that cat video from 1894!

Z is for Zzzzzs

I kid you not. Get enough sleep! The first thing that goes out the window when you're building a business is sleep. Much like when you have a baby. Thus, follow the rules of parenthood. Sleep when it sleeps. For me that has been the hardest part. Tearing myself away from social media at four in the morning and almost as often from Candy Crush. (Am I the only one still playing that damn game by the way? Because nobody is sending me any lives anymore!)

Sleep is such an import part of our overall composition and ability to function at full capacity that as I am writing this at midnight, I almost what to put myself to sleep right now, Cinderella style!

The importance of sleep only hit my radar recently when one of my boss lady idols, Arianna Huffington, wrote a book about it and started flooding her own social media with what she called the 'sleep revolution' to tackle the sleep 'crisis'. To be honest, initially I thought, what's the big deal, I'll sleep when I'm dead. (I heard that line first from Bon Jovi actually – 'Gonna live while I'm live, I'll sleep when I'm dead.') And now I've started to think, it should have been I *should* sleep *before* I'm dead or at least dead tired.

But anyway, back to the sleep revolution. I was looking for an excerpt to share here from her book, *The Sleep Revolution: Transforming Your Life, One Night at a Time*, and came across a disturbing story of a Goldman Sachs analyst who hadn't slept for two days, working non-stop, jumped to his death from a high-rise building, presumably from work stress and anxiety. And then guess what happened? Her very next paragraph is this:

'Death from overwork has its own word in Japanese (karoshi), in Chinese (guolaosi), and in Korean (gwarosa). No such word exists in English, but the casualties are all around us. And though this is an extreme example of the consequences of not getting enough sleep, sleep deprivation has become an epidemic.'

Um. Goose bumps much? How did she just talk about the exact same thing I started my book with? I swear to you I had no idea this was in the book. I'll be honest, I haven't read hers

yet because I don't get time to read. It sounds so vapid I know but I'm awake scrolling through Instagram or trying to ideate and post engaging content. But I'm ordering this book right now and I'm going to read it every night before I sleep till it's done. Because *this* is a sign.

I don't know if you believe in 'signs' but I do. Many people, including my husband have understandable scoffed at the idea, but I believe that the universe leaves you little nuggets on your path to your purpose just to reassure you that you are on the right track. Kind of like the bread crumbs in Hansel and Gretel, and I've narrowed them down to the 'glitch in the Matrix kind', 'déjà vu' or uncanny coincidences. Like this one.

Okay, let's be brutal and say, Malini – or MissMalini – what does this mean. She quoted the same concept, it's appropriate to her subject and you happened to start your book (laden with positivity) with the same exact thought. Do you see where I'm going with this? For me this 100 per cent counts as a sign. That I was meant to be writing and I'm going to get somewhere because I'm on the right path. I'm on the yellow brick road to my extraordinary life. I'm off the see the Wizard, the wonder wizard of Oz!

In my defence how is this any different from the concept of religion or the *New York Times* bestseller *The Secret*, that both expound the exact same thought. Belief in something that is larger than me, which can't be scientifically proven but gives me immense hope and guidance. You feel free to believe in Paulo Coelho. I'll believe in my signs.

PS. For some reason the number '189' features so often in my life that I have begun to take that as a sign too. I Googled and found quite a hokey explanation about an angel trying to

contact me, which I won't get into here because I stand a very good chance of being committed. But you see my point. I hope. If not, you'll enjoy this quote:

'All you need to start an asylum is an empty room and the right kind of people!' – My Man Godfrey

MissMalini ✓ @MissMalini
@MissMalini: #MMProTip Be the kind of boss you would want to follow.

@MissMalini: #MMProTip Be the best to expect the best.

@MissMalini: #MMProTip Know that not knowing everything is the best teacher.

@MissMalini: #MMProTip A blog must be real. It must be you. It must be true.

@MissMalini: #MMProTip Live the dream. There's no excuse not to anymore.

@MissMalini: #MMProTip Welcome to the world's biggest rabbit hole.

@MissMalini: #MMProTip I hesitate to write this tweet. #dontjudgeme

@MissMalini: #MMProTip Be the entrepreneur that says, 'I'm feeling lucky!'

@MissMalini: #MMProTip Facebook is AWESOME. You'll find your family there.

@MissMalini: #MMProTip One will lose at what two can do.

@MissMalini: #MMProTip What, where, when, where, how?

@MissMalini: #MMProTip Put down your phone and open your mouth.

@MissMalini: #MMProTip Knock. Knock.

@MissMalini: #MMProTip BE someone.

@MissMalini: #MMProTip Do it well or not at all.

@MissMalini: #MMProTip Jump.

@MissMalini: #MMProTip Now you see me, now you don't.

@MissMalini: #MMProTip Be extraordinary.

@MissMalini: #MMProTip Video killed the usual star.

Blog #31: The Rules of Engagement

Anti-Social media. Let's be honest, that's what your parents think of social media, right? That it's making you *so antisocial?* *'Chaubis ghante phone pe pata nai kya karte rehte hain.'*

**Translation: Spending 24 hours on their phones doing God knows what!*

Don't worry. My mom says this till date and she definitely knows what I do for a living by now...*I think.* Also, my mom spends about 75 per cent of *her* waking hours on Facebook commenting on and sharing my photos (thanks for upping my engagement levels mom!), so she's pretty aunty-social herself, get it?

Anyway, let's get to it! We have an analytics ninja in the office who spends a large part of her time reading and learning about all the new developments across social media platforms and even the tools to gauge them by. She often shares them on an office Slack group called 'good reads', so who better than Roshni Ramchandani (head of digital marketing) to give you the 411 on how to get 'engaged' on social media. Thank you Roshni for all the incredible insights you have provided for this blog and dayum, you're good!

The key players in your engagement agenda are obviously your subscribers/followers/fans. (For the sake of simplicity we are going to refer to all of these as subscribers in the rest of the blog). These are the people who decide your day-to-day fate. Keeping them interested and happy should be your number one agenda. I mean there's no point churning out content that nobody's watching.

So your first question is 'How do I get subscribers?' and the second 'What do I do to keep them coming back for more?'

1. FIND YOUR TRIBE

First identify your Target Audience. Who are they, what gender, which age group, what economic demographic? That is what we call your 'TG' (Target Group). At MissMalini, we have established our TG as 18-35, female skewed, well-educated, working and probably no kids yet. This does not mean that we shut out everyone who doesn't fit that profile, but it allows us to focus our content filters and measure how well we're doing in that subscriber pool.

2. ESTABLISH A CLEAR BRAND VOICE AND MESSAGE

It's important that you know who you are going to be on social media and how that will resonate with your audience. This is where creativity meets analytics. If you don't have a solid idea of 'who' your content is meant for along with 'what' it's meant to do for them and 'why' you do what you do, no analytics tool or no amount of data mining will help you get valuable and engaged subscribers.

3. IDENTIFY YOUR METRICS

This means you need to decide what you will deem your measure of success at different stages of your social media life cycle, basis what you are trying to achieve. Is it purely number of subscribers? Is it how many views, likes and shares you get on your content? Is it your revenue? Ideally it should be a healthy mix of all. Once you have your goals and success metrics defined, the next step becomes extremely crucial to help you keep track of your growth and achieve what you've set out to do.

4. DATA MINING

There is a natural tendency amongst most people to assume they know their audience inside out and to make sweeping statements about 'what works'. In my experience that is a dangerous path to follow because you're going based on nothing but your opinion and absolutely no data to support it. The good news, however, is that we live in an age where *everything* is absolutely measurable when it comes to online operations. So, identify the best tools for your business and mine the data you have collected *extensively*. Roshni has identified a few tools we have found extremely useful at MissMalini Entertainment. And since sharing is caring, here you go:

Native Platform Analytics Tools

Facebook, Twitter, YouTube, Instagram, LinkedIn and Pinterest have their own inbuilt analytics tools that gather data from your page with every passing second. I recommend this is where you start. These platforms also have learning centres to help you understand the data that is being captured from your subscribers and how you can convert it into actionable strategies for growth. All of this is made available to content creators free of charge.

Snapchat Analytics Tools

Snapchat has been a bit behind their peers in developing an analytics tool because the company maintains that they are a camera company and not a social media platform. Regardless, many social media creators and brands present on Snapchat have voiced concerns about the lack of analytics and some service providers have attempted to build third-party analytics

tools to help them out. Snaplytics is one such tool which we've tested and adopted. Out of all the ones we evaluated, Snaplytics has the simplest and smartest interface and a great customer support team. If you are serious about your Snapchat game, these are guys you should pay to help you up it and stay on top.

Third-Party Analytics Tools

There are many other advanced analytics tools out there that can help you make more informed decisions. I think these are worth investing in only if you are a big company with defined marketing goals. We at MM were friends with a cool startup called PropheSee, which had built a semi-customized tool for all our social media data crunching needs. Unfortunately, they shut down in 2016. We miss them a lot. (I think Roshni cried.) Before we decided to work with them and after they shut down as well, we've evaluated a bunch of other tools – Unmteric, SocialBakers, Sprout Social, SalesForce, Union Metric and SimplyMeasured. All of them have a variety of advanced analytics solutions that they bring on-board and great customer support teams.

These tools are so far evolved now that you can use them to not only understand your audience content consumption patterns to see what works, but even identify the exact time and place where people are dropping off, thereby flagging the weak links in your content.

5. KNOW YOUR PLAYGROUND

Today's social media platforms have been around long enough now to have established some clear patterns of success. As I always say, you need to go to where the party is and you must go dressed the part. Now you also have to make sure you're

having the right conversations when you get there, and you're speaking their language.

Each major social media platform has its own society in a sense. People interact and consume content very differently on Twitter (which is a conversation) than they do on Instagram (which is much more visual in nature) or stories that offer a fleeting, fly-on-the-wall perspective in a raw home-video style. Granted, almost all platforms have now adopted the 'like' or 'heart' button to establish the popularity of a piece of content, but you're still going to need to customize your content to fit a very specific mold.

Obviously, this means using the correct image dimensions, adding appropriate filters, using hashtags, tagging pages (using the handshake function for brands), etc. But an even more crucial part of this is understanding the deeper intricacies of each platform's subculture.

As a social media consumer, ask yourself as many questions as possible: How do I use this platform? What do I look for? What do I like to post? How do I navigate it? What tends to catch my eye? What do I find annoying? Who do I follow and why? Then if possible repeat the process of questioning with your TG, I promise you an eye-opening survey!

The landscape of content creation and innovation in engagement models is every expanding so I can't promise you a fool-proof plan. A lot of it depends on your personality and purpose. But here are a few things to keep in mind and I hope they're useful:

Do you have a compelling call to action? For YouTubers it's all about getting people to 'Like, Subscribe & Comment' and many of them have come up with hilarious and creative ways

to get that message across. This is the most efficient way for them to get engagement on the videos they've created and to invite new users to start following them to get notified when they put up videos.

Do you have a response ethic/plan? YouTubers and Snapchatters know that a very important job as a creator is to reply to the comments and messages you receive from your followers. When you are managing this on your own it helps to have an hour or two set aside daily for this.

Do you nudge your audience to share your content with their friends? Referral marketing is an age-old tactic that is always beneficial. Don't shy away from asking your fans to tag their friends and family in comments on Facebook if they think their friends will enjoy watching the video or learn something from it. This is not possible on YouTube because not everybody has an account or checks their tags on it.

Do you have a compelling profile design? Instagram is all about the how visually compelling your content is. Take it in writing that all serious Instagrammers spend a massive amount of time picking which photo out of the 300 ones they took will make it to their profile. They all spend a lot of time deciding what are their go-to filters and how these will make their feed appear overall, which makes the chances of getting a follow back on Instagram a lot higher.

Similarly, on other social media platforms, getting people to engage with your content is key, ask a fun question and encourage your followers to leave a comment or tag their friends. Start a conversation but don't leave without actually having it.

6. SOCIAL MEDIA VERIFICATION

What is it about that little blue tick that makes you feel so legit? I am not embarrassed to admit that till this day, seeing a little white and blue check mark by my name still makes me feel a little sense of elation. But how did it all begin? Well, Twitter introduced the idea of verified accounts in 2009 after they were almost sued by someone for having been impersonated on the social network (apparently, Kanye called out an impersonator too, without the lawsuit though). What Twitter did is find a way to demarcate the accounts of celebrities, politicians (and other people most likely to be impersonated) with a seal of legitimacy. Now here's the crucial part, Twitter didn't stop at verifying just people. The official explanation is:

> *Verification is currently used to establish authenticity of identities on Twitter. The verified badge helps users discover high-quality sources of information and trust that a legitimate source is authoring the account's Tweets.* – support.twitter. com

Like the Huffington Post says, 'The definition opens up the possibility of a wider number of accounts getting verified. Again, it establishes identity. You don't even have to be a human being.'[1]

And that's my *favourite* part. Twitter paved the way for a whole new world of communication where brands could interact with people, *like people*. No better avenue exists today than social media to bring your brand to life. Ergo, if only @Pinocchio had been

1 www.huffingtonpost.com/craig-kanalley/

a verified account on Twitter, nobody would have doubted that he was a real little boy.

I also remember early on when I was setting up my Facebook account, they launched those vanity URLs so you could get your actual name in the slug. Unfortunately, https://www.facebook.com/missmalini was taken so I had to settle for https://www.facebook.com/missmaliniblog/. But I never gave up hope, of one day securing the URL with my name on it. The girl who has it is my namesake – Malini Stephen, and lives in New South Whales, Australia. My dearest friend Shawn Fernandes now lives in Oz too and was in fact one of the first few people who sat around my living room when we first made our plans of 'MissMalini' world domination a decade ago. Shawn offered to go find this girl and ask her if she'd part with the URL for the greater good of all MissMalini aficionados in the world. I don't remember where we got with that exactly, but I thought it was SO funny that *this* was the plan we hatched. I can't remember if I ever DM'd her to ask her for it, but the many hours we spent fantasizing about various scenarios in which Shawn meets (the other) Malini and they fall in love over a Facebook URL, was epically more entertaining!

And taking it back to Tweety bird here. Wouldn't Uncle Kracker's smash hit '*Follow Me*' have been the *perfect* theme song for Twitter?!

'You don't know how you met me,
You don't know why,
You can't turn around
And say goodbye,
All you know is when I'm with you

I make you free
And swim through your veins
Like a fish in the sea,
I'm singing'
Follow me Everything is all right,
I'll be the one to tuck you in at night,
And if you want to leave
I can guarantee
You won't find nobody else like me.'

MissMalini ✔ @MissMalini
@MissMalini: #MMProTip Subscribers are people too.

@MissMalini: #MMProTip The number one key to winning at social media is being actively social with your media.

@MissMalini: #MMProTip Immerse yourself in the subcultures of social media platforms.

@MissMalini: #MMProTip Analytics, analytics, analytics.

@MissMalini: #MMProTip Everybody needs a Roshni.

@MissMalini: #MMProTip Follow me and everything will be alright!

Blog #32: How to Be a #BossLady

'A Bawse knows that if you want to be taken seriously, you need to show people who you are, and then keep showing them.' —
Lilly Singh, *How to Be a Bawse: A Guide to Conquering Life*

There are quite a few women I have come across in my life (obviously, Lilly Singh being one of them) that I admire to no end. I thought what better way to tell you how to be a 'boss lady' or 'girl boss' than to learn a few lessons from these power-houses themselves.

Side note: I was trying to find out who coined the term 'boss lady' in the first place but only discovered this definition of 'boss' via a Google search:

> *Boss is Dutch in origin and is a bastardization of the Dutch 'base.' Its use was a uniquely American way of avoiding the word 'master,' which had quickly become associated with slavery by the mid-nineteenth century.*

Okay then! But the term has since evolved significantly and found its place in the Urban Dictionary[1] to mean something more like this: 'She demands respect, and gets it, she is the Boss Lady.' Undoubtedly the women in this blog have done far more than demand respect, they have earned it and set the bar very high for entrepreneurs, leaders and forward thinkers today – inspiring not just women, but hopefully men as well.

Anupama Chopra – film critic and digital soldier

The most important learning on my journey has been the importance of a work ethic. I believe it's more critical than talent or timing. ***There is simply no substitute for hard work.*** You need to put in the hours and keep at it even when you are bone tired and ready to give up. That is really the only way to success. And when you do achieve success, don't stop to pat yourself on the back – as Dory said in *Finding Nemo*, 'Just keep swimming.'

Dia Mirza – actor, producer, director (Born Free Entertainment Pvt. Ltd)

1 www.urbandictionary.com

So much about running an enterprise is about the skill of people management. *To be a good leader one has to learn the art of communication, clarity, articulation of thought.* I have discovered over the last eight years of running Born Free Entertainment that efficiency at the work place can be guaranteed only when you strive to keep your whole team connected through communication.

Ekta Kapoor – joint managing director and creative director of Balaji Telefilms

Looking back, my rebellion began the first time someone said, 'You can't do that!' After years of swimming against the tide, the rebellion continues. Even today, I believe that *being a boss has nothing – and yet everything – to do with being a lady.*

No one fixes things like a woman does, especially if it's about fixing archaic notions.

This industry used to be predominantly male dominated, and we're fixing this lop-sided thought, one step at a time. For most part, we've been brought up believing we need to look up to a 'hero'. Have someone whom you can emulate, someone who inspires you and someone who has your back. Well in my two-decade long journey, I learnt to stop looking around for one and instead decided to become my own. Take charge of your dreams, after all you owe it to yourself.

Ekta Rajani – consulting fashion director, *Grazia*, independent stylist and brand consultant

People do as you do, not as you instruct. Whatever you wish to teach teams, you do yourself. Switch off personal judgements,

apply work-related standards only. Be sensitive as women often are. And firm. They are not mutually exclusive. It allows for teams to be cohesive, constructively critical and resilient. Take feedback and evolve. Each team and generation is different. Respond from changing points of view.

Masaba Gupta – fashion designer, founder, House of Masaba

I think the one thing that I have learnt as a boss lady is that *you should never take yourself too seriously*. It's very important that you learn to laugh at yourself and just take everything that happens to you with a pinch of salt because I think so many of us make mistakes, deal with failures and also deal with a great deal of success. Somethings come to us so easy and somethings just never happen, no matter how hard we try. I feel like neither success nor failure should be taken seriously at all because it's all in a matter of minutes and things can change. And there's one thing my mother taught me – always remember to laugh it off at the end of the day, no matter what happens. If you can just shake it off your back, you'll always do well because then you're not afraid to fail or be spontaneous.

Nonita Kalra – editor, *Harper's Bazaar*

My best career advice? *Understanding the actions of a former boss.* Since loyalty is my greatest failing, I refused a huge job – top billing, international organization, more money – because I felt hadn't stopped learning from him. He forced me to accept the new job with the simple diktat: Go out and make me proud.

This simple act taught me generosity. It taught me the importance of mentorship.

Payal Khandwala – painter and clothes maker

As someone who painted her whole life I worked in an insular environment with full control. Now, running a business, managing a team of fifty plus people, I learnt very quickly to *train and trust my team*. I had to let go of micromanaging and learn the art of delegating. This was tough but not impossible.

However, I would advise my younger self to be a little more assertive. I have learnt now that in situations where I'm uncomfortable or where I feel overextended a simple 'No' is a prerequisite. Someone told me once: 'If you can't bring yourself to say no, just say let me think about it and get back to you.' Seems like such simple advice but to be honest it took me a long time to exercise it.

For the most part I don't think of myself as the boss of anyone, my team is my family and I respect them, take into account their feedback, even criticism and, most importantly, laugh with them. It's a very flat organization because respect can only be earned., the one you demand is topical and doesn't go the distance.

Preeta Sukhtankar – founder, The Label Life

Perseverance and hard work are the only way to get where you want to go. They will help you ride every storm. And *follow your instinct, not impulse but instinct*. Hone and understand the difference – it is never wrong. We've built a whole business by this rule. Our style editors Malaika Arora Khan, Sussanne Roshan and Bipasha Basu, here at thelabellife.com embody another quality I admire and one that needs nurturing especially for young Indian women growing up in this country – fearlessness. Fearlessness to speak up, fearlessness to ask for

what you want whether a raise or a date with that hottie – do it!

Priya Tanna – editor, *Vogue*

All my learnings about dealing with people at a professional level have actually had very little to do with being either a boss or a woman. It's the way I chose to conduct myself at the start of my career twenty-three years ago, and it is has stayed with me till date. We spend so much of our time with work colleagues, we rarely realize that we spend more than half our waking hours with them. Without a doubt, it is imperative to stay professional especially when you are leading a team. Which means *setting clear goals, sharing them with the team and taking their feedback to make them feel a part of the process* and not just the execution. It also means having a clear view of the work culture you would like to build, laying down fair and well-defined guidelines and being firm about the non-negotiables.

Truth is, you can't work or succeed in isolation and that top-down companies are rapidly turning obsolete. I have mostly led women centric teams and attribute much of my professional success and career highs to being surrounded by an incredibly talented bunch of people. And in my experience, open communication, empathy and emotional support have been critical in retaining and maintaining a great team that does great work.

Rohini Iyer – founder, Raindrop Media

My biggest learning about being a boss lady would be to *not let success go to your head or failure to your heart*. It's important to celebrate all the highs life gives you and learn from your lows. I

treat every hurdle, every low and every challenge as a learning. The advice I would give to my younger self would be 'Don't be in a hurry to grow up.' I feel 'adulting' is completely overrated and not what they make it out to be. So, I would tell my younger self to 'never grow up'.

Shalini Agarwal – founding partner, In Se Legal

Having co-founded two other law firms prior to setting up In Se Legal I have had more than my share of being boss lady! Who said being a boss lady was easy, it's more like an acronym for 'being on a slippery slope' and that's apt because you must strategize on how best to negotiate the path ahead. A bit like parenting – there is no one size fits all, or universal recipe for success. Hindsight, had it appeared earlier as foresight, would have been a pretty helpful tool for how to play the game right. I also soon realized that *respect is at best commanded and not demanded*, and that is easier said than done! I also realized bullies don't only exist in the playground. Corporate boardrooms are tough places and grit and nerves of steel are a necessary survival tool. Last but not least: stay the course, believe in yourself and your vision and push on – no matter what.

Srimoyi Bhattacharya – founder, Peepul Consulting

In the age of insta(nt) gratification, I believe that you build domain thought leadership when you have a vision beyond a transaction with the interest of an industry. Be inclusive and think long term is our key to success.

In the business I have chosen, which is advisory in PR and marketing, where we basically enable brands through relationships, our key to success has been to be inclusive and

to sustain them. Staying connected to my competitors and building a rapport has helped us build an industry together where there has been no governance but norms, values or rules we are building together as professionals. This inclusive thinking applies to our client relations and media relations as every person helps move the envelope and is mobile. We are flat in our structure and in our overall approach, everyone is someone today and tomorrow. Sustaining relationships and then big ideas. We practice this in our brand strategy as well as concepts that have sometimes a year of gestation are the most impactful and memorable with patience and persistence being critical on all fronts. *Be inclusive, think long-term and sustain so you build relationships, not transactions.*

Rega Jha – editor, BuzzFeed India

Gender stereotyping is so insidious. Myths like female incompetency of over-emotionality get inside of us – we see them around us, and start believing they're true about ourselves. I've spent so much time, as a manager, second-guessing whether I'm being too emotional about a decision, and feeling like an imposter to my own influence, simply because of stereotypes. *While we fight for equality and freedom in the external world, an equivalent battle may be in our own minds, against our own conditioning.* It's taken hard work for me to trust my own gut and to break out of the suspicion that my instincts, as a woman, are 'irrational' or wrong. My hope for every woman manager and showrunner is to do the hard work it takes to get out of our own ways and trust ourselves, despite the constant cultural messaging that we're incompetent, weak, over-emotional, or whatever else, and to do that work early on.

Sunaina Kwatra – country manager Louis Vuitton

Advice I Got: 'Don't come to me with problems. Come to me with solutions.' My father instilled that in me growing up and it has helped me my entire career. Approaching any audience with well-thought of ideas and action plans versus simply stating problems will allow for a more open and positive way in solving obstacles. ***Challenges are natural but strategic thinking is critical.*** People respect proactive thinking, so be accountable and communicate problems with a solution and/or opportunity.

Advice I Would Like to Give: You will thrive in your professional life if you enjoy the environment you work in and if you have the support system in place that allows you to succeed. Make sure your work place brings out your passion and happiness. ***Always ensure you have a boss and/or mentor that will foster your professional and personal growth.***

As a boss, I strive to develop and nurture my team as much as people, employing learnings from my experiences and all the great bosses I've had over the years. Make it a priority that your team is happy, motivated and understands their professional path.

Falguni Peacock – designer

Being the boss lady comes with its challenges and it takes a while to find your ground, every single day you learn something new and I am on constant auto correct. Also, what I learnt is that *you need to be patient, and should take criticism positively.*

Pernia Qureshi – fashion entrepreneur

Starting and running my own business has taught me many things but if I had to choose the most important lesson it

would be to **have a good attitude**. Attitude is everything when it comes to work. I learnt that as the boss I should set the tone of the company. If I am excited and serious about what I do, that energy will pass on to everyone else. Even in difficult times I have learnt that keeping a good positive attitude and confident demeanour is a must! The moment you crumble everything else does too. I'm still a work in progress, but I'm constantly striving to have the best possible attitude when it comes to being a boss. This is something I value the most in employees and coworkers too. When someone who works with me is sincere, willing and motivated, that's makes them much more valuable than if they are highly skilled. Just as I want to be a good boss, I also want people with good personalities around me. Attitude is infectious!

In October 2016, I had the great privilege of visiting Washington DC along with fifty female bloggers and influencers from around the world to listen to – arguably the most charismatic boss lady of them all – Michelle Obama.

A perfect example of brands finding a way to connect with their target audience in a meaningful and memorable way, Maybelline and *Glamour* magazine teamed up on 'The Day of the Girl' to spread the word on a project close to Michelle Obama's heart. The mission? To focus extensively on female education and 'Help Girls Graduate', enabling and empowering them to live better lives.

One of the many inspiring things she said, which gives me goosebumps till this day just thinking about it, was that standing in front of this room full of female influencers from around the world she felt a sense of hope. She is optimistic about the future of the world she said, because standing in front of her were just a few of tomorrow's mothers, sisters, teachers, leaders

and more. And she felt confident that this generation of women is going to teach our fathers, husbands, brothers and sons both empathy and kindness, enabling us to make the world a better place. Because it is WE who will parent the next generation of girls and boys who will grow up to be tomorrow's parents and mentors and it's up to us what values we teach them and what lessons they learn. Boom. Kinda makes you want to have children now so we can set the world straight, right?

Feels, right? All kinds of feels.

And of course, she also stressed the importance of 'girl love', which urges women everywhere to support one another and stop tearing each other down because society has convinced us that the only way to rise is with someone else's fall. That's just simply not true. Here's what she said:

> *'We can all rise together, OK, we can all win. And we're sometimes taught in our societies that we have to compete; we have to hold each other back in order for one of us to succeed but THAT IS NOT TRUE. We need each other. And all over the world we have to be a team of women and girls who love each other, and value each other and cherish one another. Because if we don't cherish each other, no one else will. So let's start there and start working together and find a way that we are going to lift up some other girl in our lives. Maybe it's a little sister, a neighbour but you can be a mentor today. So, do that, do that work now. Get in the habit of that. You all with me?'* – Michelle Obama

We're with you, Michelle! In fact, mega #GirlBoss Lilly Singh aka iiSuperwomanii launched her very own and very successful #GirlLove campaign to combat girl-on-girl hate in 2015. Her

then audience of 7.4 million (she now has 12.5 million, 84 per cent of which are women) flooded the internet with positive tweets.

That was so inspiring that I thought why not extend this #GirlLove to Bollywood. An industry rife with cut throat competition often leading to female animosity within a peer group of other female actors. What I found was heart-warming. All the actresses I approached to share some love for each another were genuinely enthusiastic and sent heartfelt messages. I thought you might enjoy hearing what Bollywood's belles said about each other. Here's some Bollywood #GirlLove!

Katrina Kaif – There are very few people who catch my attention in terms of the way they work and Priyanka Chopra is someone who did. I think it's very hard to work the number of hours that she is. For me, if I come to know that I'll get lesser sleep, I am already panicking in my head; and the number of flights she gets on and off! I see her one day in Bombay and then two days later she's in LA. It's a lot of dedication to put in and that's definitely caught my attention.

Kangana Ranaut – There are many Bollywood actresses and I have worked with so many of them and I think a bad-ass partner in crime is Priyanka Chopra, and so is Kareena Kapoor. I have had a very brief meeting with her and she is awesome. So, for these two I will buy make-up and I would like to go out for a Valentine's lunch and gossip about men!

Kareena Kapoor – Well I think it would have to be like Sridevi cause I've grown up watching her movies and it was always a dream to become like Sridevi. Could I ever reach that mark and be like that? She will always be my inspiration.

Alia Bhatt – Katrina Kaif! I love you. I love you because I think you are frank and an honest person, and I love all my work-out sessions with you. So, I love you, Kat.

Kalki Kochelin – Kangana Ranaut. You're an amazing actor, and I'm so jealous of your natural abilities. I don't know you that well as a person because we hang out rarely but you are very cool.

Deepika Padukone – 'So many! There is Alia, there is Shraddha there is Parineeti – she is so sweet. I love you, I love you.'

It's the best kind of love, it's #GirlLove!

Lilly's campaign also donates money towards important causes like the Malala campaign and is currently aimed at helping girls in Kenya, which you can contribute to simply by buying her aptly titled *New York Times* bestseller *How to Be a Bawse* and Rafiki pins and bracelets, so that you can wear your girl love around your wrist! #LoveThat

And what have I learned about being a #BossLady? I have learned that what makes a boss lady truly unique is not only her IQ but her EQ (Emotional Quotient). The ability to scan a room and suss out the vibe, what some may call 'women's intuition' (aka be the first to call bullsh*t – pardon my French). The deftness to read body language, what we call the natural capacity for empathy, an incredibly valuable skill in management and in life. So, I urge all women to embrace that in themselves. Don't try to do business 'like a man'. Harness your EQ and shoot for the moon. Which is why one of my favourite quotes is this:

> *'Women who seek to be equal with men lack ambition.'*
> – *Sometimes Being the Queen is All We Have to Hold Onto*
> by Connie Cash

So ladies, don't just be a boss. *Be a Boss Lady*.

PS. Dear PC, thank you for the love and for writing the foreword to my book. Just goes to show that a little girl love can go a long way! #tothemoon

MissMalini ✔ @MissMalini
@MissMalini: #MMProTip Business is business, don't take it personally.

@MissMalini: #MMProTip Don't be afraid of bullies in the boardroom.

@MissMalini: #MMProTip Spread #GirlLove, be a mentor, uplift another woman in your life.

@MissMalini: #MMProTip Embrace the power of 'No.'

@MissMalini: #MMProTip Channel your EQ. Harness your intuition.

@MissMalini: #MMProTip Build relationships, be inclusive.

@MissMalini: #MMProTip Just keep swimming, have a good attitude and never grow up.

Blog #33: Trust Your Instincts.

'You Do You.'

If you were to ask me what the most important thing I have learnt on my journey through life is, it would be this: *Trust. Your. Instincts.* Nobody but you will *ever* live, breath and embody your 'brand' the way that you can and will. It's your baby after all, it is a piece of you.

There are actually two parts to this. One is trusting your instincts, which means don't be afraid to captain your ship the way you best see fit. And the other is never apologize for who you are and how you express yourself, (obviously, this is not a free pass to be a huge a**hole to everyone in your life, but you know what I mean.)

For the longest time in business meetings, where often it was a roomful of suits (primarily men), their secretaries and me and my pink highlights, I often felt an odd cocktail of emotions. Pride confidence, nervousness, anxiety and the constant fear that I would sound 'silly' or 'like a girl' when I voiced my opinion. The reason for this (and I'm sure this has become abundantly clear by now) is that I tend to see most things through a pretty 'emo' lens and I was worried that given my opinion would more often than not come cloaked in EQ over IQ, it would not be taken seriously. But I was wrong.

Ninety-eight per cent of the time I would strike a chord that connected with people and engaged them, primarily because I believed so completely in what I was saying. I do have a 2 per cent tendency to ramble a bit because I sometimes forget what I'm saying *while I'm saying it* – literally mid-sentence – because my mind has wandered off out of the room and I'm scrambling to get it back. (#TrueStory, does that qualify as ADD?) Where was I...

But I was made truly aware of the fact that my unconventional style works when, after a business meeting with a room full of high-powered suits, in the luxury automobile business – where I went down the path of emotionally connecting with your consumer – my creative head for video, Samira Major, lauded me for how it had all gone down. She said she was sitting in that meeting watching me and proudly thinking, 'Preach, Malini, Preach!' I love that and thank you, Sam.

One of my dearest friends and a bonkers powerhouse of a creature, who calls himself @CandymanLondon on the internet, gave me the most epic advice I've ever heard in this regard.

THOMAS DAWES
Creative & Digital Director, Godrej Consumer Products
Aka @CandymanLondon

MissMalini is a brand oozing with youthful positivity, energy and take-over-the-world va va voom and that's because Malini is all these things. Spend 30 minutes in her presence and she will have connected you with ten people who could make you/your company/your brand/your social life bigger and better. She's inexplicably energetic, positive and inarguably better company than 99 per cent of people you might do business with. But therein lies the rub – this isn't work for Malini, she's living her dream and wants everyone around her to do the same.

My advice to Malini? Be careful who you take business advice from. There will many ill-fitting suits queuing up to tell you how to run your growing empire. But the truth is, your inimitable style has taken you this far and will continue to take you places that spreadsheets could never forecast. Trust your gut and do business your way.

Have you watched the movie *The Intern?* That movie sums up the advice Tom gave me. Except this time, it's Robert De Niro giving it to Anne Hathaway and I've never tried to ride a bicycle through my office. (OMG Tom I should have known you'd be 'The Godfather' in my life!)

The other thing about being YOU is that you need to stick to the values you want your brand to embody. Don't compromise on that. Not for any amount of money. For example, I have a problem with fairness creams and the message they're drilling into the minds of impressionable young Indian girls. I can't support a storyline that claims a girl is a burden on her parents; no one

will marry her, so she's wilting away in the 'darkness' until she applies a fairness cream (that most likely bleaches her skin) and she magically finds the perfect man, makes her parents proud and becomes Miss India?! Come on. It's 2017. Let's grow up and appreciate the skin we're in. #BrownIsBeautiful

That doesn't mean you suddenly must become a soapbox preacher for every cause on the internet. No, just find the things that matter to you and make sure your brand lives by them, just as much as you do. A good barometer of judgement for this is to consider, 'If I do this will I be secretly ashamed that I did?' and then ask yourself; *what is the price of my soul?* – then you do the math.

MissMalini ✓ @MissMalini
@MissMalini: #MMProTip Trust yourself.

@MissMalini: #MMProTip Only take advice from people who tell you to follow your instincts.

@MissMalini: #MMProTip You don't have to be CEO to let them know who's boss.

@MissMalini: #MMProTip Don't make compromises that don't sit well with your soul.

@MissMalini: #MMProTip Love the skin you're in.

Blog #34: Give Credit Where It's Due

While I was working at G092.5, I encountered a very unique individual, our programming director, Kobad Mobedjina. He taught me an important lesson. He said, 'Always give credit where it's due.' Especially as you climb the ranks and run your own operations, it is imperative that the people in your charge feel appreciated and 'seen'. The worst possible thing, and perhaps you have experienced this yourself, is to work hard on something and either be given no credit for your effort or

worse, have it usurped by a manager or colleague simply because you were part of their team and it was easy to gloss over your contribution.

Since my blog is named 'MissMalini' this has always posed somewhat of a challenge for me. The automatic assumption about anything that goes up – good, bad or ugly – is that it has been written by me. To combat this, we decided early on to give each of the writers a by-line on their posts and let them develop a person style and voice in which to write. Over time, this has made it abundantly evident who's telling which story.

I was also always intensely conscious of the fact that whether it be blogs, web videos, television or radio; the voices of this brand should stand out and shine (bright like diamonds!). I am proud to say that today, members of my team get recognized walking down the street or at fashion week or even by celebrities who send them complimentary personal DMs in appreciation of their work. Shraddha Kapoor complimented Nats on her videos, saying she is 'original, funny and totally engaging.' You go, Nats!

Thank you, Shraddha Kapoor, how sweet is that? Aditi Rao Hydari, who is a burst of sunshine herself, had the most wonderful thing to say about Team MissMalini too.

• •

ADITI RAO HYDARI
Actress

I know you have this book that's almost out there and it's an inspiring story. I know I sound misty-eyed and all but it is. Because I think you have created such an empire and you've done it so amazingly, so seamlessly, and I want to know how you did it because I only know you as The MissMalini. What I'm curious to know is how you got the idea, how you went about it and how

you put together such an amazing team because every time that
I've been to the office or every time the MissMalini team comes
home – I don't let too many people that I don't know into my
house – but the MissMalini team always feels like home. I feel
very comfortable around them and they are just all so, so nice
and I know that a lot of it has to do with you.

• •

Now it might seem obvious that giving credit is just a matter
of throwing in the person's name in conversation or print when
they deserve it, but I urge you to take it up a notch.

While I was working at Radio One, management had this
interesting strategy of recognizing their top talent by creating a
pool of 'super employees'. We would meet once a fortnight to
ideate on larger brand and company decisions, which made us
feel like we were being rewarded for our work and thus given
more say in company operations and brand strategy. Plus,
everyone got stock options at a very minimal rate. Needless to
say, it made everyone proud to be there.

The other valuable strategy is to credit those who credit
others. Recently we did a gruelling campaign for a brand that
took an incredible amount of hard work and team-work. Yet
again, Samira, while helping me write a presentation about
influencer marketing, pointed out that there is something
intrinsically awesome and unique about how we operate. Unlike
some companies where that kind of pressure often results in the
blame game or creates little 'gang wars' and cliques, the opposite
happened. This team banded together to help each other through
the toughest of shoots. Team members went above and beyond
their expected roles to help each other out. Some even spent the
day keeping everyone's spirits up with off-camera entertainment.

And my absolute favourite part of this was that when the campaign ended and we had a town hall congratulating the team at large, each of them took the time to appreciate someone else's contribution to the project. Appreciation is the finest form of credit. Remember that.

Here's an email Neha Jambotkar (director of client services) from Team MissMalini sent a day after the project.

Hi Nowshad, Mike and Malini,

Just wanted to write to you to highlight the good work done by the team to pull this campaign off, in 1 week!

Meghna Mirgnani (Executive Producer): Appreciate her attitude of facing the challenge head on and ensuring she executes to her word. She organized the sets, thought of every detail on the set i.e. Dress Dada, Runner, etc. She took charge and ran the shoot so well! She was a fabulous director. But what I appreciate the most is her willingness to go out of the way to make things happen – she ensured the backdrops were changed on Day 3 as we needed to bring a different colour element in our videos. And more so, organized the edit schedule to ensure I have 7 videos out of 8 in hand on 6 October – merely 2 days after our wrap up. She not only talks the talk, but walks the walk.

Rishabh Maliwar (Head DOP): He was standing on his feet for the duration of the 10-12-hour shoot days. The best part – he never ever complained – always a smile on his face. It brings an amazing energy to the set!

Aditya (Runner & Sound Technician): He is so on-point with his sound technicalities now. We had an issue of Navratri music post 5 p.m. and working under that stress was crippling but he took it head on and ensured we got the best out of our talent.

Pankaj and Yogesh (Editors): They have worked diligently to get us one video out per day and manage other edit work despite Meghna not being in to supervise. The internal approvals on most videos were almost instant! *Fingers crossed* on client approvals now.

Rashmi Daryanani (Executive Scriptwriter/Video Content Strategist): I really appreciate the promptness with which Rash worked on the scripts. She helped me divide the hacks into content pegs – a job she did voluntarily which helped so much pre-production. She also helped script for bloggers who were acting difficult.

Rashmi Bhosale (Fashion Blogger): She has stepped up to sit on edits despite having almost no edit experience. She has done research on each blogger style and given such great inputs.

Mallika Kulkarni (Key Account Manager - Sales & Marketing): She *made* this happen for the company. Despite the heat I gave her for timelines – to execute the shoot of 8 bloggers/24 videos in 5 DAYS – she stood by us all and donned various hats, i.e., director, hairdresser, make-up artist, content on set to ensure we went over all the bumps smoothly.

Harshad (Special Projects Manager): He took ownership and ensured the communication with all these bloggers was seamless. His attitude of working towards the bigger picture will ensure a long successful career run here.

Happy to say that these resources made for a crazy, beautiful experience of bringing together this campaign. We still have the execution of the videos to go, but it's important to highlight good work where its due.

Regards,

Neha

Thank you, Neha, for this exceptional email and I was told you went above and beyond your role as well by everyone who was on set. And that you did it with your 10,000-watt smile. I hope you know this email is everything.

PS. Repeatedly I have seen this team step up and support one another. There is zero bitchiness at our HQ and for that I am so grateful. I however cannot take credit for this one because creating an environment where there is a great vibe and people thrive is the collective work of a team of absolute ninjas. It takes each and every team member at MissMalini Entertainment to keep this ecosystem alive and negativity free. So, thank you team. All along I thought it was up to me to teach you this company's core values, turns out you taught me.

 MissMalini ✔ @MissMalini
@MissMalini: #MMProTip 'Teamwork makes the dream work.' – John C. Maxwell

@MissMalini: #MMProTip Positive energy is the best fuel for your rocket ship.

@MissMalini: #MMProTip Don't hog the spotlight.

@MissMalini: #MMProTip Respect and appreciation are the pillars of success.

@MissMalini: #MMProTip Recruit someone on your team that will make everyone laugh every day. (Hi, Harshad!)

@MissMalini: #MMProTip Appreciate those that appreciate others.

Blog #35: The Other F Word – Funding!

As I started my maiden journey as an entrepreneur, the one thing I kept hearing time and again was 'beware of VCs!' and 'find the right investors or you're sunk'. And so, I tip-toed into the world of venture capital with a fair amount of trepidation.

I am happy to report, however, that my experience with investors has been absolutely awesome. Due props to the first two people who believed in me and my brand, Sonny Caberwal and Rajan Anandan and a great deal of gratitude to everyone else who made contributions, whether as friends, family or financial institutions.

I have asked all my investors to share their thoughts on the MissMalini brand and give me a piece of advice, which no doubt may apply to a brand or business you're looking to build too. But first here are five crucial rules of finding and keeping your funding, as I have understood them from my experience so far.

1. *Show them your passion.* I firmly to believe that investors don't invest in businesses, they invest in people. If they can sense the fire in your belly, they are more likely to believe that you will stop at nothing to achieve your dreams.

2. *Align your goals and mission.* Make sure your investors believe in the long-term potential of your brand. You're in it for the long haul, find people who are willing to give you the time to see it through.

3. *Know what you want your investors to do for you.* Whether it's to open networking doors, or provide invaluable access to technology, or simply allow you to pick their brains for business strategy.

4. *Make promises you can keep.* Don't inflate your balance sheet to an unachievable number. Be ambitious but realistic. Ambi-realistic? (Okay, maybe don't try to make up fancy words!)

5. *Be Marwari.* And by that, I mean be as frugal with your cash injection as you were without it. You want the funding to last as long as possible and your balance sheet in the green asap.

Obviously, there is a lot more that goes into funding, but I'm going to spare you the excel sheet lecture today. For now, it's over to the people who believed in my dream and continue to fuel my rocket ship.

. .

SONNY CABERWAL
Serial entrepreneur & Tech Executive

Your passion and interest in technology and sharing with friends has not only made you a trailblazer in your field, but beloved by millions of readers around the world.

Advice: Never forget how and why you started – keep on having fun and experimenting as if it's day one, and you'll continue to stay on top as the most trusted source of information for millions of followers around the world!

RAJAN ANANDAN
Vice President, South East Asia and India, Google Angel Investor

As an angel investor, my focus is on backing awesome founders who are building businesses that can scale.

I invested in MissMalini when Malini had a very small team and some level of traction on users. What struck me when I met her and her co-founder was that she deeply understood her target segment, had a truly insider view into Bollywood

with strong access to the people and stories that matter, and the team was complementary with both content and business skills. Bollywood moves in India and Malini has a great pulse on what moved Bollywood. If someone had told me four years ago that MissMalini would become one of India's leading online destinations with a very small amount of seed capital I would have said, 'No way.' Clearly they have proven that an Indian digital start-up can be built in a highly capital efficient way, and this has been great to see. As MissMalini enters their new phase of growth, their growth possibilities are infinite.

SIDHARTH TALWAR
Partner & Co-Founder Lightbox Ventures

MissMalini is a media powerhouse today. But that wasn't a part of the plan at the outset, particularity when I invested. They were a media brand that realized that India had a huge, untapped market that no one was adequately addressing – millennial women. Admittedly, a tough market to take on for a small, inexperienced team. However, at a time where traditional publications are struggling to make ends meet, MissMalini's growth is very impressive. Their brand recall is even more impressive. And the reason is that they understand their readers better than anyone else and this has been their strength from the start. That's why I invested in the beginning.

As they continue to grow, they will need to continue to evolve. Just as their readers will, and as the community around them will. If they don't evolve, there is a danger that they'll fall into the same traps that more traditional content businesses have in the past. Judging by experience, I'm sure they'll be just fine!

STEVEN LURIE
Ex General Manager, Zynga, venture capital fund founder

I am honoured to be an investor in MissMalini for the past several years. I invested because the founders are great (Malini, Nowshad and Mike are creative and smart people who get things done) and they have built a world-class team, company and culture. It is amazing how much they have done with few resources. I'm a full-time venture capitalist in San Francisco with many investments and several start-ups I've helped grow and I've never seen a team get so far with so little capital raised. MissMalini is building a unique and valuable brand in India and I'm glad to be an investor.

SAKATE KHAITAN
Senior Partner, Khaitan Legal Associates

As angels, we invest in the person. When I think of Malini, the adjectives that come to mind are innovative, powerful and sexy. To top it all Malini being the little sister of a close friend and colleague, investment was a no brainer.

Success comes from consistent hard work, striving for excellence and a voracious appetite to learn. One therefore must be constantly vigilant of overestimating one's ability, underestimating competition and becoming egoistic, all of which are impediments to growth and success.

Wish you all the very best.

ASHISH LAKHANPAL
MD of Kismet Capital, LLC

In looking at India going forward, there is no doubt that interest in Bollywood, music, fashion and cricket will only increase among

the youth, given the influence of online and offline media. We see an investment in MissMalini as a great way to tap into the passion Indians of all ages have for the intersection of entertainment, fashion, and music industries. India's role as a global influencer will only increase in the years ahead and we believe MissMalini will be the premier channel, which people from India and around the world connect with to better understand and participate in emerging trends originating out of India.

In terms of advice, it may sound trite but never lose focus on who your core customers/constituents are and always ensure the content (also events and product placements, etc.) provided is curated and tailored to meet their needs and wants.

AYUSH PHUMBHRA
Co-founder at Nectar, Previously Co-founded $CHGG, Entrepreneur, Angel Investor

Malini, who started blogging as a hobby, has become one of the leading influencers in the world and MissMalini Entertainment has the potential of being a global digital media house. Stay focused and keep it classy!

REHAN YAR KHAN
Angel Investor, Orios Venture Partners

Advice: keep doing positive media like you have been doing. Also, somewhere along the way, try and find a cause, something dear to your heart.

Business: have the ambition to build something big, very big. You are giving your youth to this company, make it count.

RAVI VISWANATHAN
General Partner, NEA

We at NEA are thrilled to be partnering with Malini and the team at MissMalini. Malini has touched on several key themes of interest to us – the power and emergence of the millennial demographic, and the rise of the Indian consumer – to create India's preeminent millennial media network.

Our advice for Malini and her team is for them to continue to focus and maniacally execute, as they've been doing, to create an iconic platform that marries content, media, social, community and commerce.

SUJAL SHAH
Former Chief Strategy Officer of MME, Founder BOHOSTAR, Early Investor/Advisor

MME was building a consumer interest destination well before many of the 'me-too' portals. It delivered relevant content to an audience which was desperately looking to satiate their need for entertainment and information. related to their biggest passions in the India landscape – Bollywood, fashion and beauty. I saw the opportunity to help take the business from a small mom-and-pop blog to a multi-million-dollar consumer interest portal delivering content and commerce to a very large, engaged mobile audience in India.

Be humble. In a growing business, one has never 'arrived' and must continuously look for ways to deliver greater value to its consumers. Listen to and know your consumer, don't assume to know what their ever-changing preferences and needs are. In the growth phase, it is equally important to surround yourself with talent that will challenge the norms, act quickly, take chances and run a business with clear goals towards success. Don't be afraid of failure,

be afraid of complacency. As Thomas Edison once said, 'I have not failed. I've just found 10,000 ways that won't work.'

As your company grows and brings on investors and shareholders, don't forget your commitment to all of those who have invested in your dream. Strong leaders and successful businesses will understand the importance of being confident enough to take criticism and understand the context of that criticism to mine the underlying opportunity for improvement. Don't let personal preferences and ego deafen your ability to take counsel from those who are also committed to your business success.

. .

'My dream is to fly over the rainbow so high.' – Yves Larock

MissMalini ✔ @MissMalini
@MissMalini: #MMProTip Find investors who believe in the dream not just the revenue.

@MissMalini: #MMProTip Don't be afraid to ask people to teach you things.

@MissMalini: #MMProTip Have ambition but also have heart.

@MissMalini: #MMProTip Be the little engine that could.

@MissMalini: #MMProTip Business evolution is the key to your survival.

@MissMalini: #MMProTip Don't waste other people's money!

Blog #36: A Word About Trolls

Back when I was growing up, trolls were these ugly mythical creatures that hid beneath bridges and jumped out at innocent people who tried to cross them. Now trolls live all over the internet and spend many their waking hours posting hate messages or flaming anyone that happens to hit their radar.

If you live online like I do you, you should very quickly make your peace with the fact that you will be trolled, if you haven't already. You have to grow thick skin and resist the urge to cry, rant or lash back in return. You must learn to be the 'bigger' person.

Remember how mom always told you, 'Sticks and stones can break your bones but words can never hurt you.' Well, let's be honest, words can do a fair amount of emotional damage in a thapad ki goonj sort of way. So here are a few ways to deal with the murky world of internet bullying and staying above the fray.

1. *Ignore them.* First and foremost, its best to just ignore trolls till they get bored of talking to themselves and move on to their next target. You know who you are, the people who matter do too, so what difference does it make if some stranger halfway across the world doesn't like you?

2. *Listen.* In some cases, a troll is making a valid point, but just doing it in a really terrible way. Try to strip the message of its caustic coating and hear what they're trying to say. Maybe there is some merit to the 'mad-ness' and an opportunity for you to improve.

3. *Kill them with kindness.* This won't always work, but I have found that trolls tend to be lonely people, just looking for a little attention. So, sometimes if you just reply saying, 'Hey, sorry you didn't like my post but thanks for stopping by!', they are taken aback enough to suddenly come back from the dark side and say something nice. (I've seen it happen many times.)

4. *Use humour.* The key to life on the internet (and probably in general) is to not take yourself too seriously. If you feel compelled to reply, post a humorous response that might

shut up your bully or at the very least earn you 'clever points' with the rest of your audience. My mother does this often on my behalf and I think it's both hilarious and awesome. One time, someone commented on my looks and said that I look older day by day. To this, my Mom wrote, and I quote verbatim, 'Who doesn't? Are you growing younger every day...will become a baby, then what?' #GoMom

5. *Block and report them.* I very rarely block people, but if they are hampering your content by spamming the comments or in other ways, sometimes its best just to cut them off. All social media platforms have a block and report feature, which you can use to expose and report trolls.

Funny story, but I've been trolled by the occasional celebrity as well. I should tell you this one because it came totally out of left field, but taught me something about human psychology.

I was hosting the red carpet at a major awards show in New York and about four hours in was exhausted. My role was to identify 8-10 major Bollywood celebrities and ask them a few fun, rapid-fire questions on the red carpet, take pictures or boomerangs of the rest and let them be on their way. At one point, a crooner came up (whom I genuinely didn't recognize, but would probably have done the same if I did) and I asked her to please pose for a picture. She immediately retorted, 'Aren't you going to interview me?' to which I was a little taken aback. Anyway, she kind of huffed off and I thought that was the end of that, but apparently not. The next day I saw a series of tweets from her lashing out at me for being a 'wannabe' for only interviewing Bollywood celebrities who are in front of the

camera. I replied nicely saying I was sorry she felt bad, but it was kind of the producer's call whom we interviewed that day, but I'd be happy to do an interview with her at the MissMalini HQ whenever she was free. Her response was that she would never do an interview with me if her life depended on it. (I thought that kind of defeated her cause but anyway...)

The tirade didn't stop there and several other singers that she had tagged jumped on the bandwagon of how they are under appreciated and I was a terrible person. Initially I felt bad, irritated, defensive even, but then I realized it wasn't about me at all. It was obviously a raw nerve with playback singers in the industry who probably don't ever get the spotlight they deserve. Although I don't know if I should have felt obliged to interview her on the red carpet that day, I do see her point (albeit cloaked rather harshly in criticism). Maybe there is something to be learnt from the occasional trolling as well?

The other time that stands out in my memory is when a B-list-ish actress was severely offended that we had fashion policed her for carrying the same Chanel bag that had been spotted with Kareena Kapoor and Deepika Padukone. I felt that in this case she was justifiably upset because there's no rule that only one celebrity can ever carry one bag otherwise the entire luxury industry would be in serious trouble today! I apologized and edited the article to say she had also been spotted with the popular accessory and wasn't copying anyone's style. It took her a while to cool off, but eventually she did.

The most worrying thing about internet trolling, in my opinion, is that it's also led to a change in millennial behaviour. Pre-empting trolling means putting all your pictures through severe scrutiny yourselves. It leads to low self-esteem and

insecurity clinging to Instagram filters for protection against the world's evil examining eye.

When I asked Deepika Padukone what she thought, she said, 'See, it's a little tricky for me. I'll tell you why. I also work in the mental health space, so I know what it does to people, but then I also know the fun side to it, so it's weird. Let's put it this way, I think as long as you don't get carried away by your social media image and you are aware of who you are in reality and you're grounded and know that, I think it's fine.'

In the spirit of supporting Deepika Padukone's stance on mental health, I'll tell you about a wonderful chat I had with a therapist I met once and a lesson she taught me that I will carry far into my future. She said, (and I'm putting it in my own words and understanding here) 'You must try and approach the world, and everyone in it, with a shield of empathy and kindness. Not for them, but for yourself. Because when you approach others with empathy, you will realize that whatever they might be doing that's making you feel hurt or sad, is *not about you*. It's about them, and perhaps at that time all they need is your kindness to live with themselves.' Boom.

What's the moral of the story and the golden rules of dealing with internet bullying?

- Approach the world with a shield of empathy and kindness (especially when it comes to trolls)

- Remember that often, it's about them, not you.

- Take the opportunity to learn something from it, or let it die its natural death like all anger does.

- It's never too late to say you're sorry, Justin Bieber.

Did you know by the way that the opposite of love is not hate? The opposite of love is indifference. So, if you're eliciting a response of any kind you're still winning. And if you're a troll who's reading this book and gagging to post a mean comment about it online, thanks for buying the book! xoxo

MissMalini ✔ @MissMalini
@MissMalini: #MMProTip Hear no evil, see no evil, speak no evil.

@MissMalini: #MMProTip Try to get to the raw root of the anger.

@MissMalini: #MMProTip approach the world with a shield of empathy and kindness and nothing will ever hurt you.

@MissMalini: #MMProTip It's them, not you.

@MissMalini: #MMProTip Celebrities are humans too.

@MissMalini: #MMProTip Everybody needs a Chanel bag.

Blog #37: A Lesson from Karan Johar (+ 4 Really Inappropriate Questions to Ask Celebrities)

While shooting the first season of *MissMalini's World* on TLC, I had the opportunity to interview Karan Johar for the very first time. It was awesome and since he is the best at goading out celebrity secrets, I thought I'd ask him for a tip. He said the key is to have a *conversation* with your interviewee. You may go prepared with twenty questions, but it's quite alright if you don't ask even one of them. Unless you have a real conversation with someone, the interview will always feel forced. You should *listen* and then ask the next question, so it makes sense in the flow of things. You must make a genuine connection while speaking to people. I thought this was brilliant – and yes, quite simple now that you think about it – and since then, I have always tried to apply that to all my celebrity interactions.

I was petrified to interview Amitabh Bachchan, for the movie *Pink* in a Facebook Live. I started off with a nervous, 'Alright guys, I have the one and only Mr Bachchan live with us...' He interrupted, 'Why did you say guys? You should say girls.' And there ensued one of my most awkward interviews ever. Until I pulled out my ace in the hole. See, as it turns our Mr Bachchan's father, Shri Harivansh Rai Bachchan, had been a professor at Allahabad University while my father was a student there (I'm talking 1960s). In fact, my father was his best student and thus had earned a hand-written letter of commendation from Senior Senior Bachchan, of which I had a copy. When I told him this story, he warmed considerably and asked if he could keep the print out (which I had initially hoped he would sign as a memento, but hey, if Big B wants a copy, you give the man the copy!) He then said, 'Thank you for this. I think I will ask everyone who has letters from my father to send me copies and maybe I'll compile them into a book.' Bam. Go Allahabad! you came to my rescue when I needed it most.

But that aside I'm going to go ahead and add an addendum to Karan Johar's advice; something I think should probably be solved by having a *conversation* instead of an interrogation. Always ask *yourself* the questions you plan to ask during the actual interview before you go rogue in excitement. Very often you might think you've come up with this clever Q&A and can't wait to blurt it out like, 'Hi Mr Khan! If I gave you a penguin and a typewriter, what would you do with them?!' (Chetan Kapoor and I know that the *only* answer to this question is 'pass the soap', but that's a whole other story.) You need to think about the fact that if you were asked this very same question, what would *you* say? Especially in the 5 minutes you have to finish fifteen media

interviews and take 189 fan selfies. *It's annoying*. I'm not saying don't think outside the box, but try to stay on the planet.

Also, try not to be a d*ck about it. I'd almost allow the penguin-typewriter question if it meant that you solemnly *swear* to steer clear of the wildly personal and utterly inappropriate questions, just to get a 3-second reaction for your viewing pleasure. I've seen this happen so many times that sometimes I feel embarrassed to be called a 'Bollywood journalist'. Here are four actual incidents I witnessed first-hand (well one second hand) and I would love to know if you would ever answer such a question yourself.

1. CAN YOU PLEASE RE(TWEET)PEAT THE QUESTION?

During the interviews for *Happy New Year*, Shak Rukh Khan and the rest of the cast were doing a mammoth day of interviews at the Red Chilies office before they took off on a world tour (of sorts). So obviously – as with all things – everything was running a *little* behind. Okay, a LOT behind. Ironically it was Independence Day and we sat in anticipation for our 7:30 p.m. slot to come in *Waiting for Godot* style. Hours passed. But I knew, that no matter what, I would not and could not leave, even if my entire crew upped and left. I would hold fort and do my interview! Anyway, by 2 a.m. I was in too deep, I wasn't going anywhere. I was prepared to wait till dawn and just shy of 4 a.m. it was almost our turn. There was however another Bollywood gossip website scheduled to go right before us and this lanky boy, who had been waiting a good 9 hours now went up to SRK tentatively, stuck a small recording device in his face and said, 'Shah Rukh *apke baare*

main jo Salman ne tweeter [yes, tweeter] *pe bole uske bare mein apko kya kehna hai?'* Translation: Shah Rukh how do you feel about the comment Salman Khan made about you on Twitter? To which Shah Rukh put a hand on this poor boy's chest and said something to the effect of, bro don't meddle in things you know nothing about. Interview over.

Luckily for us we had come armed with cupcakes and a bowl of chits for them to play charades and while Shah Rukh Khan acted out *Bluffmaster* for Abhishek Bachchan – visibly lightening the mood – I thought to myself, *you waited 9 hours to piss off Shah Rukh Khan?*

PS. This was also the interview where Shah Rukh taught my husband the famous Raj 'air hug'. #livingthedream

2. THE MODEL JOURNALIST

During one fashion week, there was a young newly-wed actress who had just walked the ramp for the first time. And in the press conference a journo chimed in, 'Madame, when you walk the ramp, do you miss your husband?' Um, what? For all 7 minutes, you mean? Now the thing is, if she were to say 'yes', he'd say she isn't serious about her career and if she were to say 'no… well, then she's probably a slu*, never mind.

3. EXCUSE ME, WHAT?

During interviews in Delhi, the Bollywood brand ambassador for a fashion tour was doing back-to-back video bytes. Suddenly one interviewer asked her in Hindi how she had felt knowing that her alleged boyfriend's wife had wanted her thrown out of a house party. The actress looked stunned and walked over to

her team and said, 'What is this nonsense? What have I hired *you* for? If this continues, I'm walking out of here right now.' As she should! What a terribly inappropriate thing to ask someone on or off camera. Again, I was next and I meekly said, 'Hi, I'm MissMalini I'm so excited to interview you,' to which she responded, 'Oh! Hi MissMalini, I've been looking forward to our chat!' After that we had a nice chat about movies, fashion and girl power and I kept thinking what a d*ck move to make someone feel so humiliated in front of a roomful of people. #megafail

4. AT GUNPOINT

I got this story second hand, but my source is 100 per cent legit. Also, this happened at a press conference, so I'm sure there's footage somewhere to corroborate. After an actress, known for doing theatre, had just finished a wonderful monologue she had written herself, the press conference started. First off a journalist began by asking her super inane questions like, 'Madame, what is your favourite colour?' And she answered, as you must. Then he proceeded to ask this question, 'If you had once magic bullet and you could use it to shoot and kill anyone without any repercussions, would you shoot your ex-husband [who is a well-known director]?' I can only just image her shock at this ridiculous question. I just wish she had said, 'No, I would have used it to shoot you.' Bam.

I'm sad to say we're probably only scratching the surface here. I blame much of this press ridiculousness for fuelling, and often. starting fires where there need have been none. Case in point the Hrithik–Kangana saga. But I'm not going to go there, I think.

OH, MAKE THAT 5

You know, I have always maintained that I've been lucky in my entrepreneurial journey. I never faced any blatant sexism that I can recall; in fact, being a woman often played to my advantage when I nudged my way to the front of the line with my little flip camera in hand. And I've told this story loud and proud, many times. Hoping that there was a version of life here in India that was free of the pitfalls for women in a 'male-dominated' society. Alas though, that wasn't meant to be. During a conference, where I was invited to speak about brand-building and story-telling (having just won IMPACT's #1 Most Influential Woman in Media, Marketing and Advertising 2017), the Q&A was to be conducted by a very senior member of the media fraternity. He was meant to ask me just two of his own questions and then throw it open for people to tweet in theirs. He started off by saying, 'So MissMalini, I've heard you're very expensive,' to which I amusedly replied, 'Am I?' Assuming that he didn't mean the double entendre his sentence had uncomfortably just implied. And then, I'm so sorry to report, that of ALL the things he could have asked a successful, young woman entrepreneur, he chose to ask me this: 'Malini, I've always wanted to ask you this question, how have you resisted the urge to have an extra-marital affair with a Bollywood star?'

Now the sucky thing is, you never think of the brilliant comeback at a time when you need it most. They all come tumbling into your brain hours later. I wish I'd said, 'Have you seen how handsome my husband is?' or 'How have YOU? Oh, wait, never mind, you're a walking chick repellent.' or 'Well, Mr if-you-can't-be-sexy-be-sexist, if I was a man would you have asked me the same question? I think not.' Bam. Lawsuit!

Unfortunately, I mumbled something about how that's not how I see the stars, or how they see me and laughed it off. Uncomfortable. As I walked to my room fuming with the realization that I had just had my first truly sexist experience – with an educated member of the fraternity no less – I was most angry with myself for not having said something immediately. What mental conditioning had led me to let him get away with that in a roomful of people and allowed them to laugh at what they genuinely believed to be an acceptable joke.

Of course, the machinery went into motion immediately and many apologies were profusely made by the organizers (not by him though, I refused to give him that closure). But my faith in men was somewhat restored by my CRO Mike Melli, who immediately went up to him, in front of the heads of the event, and said with a smile on his face, 'Congratulations on being a d*ick! You know, *you're* what's wrong with this country, and your hair is ridiculous.' #afewgoodmen

 MissMalini ✔ @MissMalini
@MissMalini: #MMProTip Listen. Absorb. Converse. Repeat.

@MissMalini: #MMProTip Karan Johar is a boss.

@MissMalini: #MMProTip Only ask a question you too would be willing to answer.

@MissMalini: #MMProTip Even monsters get media passes.

@MissMalini: #MMProTip Always stand up for yourself, even if society has taught you to sit down.

Blog #38: Pay it Forward

We come from the land of karma and I assure you that the fastest way to earn karma points is by doing things for people

with no agenda or expectation in return. The trajectory of my entire success can be map based on the kindness of strangers, many of whom have already featured in this book at various turning points of my career.

I first came across the 'Pay It Forward' concept in a movie starring Haley Joel Osment (yeah, the kid from *The Sixth Sense*) where, for a school project, he comes up with a plan to 'pay forward' the kindness of strangers. Instead of returning a favour, he would pay it forward to three other people. He'd then make them promise that they'd do the same, in the hopes of making the world a better place. The movie is inspiring and the idea so simple and elegant that you immediately want to join the movement. I know that this is obviously easier said than done in the rat race of our lives but I urge you to start, even if you start small.

For example, the next time you're in line for something, let the person behind you go first. Or when you're buying a coffee, pay for someone behind you. Or just give a stranger a compliment. Do it for no reason at all and see the way it lights up their day. More importantly, see how it lights up yours.

Historically the concept of 'random acts of kindness' dates to 1982, where author Anne Herbert wrote on a place mat, 'Practice random acts of kindness and senseless acts of beauty.' It was her flip side of the phrase, 'random acts of violence and senseless acts of cruelty'. Apparently, another guest at the restaurant saw it, copied it and the quote took on a life of its own appearing on the *Oprah Winfrey Show*, and earned its own World Kindness Day, 13 November. They've also added a RAK week, 11-17 February, but I say give it a whirl any 'ol day!

One of the people who most inspires me to commit random acts of kindness is Ashok Kurien (whom I have always called Mr K). Besides being a genuine and generous supporter of my brand and I since its inception, I have watched him continuously dive into large projects that are changing lives day by day. Why does he do it? Because he cares and because he can. Literally all you need to jump aboard the pay it forward train.

Check out his latest project 'Give Her 5' to help provide sanitary napkins to underprivileged girls and prevent them from dropping out of school once they start their periods. I bet you didn't even realize that's one of things hampering female education in India today, right?

. .

ASHOK KURIEN
Co-founder: Zee Entertainment Enterprises Ltd., Playwin Lotteries (PPIL), Dish TV India Ltd., India.com and Livinguard Technologies
Founder: Ambience Advertising, Hanmer & Partners Public Relations

I first met Malini almost twenty years ago as a young girl helping a friend of mine on a Mumbai project. I was struck by her confidence, her quick, but intelligent and humorous repartee, her personality and her voice. Unique!

I followed her journey through her days as an RJ, culminating in her own show. Her charm, ability to hold audience attention and personality evolved by the day.

When she first started MissMalini, I even attempted to buy equity into her business, but quickly realized she was going to be too powerful a brand on her own. She didn't need anyone.

Malini has a huge heart. She put her full passion and energy into the Giveher5.org, an online campaign to help promote low cost sanitary napkin solutions for underprivileged girls. MissMalini reached out to over 6 million girls!

Today, she is a voice of authority and respect for millions of young women and she will continue to grow into one of the greatest influencers of young Indian women...in their style, attitude and in their social responsibilities.

More power to MissMalini.
Respect.

• •

 MissMalini ✓ @MissMalini
@MissMalini: #MMProTip Pay it forward. Commit random acts of kindness.

@MissMalini: #MMProTip No act of kindness is too random or too small.

@MissMalini: #MMProTip Give her 5 days of her life back! #Giveher5.

Blog #39: *Without the Bitter, The Sweet Ain't As Sweet!*

You will make mistakes. It's just a fact of life. What you *can* do is be honest enough with yourself to identify the ones you have made, try to correct them, and if all else fails, write them up in your memoir and hope you or someone else learns something from them eventually! I never wanted to write this blog, but then it came knocking on my conscious and I thought I should tell you the biggest mistakes I've ever made and what I think they've taught me. Here goes...

Ragging on Rajinikanth – Early in my blogging career someone sent me some pictures of Rajinikanth without his hair and makeup on. I thought it was fascinating how different he

looked, and since a lot of Hollywood gossip sites would often post makeup-less celebrity photos, I thought, why not? I had no idea what a storm this was about to stir up until the post was flooded with comments berating me for doing such a terrible thing. Rajini fans from around the world came together to express their anger and I had never been at the receiving end of so much hate in my life! I was shocked and sorry. I took down the blog and wrote an apology and have since never posted a picture pointing out a celebrity without their makeup on (unless it's in a good way). Now at first glance you might be thinking, 'Oh no, you didn't girl!' or 'What's the big deal?' or 'Why did you cave?' But the result of this experience was far more impactful on me than you might realize. One, I felt genuinely bad about unintentionally ridiculing someone for their appearance. And two, it taught me that Indian fans are far more loyal and supportive than I'd have ever imagined. Globally, most people love to see a shady celebrity spotting, wardrobe malfunction or an ugly star photo. But often, the Indian fan will come to the rescue of the celebrities they love and say in all caps 'HOW DARE YOU?' to the press. And frankly, I love that. So, if the Indian film fan wants to celebrate their stars and put them on a pedestal of sorts, who am I to rip them down? #GameChanger

A few years later (while I was still blogging a fair amount of 'gossip'), I ran into Ranveer Singh right at the beginning of his career and he was quite upset with me because apparently one of my bloggers had made fun of his rapping skills. I thought it was endearing that he genuinely told me how bad he had felt. My first reaction was to say, 'I didn't write that story!' But then I realized, so what if I hadn't written it? I had allowed it to go up on my blog. So, either I take ownership of it or if I'm

embarrassed and apologetic about it, then maybe I shouldn't post things that make fun of people at all. And therein was born MissMalini's bully-free blog policy: i.e. *I won't blog anything I can't say to your face.*

I think this takes care of me inadvertently trolling anyone and I honestly feel better about myself as a person. I guess I realized one day that if I was lurking around a celebrity, even afraid to make eye contact because of something we'd written, I was probably doing something wrong. And more importantly, whenever I realized our words had hurt someone's feelings, whether I meant them or not, I felt really sh*tty about it. we took things back to the drawing board and now I sleep better at night.

Presently Absent – I have a genuine distraction problem. I think about and try to do too many things at the same time and thus feel I am never fully present in any situation. (This is why my best friend Parul waits for my phone to die to get my full attention.)

I feel like this is a combination of my personality and the scattering impact of today's 'virtual reality' where there's always an email, social media ping or WhatsApp message waiting impatiently in the wings. As to why we feel that virtual message is more important than the real-world conversation we might be in the middle of at the time, I don't know. But my excuse is that the messages pile up and I can't stay afloat if I don't answer immediately and now that I know there's an unread text on my phone, I will obsess about it till I see it. Sad but true!

I noticed this while shooting the first season of my show on vh1 called *Inside Access*. I know I was deeply frustrating to work with at times because I was constantly distracted by my phone

and wasn't spending enough time getting into the segment we were shooting. I know I can 'faff' my way through things. I don't require a great deal of prep, but I can also see the difference it makes in delivery when I commit fully to what I'm doing.

Also, I realized it's just not very satisfying to do something with half your mind in the game. Then you're in a constant state of flux and unable to live in the precious moment of now, which we all know is all we have.

'Living in the moment means letting go of the past and not waiting for the future. It means living your life consciously, aware that each moment you breathe is a gift.' – Oprah

I know it's a bit late in the day to make a New Year's resolution but let's give it a whirl anyway! And thank you Monia Pinto (Producer FACE) and Natasha Baig (director FACE) for always steering me in the direction of 'let's make it more awesome' despite my terrible tendency for distraction.

. .

MONIA PINTO
Producer

The only brief ever given to Malini for her show *Inside Access* was 'be yourself'. That's it! Then the camera never mattered and neither did any distraction. It was easy. Funnily enough, any scripted portion was for her a nightmare because she is a natural. I think the best attitude Malini has is to enjoy everything she does and I guess that's what we see in her writing and on camera. A people's person, Malini wins hearts quickly; the crew loves her and sometimes her idiosyncrasies too. Personally, I

love that she is a powerful woman with a girly mindset that sets her apart. MissMalini must always 'be herself' in whatever she does because that's what truly defines this woman of substance.

. .

I'm going to take you back to Simon Sinek now and suggest everyone try something he says – STOP taking your cell phones into meetings. The few minutes you get before you start working is the crucial bonding time between colleagues, where you might ask something as simple as, 'How's your dog?' or 'What did you do this weekend?' But those few minutes impact office dynamics and culture more than we realize. It might be an occupational hazard to be forever attached to our cell phones (mine is) but I am going to make a conscious effort to be more present from now on. (Let me know how I'm doing, Parul?)

'Being present is a selfless activity, you are not present until others say you are.' – Simon Sinek

Devil Wears Prada Syndrome – You laugh, but it's true. Sometimes I can feel myself turning into the Cruella de Vil version of Meryl Streep and find it difficult to reign in my bubbling temper. The thing is, it subsides as quickly as it flares up, but does a fair amount of terrorizing in its wake! I know I need to work on this. There are probably better, calmer, kinder ways to get my point across, but if you've ever managed a lot of people you know that sometimes rattling the cages is the only way to get the zoo back in order.

What I do regret however, is sending very emotionally charged emails that can often be lost in translation no matter how many emojis you throw in. I have learned that it is far better

to take a deep breath, count to ten or distract myself when I'm angry, rather than act on the impulse. Especially when it comes to non-verbal communication. I suggest if you're feeling an overwhelming urge to send a scathing email or text, first type it out and send it to yourself. Then try to read it from the other person's point of view, keeping in mind how the language and tone may be doing even more damage to the situation. More often than not you'll want to rephrase a lot of it and strip it down to the real sore points, which are always best communicated face to face. Also, always remember how much of WhatsApp communication can be lost in translation and misconstrued by a simple slip of punctuation. Again, be human. Phone a friend.

The Bollywood Tightrope – People often ask me how I 'balance' my Bollywood relationships. Having seen quite a few Bollywood dramas unfold over the years; I think I have a pretty good sense now of when a fun piece of gossip is going to turn into something far murkier. At first I thought I had to always take a side, because when Bollywood starts b*tching, they let loose and you feel compelled to nod and tag along. But soon I started to realize that doing that was making me feel like a hypocrite and potentially look like a double agent (spy v/s spy v/s spy) in some celebrity circles. My stance is clear. As you know, I won't blog something I won't say to your face, so we're safe on that count. But I also won't b*itch one celebrity out to another because that's just as bad really, isn't it? I also get that there are moments where the rich and restless feel the need to thrash out their differences in the spotlight (some say it's always for an upcoming movie's publicity, but I don't think that's always the case). But it is entirely up to me how many rides of the media

circus I want to jump on. And for the most part, I find that the celebrities themselves respect that.

The truth is, everyone has their demons (my closet is full of them, I assure you) so let's all either come out of the closet together or just go play nicely in the park.

MissMalini ✓ @MissMalini
@MissMalini: #MMProTip I won't blog what I can't say to your face.

@MissMalini: #MMProTip Live in the now.

@MissMalini: #MMProTip Control your temper.

@MissMalini: #MMProTip Always resolve arguments face to face.

@MissMalini: #MMProTip You don't have to pick a side to have an opinion.

Blog #40: The Big Four – O

One of my readers, Vishali Singh Solanki, asked me to write a letter to my eighteen-year-old self on Instagram, and now that I think about it, twenty-two years later (wow, that doesn't make me feel old at all) that's probably a great idea. What *would* I tell my starry-eyed teenage self? Let's see.

Dear eighteen-year-old me,

If there is one thing that I know for certain now it's that the most important currency in life is TIME. Time brings you knowledge, time can bring you success and fame. Time stores your memories. Time even has the supreme ability to heal broken hearts. When I look back at the last twenty-two years, or even the last forty, the things that stand out in my memory are all the times you laughed out loud till your stomach hurt, the times you danced your heart out on stage or sang loudly to yourself with

headphones on at the radio station at midnight. Even the times you cried yourself to sleep over heartbreak and hard lessons. And most vividly, all the times you fell.

'This too shall pass, so I do what I can to make it last.' – *'Embrace'*, Shaa'ir and Func

Use every waking breath to learn, to grow, to love. Just like Robbin Williams said in *Dead Poets Society* – 'Carpe diem, seize the day boys, make your lives extraordinary!'

You have always been a big proponent of anticipation. Of something to look forward to.

'Happiness is pretty simple: someone to love, something to do, something to look forward to.' – Rita Mae Brown

But the biggest mistake you can make in waiting for the next extraordinary adventure, is wishing time away. We all know how the cliché goes, tomorrow never comes, so live today. This is truer than you can possibly imagine.

'Forever is composed of nows.' – Emily Dickinson

They say your life flashes by you when you're dying, but the truth is it's flashing right before your eyes today. Each moment is a magical opportunity to create the kind of memories that will stick in your conscious forever. The richest are those whose minds are filled with memories that didn't fade away. Society has conditioned us to believe that the most important things in life

are power and money. But that's simply not true. We were never put on this planet to brush past each other in the pursuit of some elusive end game. We are here to experience life. To connect and engage with the rest of humanity and most importantly, to love. Its only lonely at the top if you alienate the real people in your life in the race to get there. I urge you to stop and acknowledge every day the life that you've been given. We are the only species capable of contemplating ourselves in this manner.

'*I think therefore I am.*' – René Descartes

Be grateful for this time. The next twenty-two years are going to be filled with unimaginable delights. You will follow your heart as you always have and it will light your path on an extraordinary adventure. Just remember to be present for it. You don't realize it now but you have in your possession the most valuable thing of all. You have so much time.

'*If you love life, don't waste time, for time is what life is made up of.*' – Bruce Lee

Love,
xoxo
MissMalini (Who you will one day be!)

PS. Best advice anyone ever gave me about doing long distance relationships.
Keep busy.
Don't wish time away.

Blog #41: Glitter, Confetti and Rocket Ships

I have a bunch of amazing memories from my first IIFA in Malaysia. I was invited to host their backstage videos and got to see a whole other side of the stage. While I was interviewing Malaika Arora Khan, (who was looking absolutely ravishing in a white gown, I might add) Deepika Padukone appeared out of the blue and planted a kiss on my cheek for no reason. I think I blushed and beamed all night long after that! #GirlCrush

Later on, I was chatting with Farhan Akhtar and I asked him about the vibe backstage and it seems like everyone was really getting along and having a good time and he told me that Bollywood is actually like one big happy family. People get along, they hang out, it's really not the torrid, dysfunctional war zone people make it out to be! And I saw the sweetest thing during Anushka Sharma's performance. Ranveer Singh came to watch her entire dance on the screen backstage. He watched intensely and at the end of it burst into a loud applause for his buddy. I thought that was just awesome. And finally, and I HAVE to tell you this, Arjun Kapoor who was co-hosting the awards with Ranveer that year used a knock-knock joke I told him on stage. Wanna hear it?

Knock, knock.
Who's there?
Ya.
Ya who?
Who do you think you are, Shammi Kapoor?

Bahahahaha.

In 2017, I went to Ekta Kapoor's mammoth Diwali party, filled with every Bollywood and TV star and starlet you could imagine and had a wonderful time. But the moment I will always remember from that night, which will forever make me smile is this. As I was walking in, I bumped into Karan Johar wearing a seriously blingy Abu Jani and Sandeep Khosla sherwani (twinning with Sonam Kapoor) and when I told him he looked very nice he said, 'Someone just told me I look like a Sanjay Leela Bhansali set!' That just goes to show how epically funny Karan is and that he has learnt the true secret to life – not to take yourself too seriously. I love you, Karan Johar!

Speaking of SLB. I have the most incredible memory of him from the sets of *Bajirao Mastani*. My very first face-to-face with him was when he invited me to get a breath-taking look at the Aaina Mahal (mirror palace) he had created at Film City. I don't think I've ever seen anything quite like it. But what truly blew my mind was the interest with which he listened to *my* 'zero to hero' story. Complete with the pigeon plot and everything. Obviously, somewhere in the ever-so-slightly deluded dream-world of my mind, I started to imagine SLB making a movie on my life and began to silently cast the film. Who would play MissMalini, I wondered? (Did I mention I am easily distracted?) But if there is one person who can keep you grounded it's Sanjay Leela Bhansali. The intensity of his gaze leaves you convinced that he has peered right into your soul and figured out how all your heartstrings work. Ripe for the plucking. #SLBisBoss

As you can see I have a ton of incredible memories through the decade I have been blogging but I thought it might be fun to get a window into my Bollywood world through my teams eyes too. Hope on over to the end for a whole host of Team MissMalini's favourite celebrity encounters.

Also, Meghna Mirgnani (executive producer at MissMalini) sent me the best message the other day.

Dhruvil Mehta: From standing outside his house to catch a glimpse of him, and this time to see him so closely, was something very unbelievable. But somewhere I knew the fate had a different plan because this time I had the MissMalini team on my side. It all started to build up when I was waiting for my turn to meet THE Hrithik Roshan while team MM's Priyam was interviewing him for his film Kaabil. The moment came, and that moment was beyond imaginable. He not only comforted me by saying things like. 'You do not have to express your love I can feel it,' but also gave me a three-second long hug which made me go from alive to numb. To have spent those 10 minutes of his life with a fan, it must be very normal for him but for me it meant the world. I got my silver lining that day. Thank you, MissMalini, for you gave me a reason to dream.

You know, I always say I understand what I do for a living isn't about to save the world. But what if, for one brief moment, it makes it a better place for someone else? That's good enough for me.

And to everyone who has ever asked me or my team this question, 'How come you guys only write positive stories?' I say this: in a world, so full of war and sadness, isn't it up to us who live charmed lives and can do whatever we dream of doing to spend our time spreading love not hate?

We all love Bollywood so much, otherwise it wouldn't feature in this list of things that rule the Indian consciousness.

'ABCD' – Astrology, Bollywood, Cricket and Devotion. For many, Bollywood offers a dream, a three-hour escape from a difficult or mundane life, an alternate universe if you will, filled with endless possibilities. Which is why we care about the stars who feature in them – what they eat, where they go, whom they date, what they wear – because it is simply an extension of that dream. So, isn't it a little hypocritical to love the magic but tear apart the dreamers who bring it all to life? Then wouldn't a better question be to those who constantly criticize, 'How come you guys only write negative stories?' And to steal a lyric from Kishore Kumar and one of my favourite songs from the original *Dostana*:

> *Mere doston, tum karo faisla,*
> *Khata kiski hai,*
> *Kisko de hum sazaa?*

Blog #42: #AskMissMalini

I started by saying that the answer to life, the universe and everything is 42. It's only fair that I put my thing down and flip it and reverse it – only Missy Elliot fans got that reference – and let you ask the questions. Towards this, I asked my subscribers on social media to send me their questions. I promised them that a selected few questions would make it to my book. And now ladies and gentlemen, I give you, the people v/s MissMalini!

> 1. **Priya Mishra: What kept you going in your tough times? Are you a meditator? If so, how long do you practise and how?**

I guess for me tough times have always been when there was any emotional upheaval, never professionally, so diving into work was a huge respite. I am happy to say I have always loved all my jobs, no matter what I did. Maybe challenging/tiring, but it never made me sad, does that make sense? Also, unfortunately no, I'm not a meditator. I've always wanted to try it, but I can't seem to find the time (lame I know, since it only takes 5 minutes) but I'm so easily distracted, I think I'd find it difficult to focus. I occasionally use a meditation app to fall asleep to, which involves sounds of the ocean! It's called Calm.

2. Kadambari Singh: How do you plan everything around you? What keeps you motivated even on days when nothing seems to be working right? Don't you ever feel overwhelmed?

Honestly, my days are all kinds of crazy. Some days I don't know whether I'm coming or going and almost every day I wake up and the hours race by in a blur, leaving me wondering where my day went. But time flies when you're having fun, right? I rely heavily on my Google calendar to keep me on track. Plus, my A-Team: Ambika (personal assistant), Nelly (stylist), Yeansha (stylist's assistant) and Eshwar (hair and makeup) are always on point to schedule my life and keep me in perfect form from top to toe, no matter how wild my day gets! #razzledazzle

Stress is a given with this kind of non-stop living and it can be overwhelming at times, I try to switch off with my friends on the weekends and go dancing (but truth be told I'm never offline until my phone battery dies). Staying happy is about reminding myself what a blessed life I have to be living my dream and the luxury to hit snooze at least 5 times each morning.

3. PPayal Ved Liju and @acharmedlifein: How do you strike a balance between your work and personal life?

I have never could tell where work stops and my personal life begins. It all seems to overlap. The upside of that is work doesn't feel like work but the challenge is that it's easy to get caught up in it all. Nowshad and I working together is a great boon because we understand each other's work commitments and often get to travel together, making work into play and enjoying it like a holiday. But we also never stop working in a sense. We're both lucky to have very supportive families and when you live apart from them you can make more quality time together when you meet. Our favourite thing to do to together to unwind, is watch Netflix and actually chill!

4. @smashingsamriddhi What's at least one thing that you want to change about your life?

I guess the only thing I'd change about my life if I could (and I should) is not taking out any time to focus on my health and fitness. I know it's going to catch up with me one day, the lack of sleep and exercise. I keep promising myself I'll join a class or adopt a healthier diet but butter chicken calls my name after midnight on a regular basis, what to do? I'm gearing up to start yoga and meditation in 2018 and my friend Junelia is going to introduce me to Reiki 1, which I'm looking forward to. #ProjectZen #MMDetox

(My friends will all laugh reading this because all my grand detox-month plans only ever last till Friday. Laugh it up soulmates, laugh it up.)

5. @niks_wanderlust: How can I join your team?

Email arti@missmalini.com with your resume, a cover letter and fifty words on why you belong at TeamMissMalini. Well, that was easy!

6. @_equinox_: What's the one thing that keeps you motivated? What's left on your bucket list?

I'm motivated essentially by FOMO, the Fear of Missing Out! To be completely honest, a lot of times when I don't feel like getting out of bed, the FOMO kicks in and I jump to it. Aside from that I would say I'm an ambitious person, so my motivation to shoot for the moon runs in my veins.

There are probably a billion things left on my bucket list (the Bollywood versions of which you will find at the end of this book.) But one I've always had, since as long as I can remember, is to open a massive glass door and step out on to the balcony of a house located right on the beach (the one just like in the movie *Sleeping with The Enemy*) knowing it belongs to me and feeling the salty breeze on my face standing next to someone who loves me. *sigh*

7. @drishti0694: How do you define MissMalini in just one sentence? Also, if MissMalini was a superwoman, what would her superpowers be?

MissMalini is your happy shiny Bollywood BFF!

If I had a super power, it would be to travel through time.

8. **@anushka.purohit: What part of your job do you look forward to most every day, and what has this unique job taught you?**

I look forward to waking up and scrolling through all your comments on social media and the blog. It makes me smile to see all of you living and breathing there. I also love when I have shoot days for my TV show and a chance to sit and write something myself (preferably in PJs on my sofa.)

This job has taught me that you don't have to be asleep to live in the world your dreams. And that relationships are everything.

9. **@sumiran_g: MissMalini has never been in any controversy. You've kept everything clean and made sure your news never hurt anyone. What do you do to make sure it doesn't happen? Also, to what do you attribute your success?**

I have a very simple rule – I won't write anything I couldn't say to your face. That pretty much keeps the soul of the blog clean. I also believe that while a little gossip is all fun and games, once it starts to get dark and ugly, it's not gossip anymore. Then its revelling in someone else's misery and that's not cool. I believe the secret to my success has been hard work, passion, an incredible team and being unabashedly positive!

10. **@flexcia_dsouza: In the initial stages, how did you monetize your blog? How difficult is it to explain to brands how blogging works? Did you work for free? Is it the right thing to do?**

Initially, the blog survived purely on barter and I survived on the income from my radio show and my job at Channel [v]. It took a long time for brands to understand and get on board with the impact of influencer marketing, and I'm proud to say we did a lot of the grunt work for many of the thriving bloggers today. My blog was not a business when it started so the goal was never making money. I wrote about the things that I loved or intrigued me and often those would overlap with brands. For a good year, I did things on barter – if you want to call that for free – when they would fly me somewhere or give me products to review. But my rule was to only ever feature things I endorsed. I'm proud to say we maintain till this today.

Honestly, it is entirely a personal decision to work for free or expect be paid. To expand my blog and turn it into a media network, I obviously needed to look at it from a business perspective. I believe I have always been always entirely upfront about anything that was sponsored and my followers know that.

But if someone wants to barter their way around the world who's to say that's wrong either? After all the first currency of the human race was the barter system, right?

11. @shivani_v_07: How has your journey been till now? Does your success overwhelm you sometimes?

You have no idea how surreal it all is! I'm sitting here on my pink sofa answering these questions and I still can't believe I'm writing the last chapters of my book. An actual book about MY life. You know how everyone always says they want to write a book one day? Ya. That. Overwhelming much?

My journey has been nothing short of mind-blowing and supercalifragilisticexpialidocious. These days I've been having this existential crisis of 'Why am I me?' and the only answer I can think of is because the universe thinks it's my birthday.

12. @tiya_tultuli: Who, according to you, is the most inspirational Bollywood celeb and why?

You know I feel there are so many that inspire different people in different ways. Whether it's through their charity work or the bravery they have shown coming forward with their personal traumas. The fact that millions, sometimes billions of people find some sort of personal joy in a Bollywood movie, song or star means they are all winning. If you're asking me who inspires me most, it has to be Aamir Khan. But then again I've had a crush on him since I was ten!

13. @Sharan Mehra: Do you prefer being a blogger to a radio jockey? What would you be if you were neither of the two?

Hi Sharan, and thanks for being a supporter since my radio days. It's so hard to pick, radio was my first love and blogging is my soulmate. I love that today I get to do it all, blog, TV, radio and who knows what's next?

If I wasn't a blogger or radio jockey...initially I wanted to be a criminal lawyer (probably from watching too many TV shows) or I'd be a therapist because I think I'd make a good one.

14. @ry_scientist: How did you plan to start a website when you had no technical domain background and how did you pull off getting the digital life of Bollywood blogging in India when it wasn't even anticipated?

When I started, my friend Karan Wadhera made me a WordPress account, which has a pretty badass backend for rookie bloggers. The CMS is very intuitive and you can just sign up and blog your heart out with very little technical expertise.

Soon after there was this awesome guy Mr P who just randomly offered to help me manage my blog and make small tweaks and add widgets when I needed. He did it for free! Later, I commissioned the first iteration of my anime for Rs 8,000 and it was off to the races...

Once things started blowing up, Nowshad jumped into the mix and took over the technical aspects of the blog and I deep dove into social media. The secret to digital life is treating it like real life. Be present. Be there. (Or Be Square!)

PS. Thank you for always being such a lovely supporter, your comments on Instagram have always meant the world to me.

15. @ikomalmistry: Was there any point in your career or personal life where you felt just alone, really alone? How did you deal with it?

Oh, so many times! Everyone has those heart-wrenching breakups where you think your heart will implode. I remember sitting at the radio station crying my eyes out between links for hours and hours and hoping my listeners couldn't hear it in my voice. But then something incredible happened. Someone

sent me a message saying, 'Are you okay?' And I decided I'd tell everyone I had just had a terrible breakup and my heart was broken, and I was going to play sad love songs for an hour to torture myself till midnight. It turned out to be cathartic and everyone shared their breakup stories and how they dealt with the pain. It felt very healing in the end. Lesson learnt: You're never really alone unless you want to be.

16. **@miss_catttitude Getting into the industry is difficult, and making it big there is like a knock on the door of impossible. In the process, you must have met men and women from different walks of life, some nice, some others rude, how did you deal with them?**

Over the years, I have noticed a change in the way people talk to me and at first it used to make me mad that they didn't before. But then I thought about it and realized that it's all a matter of perception. When I meet celebrities, I have so many things to ask them and when I meet a follower or a fan do I take the time to ask them as many questions? Now I do. At least I try, but I don't always know enough to ask about. And I guess that was the same case for me.

I find that the best judge of character however is to watch how people speak to the people *they* don't think matter, when they think nobody is looking. It never killed anyone to say thank you, so remember the nice guys (and girls) are the ones who do.

Bonus question!

17. @Tina Bedi: If you could come away at this point in your life, and say I have learnt 3 good lessons, what would they be and why?

1. The only way to live is to have a dream and the passion to pursue it.
2. There are signs everywhere. Learn to follow yours.
3. In the end all that will matter is how you loved and who loved you, for you.

I guess that about wraps it up. Dare I say this is only the beginning? *Aage aage dekho, hota hai kya! #Jalwa*

I will always remember this moment when I wrote the last few lines of my first book. (Nowshad has promised me that we're getting a brand-new bookshelf just to have somewhere to put it.) I am so very grateful for this extraordinary life and for you, my dear reader, who cared enough to deep dive into it. I hope you found a little piece of you, in the many pieces of me.

'May the odds be ever in your favour.' – *The Hunger Games*

MissMalini's Bollywood Bucket List

☐ Look wistfully out of the window of a car with a heart-wrenching song playing in the background. Tears and rain optional. (Too many options, but I'm thinking a Priyanka Chopra-style and *'Tujhe Bhula Diya'* in the background on my Saavn app)

☐ Run down an icy slope into the arms of my lover in a red chiffon sari. (Sridevi, any movie. Preferably Switzerland)

☐ Stand at the bow of a cruise liner and scream, 'I'm the Queen of the world!' with my hands up in the air just like Leonardo in *Titanic*.
(I know it's not Bollywood but it's close enough! Hopefully completed on my fortieth birthday on *The Voyager of the Seas*. #MMBirthdayCruisers)

☐ Dance in the rain. *(Kajol in DDLJ)*

☐ Ride around lying down in the sun, on the back of a tempo on a huge pile of hay in the sunshine *(Madhuri Dixit in Dil)*.

☐ Dance to a choreographed sequence in a nightclub with at least two Bollywood stars *(Alia Bhatt in Student of the Year)*.

☐ Do the 'kabhi disco main jaaye' dance with Govinda (DONE THAT, B*ITCHES!) Thank you, DJ Aqeel and Sirkus (Raveena Tandon in Bade Miya, Chote Miya).

☐ Ride a horse cart with Aamir Khan – okay, I'm pushing it – maybe just ride a horse cart around rural India singing 'Elo Ji Sanam Hum Aa Gaye'. (Raveena Tandon in Andaaz Apna Apna)

☐ Take a road trip to Goa with my besties. (Dil Chahta Hai) I've done train and bus, road trip pending!

☐ Dance the flamenco somewhere in Spain (Zindagi Na Milegi Dobara).

☐ Try the Tomato Festival (Le Tomatina) in Valencia with my BFFs. It sounds just like Holi (Katrina Kaif in Zindagi Na Milegi Dobara).

☐ Speaking of Holi – enact out the entire 'Rang Barse' sequence (Rekha and Amitabh in Silsila).

☐ Do an item song – does me being Kareena Kapoor in Don for a BBlunt commercial count? I think it does Adhuna, Tom and Shaun, I think it does!

☐ Have someone say, 'Jaa Simran jaa, jee le apni zindagi' and run along a train while someone pulls me on board. (Kajol in DDLJ) – kinda did this one in Gstaad...just that it was the wrong station and nobody pulled me on board.

☐ Go on a cruise! (Priyanka Chopra in Dil Dhadakne Do) #BirthdayGoals #MMBirthdayCruisers woohoo!

☐ Live in a house on the beach (Deepika Padukone in Break Ke Baad).

☐ Road trip through Europe (Kajol in *DDLJ*).

☐ Dance on a table to '*Desi Girl*' (Priyanka Chopra in *Dostana*).

☐ Play badminton in 1970s gear to the tune of '*Dhal Gaya Din*' *tak* (Leena Chandavarkar in *Humjoli*).

☐ Drink tea from the same cup with my bestie (Aamir Khan and Salman Khan in *Andaz Apna Apna*).

☐ Have a big fat Bollywood wedding sangeet. Check! Done that. Way too many movies to name but there's a video of mine on YouTube titled 'Malini & Nowshad's Wedding Trailer'. Go see!

☐ Dance on broken glass to '*Jab Tak Hai Jaan*' in a villain's lair (Hema Malini in *Sholay*).

☐ Do the 'best friend' hand shake and say 'You're my best friend, yaaaar!' (Kajol & SRK in *Kuch Kuch Hota Hai*).

☐ Be rescued by the hero. Although I honestly believe what Tom Robbins has to say on the matter, 'We are our own dragons as well as our own heroes, and we have to rescue ourselves from ourselves.' – *Still Life with Woodpecker*.

Team MissMalini's Bollywood Encounters

I thought it might be fun to get a window into my Bollywood world through my team's eyes too. Here are the stars of Team MM and their favourite celebrity encounters while working at MissMalini Entertainment!

Alisha Fernandes – Lifestyle Editor

It was just another day at Lakmé Fashion Week and I was with Hrishitaa and Natasha Kishore. We were waiting impatiently at the St Regis coffee shop to get our interview with Tarun Tahiliani or as he's better known, Gru from *Despicable Me*. Now, because the interview was for Saavn, we knew audio quality would be even more of a priority and weren't at all pleased to hear the din of clattering crockery and cutlery. But in addition, just as our luck would have it, the pianist started to play as soon as we hit record.

In a generous move, TT (Gru) ferried us up to his suite so that we could get a better interview. This was all great of course, because he's quite the story-teller but the most memorable part happened when he asked one of his team to take a picture with all of us MM girls, for posterity you know? He put his arms around us, asked if we were ready with our picture-perfect smiles, counted us down and on three, and just swung sideways so that all of us collapsed in a heap on the bed behind us, in SPLITS.

Divya Rao – Bollywood Blogger

I had never been on a train before and the first time I took one in India was with Shah Rukh Khan. We were in the same compartment for 18 hours – going from Mumbai to Delhi for a film's promotion, and it was surreal! Every time the train stopped, his fans would throng the station and scream out his name, hoping to catch a glimpse of him. Firstly, I never thought I'd find myself on a train ever, and secondly, I didn't ever expect to find myself on a train with Shah Rukh Khan.

Eshwar Log – Makeup Artist

I'd always prepare myself to avoid getting star struck, but alas, no matter how hard I tried, I always would. Amitabh ji, Sri Devi, Maduri Dixit, Prabhu Deva, Ranbir Kapoor, Katrina Kaif, Akshay Kumar, Vidya Balan, Deepika Padukone, Kareena Kapoor, Anushka Sharma and the list of celebrities whose personalities and charm blew me away goes on.

Hrishitaa Sharma – Fashion Blogger

I tell this story with absolutely zero exaggeration. It was a Lakmé Fashion Week day when Ranbir Kapoor walked the ramp for Kunal Rawal and I went to interview them post the

show. Ranbir looked very pumped about the show and Kunal's collection, and as I began the interview and introduced myself and them, Ranbir hugged Kunal. Seeing my short window of opportunity, I did *chance pe dance* and told Ranbir that I felt left out since he only hugged Kunal. Little did I know at that point, that I dreamt every girl's dream and made it come true in that very second. Ranbir quickly held me and snuggled into a nice hug which lasted the entire 10 minutes of the interview!

Mallika Kulkarni – Key Account Manager Sales & Marketing

Shaggy's songs were a key feature on my teenage playlist, I've even taken a BuzzFeed quiz on decoding the lyrics to '*It Wasn't Me*'. I got to interview him before his India tour last year where he performed in Mumbai after 20 years! Although it was a phone interview, and I never got to meet him, it was honestly SURREAL just to be able to speak to him. We chatted at length about competing with Justin Bieber, getting Priyanka Chopra to star in his videos and his undying love for butter chicken and garlic naan. All I can say is, somewhere my thirteen-year-old self had died and gone to heaven.

Meriam Ahari – Director of Fashion & BeautY

My most memorable experience is not with a Bollywood starlet per se, but isthe social media mogul Malini Agarwal.

So, what is Malini *really* like when all eyes aren't on her? Selfless. On our first night out together, I decided to carry a clutch. Like any good drunk on the dance floor, I flail my arms around *a lot*. I inadvertently called out the poor choice of accessory sandwiched underneath my armpit, clearly hindering my moves. Without hesitating, Malini grabbed my clutch and

held onto it for the rest of the night. Even when I insisted on taking it back – horrified at the thought of my new boss carrying around my purse all night – she wouldn't budge. It was clear that Malini wanted me to let loose and enjoy myself.

Kind-hearted. You never know what you'll find at one of Malini's epic house parties, but one thing you can be sure not to, is a wallflower. Even at the stuffiest events, this social butterfly is the queen of bringing people together.

Thoughtful. One evening I told Malini I was bummed that my boyfriend had to spend his birthday in London for work and that I wished I could surprise him. By next morning, my WhatsApp was filled with contacts for balloon and edible arrangement delivery services that Malini had asked her sister Shalini (who's based in London) to recommend.

These random acts may seem trivial, but most can attest that the foundation of any relationship worth its salt, are 'the little things.'

Mike Melli – CRO

Malini and I were in her green room during a shoot and she got two surprising phone calls back-to-back. One from Kangana and the other from Hrithik. Rumours were flying between these two at the time, and both wanted their stories to be heard, but not in a public forum. They spoke separately with Malini, revealing private details and emotions. This was not stuff that they wanted to get out in the press, and yet here they were telling a celebrity blogger EVERYTHING. But they knew they had nothing to fear. Anything they told Malini in confidence would never find its way into our publication; she wouldn't even tell me, her most trusted adviser, who was sitting right next to her. I knew then that our effort to build trust among the celebrity class had paid off. In conversations with investors and

business magnates, we always said that Malini was a 'friend to the stars', but that day it became clear that she's not just a 'friend', she's a peer.

Natasha Patel – Senior Beauty Blogger

1. Shraddha Kapoor randomly DM'd me and told me how she watches my tutorial.
2. That time celebrity skin expert from LA, Nurse Jamie READ MY BLOG and loved it.
3. When makeup gods like Mickey Contractor and Sonic Sarwate not only recognize me, but come up and say hey to me. I love everything about those two!
4. When Mira Rajput came to our office for an interview and asked where 'the girl who does makeup videos' was. Small moment but very happy she knows me as the girl in makeup videos.

Neha Jambotkar – Director of Client Servicing

While working on my first client campaign, Ola, Malini asked me who I would want to meet. I said Kareena! She looked at me and said, 'I promise I will make you meet her by the end of this year.'

Two months later, we were at Taj Lands End in a room where Kareena was sitting across from me being interviewed. I was ecstatic JUST to see her. She looked bored with all the journos and I kid you not, when she saw Malini, she lit up. The interview got over and I thought we would leave immediately. It didn't even strike me to check if I should like say hi to Kareena. But Malini called out to me and introduced me to her. The rest is a blur! I just remember mumbling some pathetic stuff to as Kareena smiled politely and took pictures.

Nelly Wadia – Personal Stylist

I thought I'd be most star struck by Shah Rukh Khan, when we saw him at 5 a.m., also because I absolutely love the star he is, but turns out I was gob-smacked when I saw Priyanka. It's like I was in this daze of purple allure (because purple is my favourite colour I tend to associate it to my other favourite things) in this case a person. She was polite, funny and beautiful AF, I'm still really taken by the workaholic she is.

Nowshad Rizwanullah – CEO

I was excited. It was our biggest interview till date, and it would be airing on our first-ever TV show. Little did I know our 7 p.m. slot with Shah Rukh Khan would be delayed by 9 hours. I was ready to call it quits at 10 p.m. By midnight, I was seething. When our turn finally came at 4 a.m., I was ready to set fire to the building. That is, until we shook hands – and in an instant, all was forgiven. There are certain people blessed with almost supernatural charisma that is hard to explain, and impossible to escape. SRK is one such person. Before long, we were standing side-by-side, legs planted, arms spread wide, while he taught me the signature move that has made entire generations swoon. As we left, he kissed my hand and wished Malini and I a happy married life. I still don't know what Jedi mind tricks he pulled on us that night, but from that moment on, one thing was abundantly clear: Shah Rukh is, without question, King Khan.

Priyam Shah – Bollywood Blogger

One day, while I was on leave from work and in Delhi for my friend's wedding, I got a call from Rashmi asking me if I'd be able

to take time out and interview Shah Rukh Khan for *Dear Zindagi* because he was in Delhi and they wanted to know if anyone from MissMalini was available. Mind you, SRK is the only man I have ever truly loved. When I met him, it was everything I ever imagined it to be but better. I told him about how much I loved him and how he is absolute magic. It easily was the best interview of my life and I still get comments and messages about it.

Cut to a few months later, at Karan Johar's launch of his book, SRK recognized me from a distance and gave me hug. Life made!

Rishab Maliwar – Head DOP

My best fan moment was when I met the most beautiful actress Deepika Padukone during her movie promotions for *Finding Fanny*. And after we got done with the shoot, our lovely boss Malini said, 'Deepika our favourite boy Rishabh is a huge fan of yours.' Deepika then came towards me and gave me a really tight hug. I could not believe my luck.

Samira Major – Creative Video Head

The day Kalki Koechlin and Rajat Kapoor came to office and kept asking for MissMalini. I'm head over heels smitten by both by the way. I was blushing and giggling like a teenager and told them I was MissMalini. That lasted for like less than 5 minutes but it was GREAT.

Shreemi Verma – Bollywood & Lifestyle Blogger

We were shooting for the *Dilwale* promotional video. It was one of the first 'concept videos' we had created and it was scripted within half an hour. The idea was simple: Shah Rukh Khan and

Kajol would bicker like best friends, while Malini has kept them on a conference call (without their knowledge).

We reached Mehboob studios at around 4 p.m. The team consisted of Nowshad, Rashmi, Aayushi, Rishabh and me and we were all really, really nervous. It was the first time I was seeing the love of my life Shah Rukh Khan in person, enacting a scene which I helped in scripting. It was insane!

We had to wait for hours (that's how Bollywood works), but the moment he started reading our lines, he had this bright smile on his face. (Those dimples deserve another chapter of their own to be honest.) He was ready to shoot within minutes, he improvised, added his own lines, laughed a lot and the entire sketch took 10 minutes to shoot. I have always been a fan of SRK, but meeting him and working with him in a certain capacity made me realize what 'charm' means.

Swagata Dam – Bollywood Blogger

Having spent more than 6 years in the field of film journalism, I have met almost every superstar including Amitabh Bachchan and the Khans. And being a Bollywood lover, I have enjoyed all these rendezvous. But the day I met Rajinikanth is something that's going to be etched in my memories forever. I had gone to Chennai for the grand music launch of his film with Deepika Padukone, *Kochadaaiyan*. A few sturdy bouncers had to escorts us to the venue as there was madness out there. People were chanting '*Thalaiva Thalaiva*' and that was the first time I witnessed Rajini sir's fandom in Chennai. We had been promised interviews with Deepika, A.R. Rahman and Shah Rukh Khan, who was a special guest at the event. But unfortunately, due to Juhi Chawla's brother Bobby Chawla's sudden demise,

SRK and DP had to rush to Mumbai. Meanwhile, a media shy Rahman also left the venue. And that's when Rajini sir and his wife came up to us, apologized for the turn of events and invited us to their home. YES! THE Rajinikanth invited me to HIS HOUSE. He had a long conversation with us and offered us food and buttermilk and posed for pictures with each of us. We had requested him for a group photo but he insisted that we take individual photos. I can never forget the smiling face with which he hosted us that afternoon.

Yeansha Lodha – Assistant Stylist

That absolute awkwardly star struck moment, where I didn't know whether to smile or breathe, was as Shah Rukh Khan used my back to sign t-shirts on and Malini brought up our long running joke about how I only like 'bad boys' and asked him to give me some advice! To which he said, 'Yeah you should go for bad boys because I'm playing one in my next movie.' I died.

> I also thought I'd dig deep and ask ex team members, who went on to pursue their other passions to pull out their favourite memories from the archives!

Amruta Khatavkar

One of my favourite MissMalini memories was the day SRK took a selfie with me! Believe it or not he was so casual about me passing my phone to him, switching my camera to selfie mode and clicking a picture. It was covered in the newspaper as 'Shah Rukh Khan clicking a picture with someone at a party', and that was the cherry on the cake.

Anushka Mulchandani

In January, I told Malini that going to Coachella was on my bucket list. She said, 'So why don't you just write to them and tell them you want a press pass?' I had nothing to lose; I sent that email and filled out their press forms and forgot about the whole thing. Come March I got an email from their team telling me they'd love to have me over and I was in shock! Yes, I went to Coachella that year (with a free festival ticket no less) and had the best time of my life.

Chandni Lahotl

The most memorable moment for me while working for Team MissMalini Dubai, was attending the TOIFA Awards 2016 Red Carpet alongside Malini and the team for the first time. I got to see the biggest superstars, from Amitabh Bachchan to SRK to Salman Khan off screen, right in front of me.

Dhruvi Shah

My favourite director in the world is Imtiaz Ali and this is no secret. At MissMalini, I have a fellow Bollywood dreamer, Rashmi Daryanani. On a summer afternoon in 2014, we trekked to Andheri (albeit in a sedan) to Imtiaz Ali's brand new office. We were interviewing him for *Highway*, realizing much later that he revealed the plot and characterization for *Tamasha*! We were just happy that when we requested for t-shirts, he gave us the crew t-shirts for *Highway*. The treasure he has left with us is priceless.

Lumen Beltran

MM HQ is known for having big Bollywood stars as our guests, and consequently there's a certain pressure for the team to

perfect every shoot within the time constraints given. The reason I'm so fond of Spiderman and Mallika Dua's visits is because they brought an infectious energy that allowed everyone in the office to let loose. I think it's a strong reflection of the company culture MissMalini has built when even our CEO, Nowshad, can participate and take fun photos with our guests while still maintaining a high level of professionalism. I felt even more connected to the team after each visit.

Mahak Jain

I was nearly 9 months pregnant (and very obviously ready to pop) when I met Shah Rukh Khan for the first time. He was in Dubai promoting *Raees* and from the moment he walked into the interview he made it about me. He asked me if my chair was comfortable, made sure no one had any cigarettes in the vicinity, and even brought up memories of holding his own kids for the first time! And then, in the middle of chatting about the film, he paused and said, 'Actually, you shouldn't watch that scene,' and went on to tell me that I should step out of the theatre during a particularly gory scene in the movie because it wasn't something an expectant mother should see. As if that wasn't enough to completely melt me into a pile of mush, he took my hand and kissed it at the end of the interview, leaving me with a 'God bless' and 'good luck' for the baby. No words.

Marv D'Souza

Malini did all the major Bollywood interviews. Once, the team couldn't make it in time and I, as a shy fashion stylist, was the last choice. But Malini called from New York and instructed me to do and it led me to interviewing Priyanka Chopra. It was

wonderful meeting a superstar who actually paid attention to a shy newbie and make me comfortable instead of the other way around.

Ranjit Rodricks

My best memories are of all the insider Bollywood gossip we would share around the lunch table (that stuff was always spicier than the food) and the frequent dress-up parties we would have in office.

Sukriti Gumber

Alia Bhatt was promoting *Dear Zindagi* with Shah Rukh Khan, and it was one of those rare opportunities when you meet a celeb in Delhi. I wore my Zara sneakers (and planned an outfit per them) that Alia once wore to the airport, hopelessly hoping that she would notice them. When we met, I sheepishly drove her attention to my shoes and she casually started a conversation about it. I was so dazed!

Letters from the Stars

Anu Malik: MissMalini can see the bigger picture and understand multiple view-points. She has redefined journalism in the Hindi film industry. Cheering for MissMalini all the way to the moon.

Arjun Kapoor: Here's to the girl who started a movement! The digital entrepreneur who saw things before anyone else did – the trendsetter, the jetsetter, the beautiful and stylish Malini.

Elton Fernandez: I don't think most people understand how much of a workaholic Malini is. She's always hustling and projecting bigger life goals. She's somebody who's always thoughtful and a loyal friend. Incidentally, she's the person who planted the idea of starting my YouTube tutorials, and am I glad I took her advice! We constantly collaborate and work so

beautifully together, and I feel like we unwrap a new layer to each other, and I respect her more each time. I have immense admiration for the brand that the team has seen grow over the years, and wish them every luck and success.

Farhan Akhtar: What can I say? You've got to love this girl and applaud all she's achieved. Shine on, Malini.

Jacqueline Fernandez: She's been one of my inspirations with her focus, dedication and for being a pioneer in the digital world with her blogs and amazing content You always know it's a good show or story if Malini is covering it. Love her!

Karan Tacker: I mean there is inappropriate and then there are MissMalini's inappropriate questions. The one I did on my birthday is one to remember! Had a blast being awkward, that's what team MissMalini does. But must give it to her for coming in and sweeping us off with all her updates. So happy for you Malini and wish the portals keep increasing, in case you don't know what I mean, you have to go see @missmaliniloveandsex on Instagram.

Malisha Mendonsa: I know Malini from a radio station we started working at together. I distinctly remember thinking, as she went about prepping and planning her show, how proactive and resourceful she always was. She made all ideas and their execution seem so easy. Over the years, I've seen her evolve into a brand everyone wants to associate with and how! She is so deeply involved with all facets of everything that she does and makes it look so effortless. I'm sure she and her super team

have a ball while doing all that they do. However, I know it is hard work and it is commendable and inspiring. I remember writing to her a few years back, telling her how proud it made me to see her do so well and aiming for the moon. I have no doubt that she will make it there and beyond as she puts her mind to it. I wish you so much luck for the future. Malini, you go girl!

Mandira Bedi: It's been lovely to see the growth from strength to strength of this lovely girl, MissMalini. I remember her from her *Mid-Day* days and it's amazing how far she has come. Where she is at is a natural progression, but I don't see anyone else where she is. She has the first-mover advantage in the world of blogging and social media and her brand now has reached a position no one else can touch.

My two best memories of her are when she walked the ramp for me in my first fashion week show, as a woman of substance. And the second one, in Delhi, when we danced the night away to the '*Shape of You*'.

Nikhil Mehra: From the moment I saw her, I knew she was special. She had come not to impress but to take over and, by God, she did.

Rohit and Rahul Gandhi: We remember meeting Malini during the Chivas tour, when Ranveer was walking the ramp for the first time. We met her backstage before and after the show, she was quirky and young and the three of us had a great time. We both remember it as the first time that an interview was a fun conversation!

Rahul Bose: I cannot think of a time in the last 10 years that the team at MissMalini has not supported an event held by my foundation or of any of the movies I have done. Their support of *Poorna* during its release went well beyond professional requirement. They were proactive, kept their word and followed up on every story to do with the film. In today's world, that is pure gold.

Richa Chadda: About time you did a book about your incredible success and how you came from doing what you loved and built this empire on your own. I've seen you grow, seen your office grow and your employees grow, and I am just so proud of you. We need more women like you out there, doing their own thing and making it their own thing. So, good luck and I can't wait to read your book!

Sunny Leone: Good luck for your book l and I wish you all the best. Glad to see your unique journey find success.

Thank you, Universe!

25 ⬛ HarperCollins India Pvt. Ltd

Celebrating 25 Years of Great Publishing

HarperCollins India celebrates its twenty-fifth anniversary in 2017. Twenty-five years of publishing India's finest writers and some of its most memorable books – those you cannot put down; ones you want to finish reading yet don't want to end; works you can read over and over again only to fall deeper in love with.

Through the years, we have published writers from the Indian subcontinent, and across the globe, including Aravind Adiga, Kiran Nagarkar, Amitav Ghosh, Jhumpa Lahiri, Manu Joseph, Anuja Chauhan, Upamanyu Chatterjee, A.P.J. Abdul Kalam, Shekhar Gupta, M.J. Akbar, Tavleen Singh, Satyajit Ray, Gulzar, Surender Mohan Pathak and Anita Nair, amongst others, with approximately 200 new books every year and an active print and digital catalogue of more than 1,000 titles, across ten imprints. Publishing works of various genres including literary fiction, poetry, mind body spirit, commercial fiction, journalism, business, self-help, cinema, biographies – all with attention to quality, of the manuscript and the finished product – it comes as no surprise that we have won every major literary award including the Man Booker Prize, the Sahitya Akademi Award, the DSC Prize, the Hindu Literary Prize, the MAMI Award for Best Writing on Cinema, the National Award for Best Book on Cinema, the Crossword Book Award, and the Publisher of the Year, twice, at Publishing Next in Goa and, in 2016, at Tata Literature Live, Mumbai.

We credit our success to the people who make us who we are, and will be celebrating this anniversary with: our authors, retailers, partners, readers and colleagues at HarperCollins India. Over the years, a firm belief in our promise and our passion to deliver only the very best of the printed word has helped us become one of India's finest in publishing. Every day we endeavour to deliver bigger and better – for you.

Thank you for your continued support and patronage.

⚏ HarperCollins*Publishers*India

Subscribe to Harper Broadcast

Harper Broadcast is an award-winning publisher-hosted news and views platform curated by the editors at HarperCollins India. Watch interviews with celebrated authors, read book reviews and exclusive extracts, unlock plot trailers and discover new book recommendations on www.harperbroadcast.com.

Sign up for Harper Broadcast's monthly e-newsletter for free and follow us on our social media channels listed below.

Visit this link to subscribe: https://harpercollins.co.in/newsletter/

Follow us on

YouTube ▣ Harper Broadcast

Twitter ✈ @harperbroadcast

www.harperbroadcast.com

Follow HarperCollins Publishers India on

Twitter ✈ @HarperCollinsIN

Instagram ▣ @HarperCollinsIN

Facebook ▣ @HarperCollinsIN

LinkedIN ▣ HarperCollins Publishers India

www.harpercollins.co.in

Address

HarperCollins Publishers India Pvt. Ltd
A-75, Sector 57, Noida, UP 201301, India

Phone: +91-120-4044800

On the cover
Hair & Make-up - Elton Fernandez
Hair & Make-up Assistant - Krishna Kami
Styling - Nelly Wadia
Styling Assistant - YeanshaLodha
Dress - FCUK
Jewellery - MalvikaVaswani